THE WEEGEE GUIDE TO NEW YORK

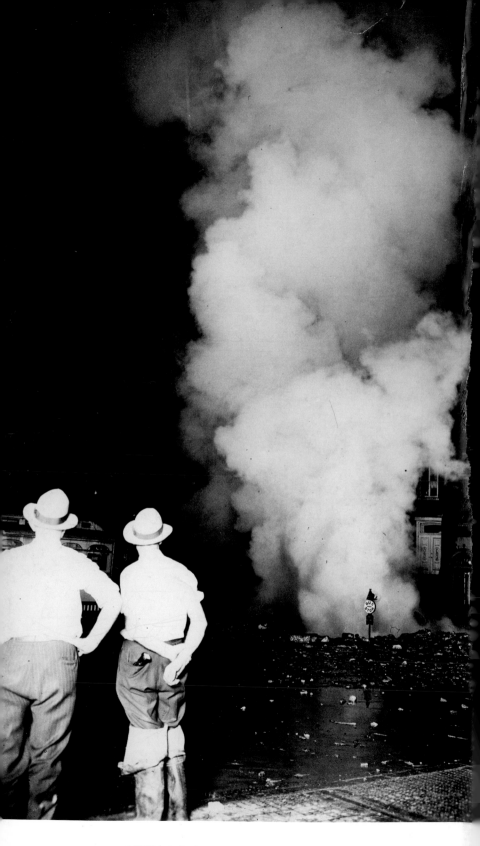

THE **WEEGEE** GUIDE TO NEW YORK

ROAMING THE CITY WITH ITS
GREATEST TABLOID PHOTOGRAPHER

Researched and Compiled by
Philomena Mariani
and Christopher George

International Center of Photography | New York
DelMonico Books · Prestel | Munich London New York

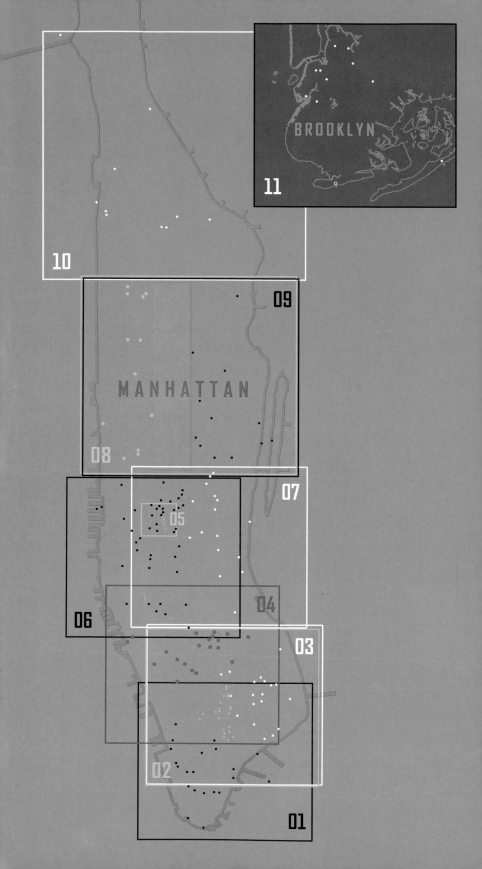

BROOKLYN

MANHATTAN

01
02
03
04
05
06
07
08
09
10
11

CONTENTS

EXCAVATING THE CITY THROUGH PHOTOGRAPHS

Strolling along New York's West 42nd Street or through Times Square today, one would be hard-pressed to identify even remnants of the neighborhood that the photographer known as Weegee recorded in his night-time prowls around the city. The blazing movie marquees and glowing neon signs advertising Four Roses bourbon and Wrigley's chewing gum are long gone, as is most of the architecture of Weegee's day. Erased, too, is any evidence of the area's incarnation as a seedy redlight district, symbol of the city's "decline" in the 1970s. The peep shows, the sex trade, and the video arcades have all been cleared away for venues of family-friendly entertainment, the flophouses replaced by high-rise corporate towers. Still an advertising mecca, the square's gigantic digital screens allow no darkness to disturb the tourists and busloads of suburbanites who invade the area by the thousands. The remaking of Times Square into a wholly commercialized space is so complete that it is sometimes difficult to remember it's a *public* space.

Weegee's photographs are, above all else, a celebration of the public. He made his living photographing accidents and murders, but also captured the heart and humanity of everyday folks on the street. And it is the site specificity of his photographs, their long and lusty homage to specific streets and locales throughout Manhattan, that lies at the heart of *The Weegee Guide to New York*. Our goal was to reconnect Weegee's photographs to their original contexts, not only to retrace the photographer's footsteps but also to recapture for modern walkers the urban spaces in which he worked. This focus on the situatedness of Weegee's photographs, illuminating the landscape of 20th-century New York for 21st-century viewers, is more than a nostalgic exercise—although who doesn't mourn the passing of those movie houses and neon signs that once dominated Times Square? Mapping past configurations of a constantly transforming city is part of the mission of the International Center of Photography to excavate and to reanimate content contained in the photographic image. In addition, this reflects our general commitment to the preservation and study of photographs as documents of material culture and social history. The comprehensive Weegee Archive at ICP—which includes more than 20,000 photographs, negatives, letters, and films— affords such an opportunity to explore photographic materials from new angles.

Many people made the *Guide* happen. Leading the effort were Director of Publications Philomena Mariani and Imaging Technician and resident Weegee expert Christopher George, who spent years searching out the sites of Weegee's photographs. This project also gained from research conducted by Chief Curator Brian Wallis and others for the 2012 ICP exhibition and book *Weegee: Murder Is My Business*. The authors received crucial help in accessing and investigating the Weegee Archive from Curator of Collections Edward Earle and Assistant Curator of Collections Claartje van Dijk. Chief Financial Officer Steve Rooney was an enthusiastic supporter of the project from its inception and provided the necessary resources. Many thanks also to former Assistant Curator of Collections Erin Barnett, who, in addition to indispensable expertise in all things archival, buoyed the project with her humor and her enjoyment of all the little discoveries about Weegee and the city made along the way.

For their generosity in contributing images to the *Guide*, we would like to thank Jean Pigozzi and Tasha Seren of the Pigozzi Collection, New York; Hendrik A. Berinson, Natalia J. Kazmierczak, and Edyta Golab at Galerie Berinson, Berlin; and the private collector Manfred Friedsam. We are grateful to Rene Aranzamendez at Getty Images for help in resolving some sticky technical issues.

Elisa H. Maezono gave us not only a wonderful design but critical guidance in the conceptual organization of the book. We are grateful as well to Bethany Johns and Ben Shaykin of the Rhode Island School of Design for their spirited commentary. We were fortunate to work with Adrian Kitzinger, cartographer extraordinaire, who tackled the enormous job of reconstructing 1940s New York with his usual dedication and intelligence. And we are deeply indebted to the brilliant team of Mary DelMonico and Karen Farquhar of DelMonico Books · Prestel and look forward to working with them on many more projects.

Mark Lubell
Executive Director

WEEGEE'S URBAN RECONNAISSANCE

In the photographic world, "Weegee" and "New York" are synonymous. The photographer's love affair with his city yielded 10,000+ images and several books, earning him an enduring reputation as the documentarian of urban calamity. But perusing the Weegee Archive at the International Center of Photography reveals much more than sensationalist pictures destined for the tabloid market. Taken together, Weegee's photographs revivify modes of public life inherent in the industrialized, pre-gentrified city.

Born Usher Fellig (1899–1968) in a backwater Austrian town, Weegee emigrated with his family in 1909 to the Lower East Side. Intimate familiarity with the messiness of life as lived in a down-at-heel, overcrowded neighborhood paid off in later years: his ease in finessing sketchy situations and managing crowds of strangers is evident in his pictures. Beginning in the mid-1930s, in pugnacious pursuit of his chosen vocation of crime photographer, Weegee competed with likeminded shutterbugs for space in New York's tabloids. Planting himself in the center of the action, he lived a grubby existence in a one-room studio across from police headquarters on Centre Market Place. Next door was "The Shack," otherwise known as the Headquarters Press Building, where crime-beat reporters congregated. His prodigious output was gathered during seemingly round-the-clock patrols through the city in a car equipped with photographic apparatus in the trunk. Weegee was at home in the streets, and always on the job.

His work was of a piece not only with the rise of the tabloids but also the hardboiled/noir sensibility and its dark vision of the city popularized through pulp magazines such as *Black Mask* (whose stories occasionally featured photographer-snoops as central characters) and Warner Bros. gangster pictures. His images are simultaneously brutal and sentimental: Jimmy Cagney and Eddie Robinson would have been at home in a Weegee tableau, as would Wallace Beery and Jackie Cooper. And although Weegee was not a "documentary photographer" in the traditional sense, he left a record of 1930s–40s New York comparable to the urban documents produced by the Photo League. The tabloid photographer who made a name recording murders, disasters, and everyday catastrophes (he was always on hand for a water-main explosion), also—as a staff photographer for the liberal-left daily newspaper PM—documented New Deal and wartime New York, covering bond drives and rationing initiatives, public pools and amusement parks—anywhere New Yorkers congregated in

large numbers to mourn, celebrate, rubberneck, play, do business. He was stupidly derisive of collective action, yet he captured folks in moments of solidarity—in leisure, in crisis, in the dramas of everyday life—with an artfulness that elevated even the most sordid of backstories.

The Weegee Guide to New York presents some 265 images—many never before published—organized as a series of excursions through the photographer's stamping grounds, from Lower to Upper Manhattan, with a bit of Brooklyn thrown in, spanning the late 1930s to the early '60s. These photographs vividly evoke the texture of everyday life and the built environment of mid-20th-century New York, often seen through a scrim of smoke or steam, a crowd of gawkers at a crime scene, or the mangled wreckage of a traffic accident. Aided by contemporary and period maps, the intrepid explorer or the casual rambler, even the armchair traveler (via Google Maps), can follow Weegee's night- and daytime treks through a now-disappearing urban geography and its attendant public life.

The *Guide* is a natural offshoot of another ICP project, the 2012 exhibition and publication *Weegee: Murder Is My Business,* organized by Chief Curator Brian Wallis. Focused on the first decade of Weegee's career as a photojournalist in New York, *Weegee: Murder Is My Business* represented a major reassessment of the symbiotic relationship between the photographer and the Depression-era city. For the project, ICP curators conducted research on the content and location of some of Weegee's most famous photographs, and organized "Weegee walks" to revisit some of the sites of his crime reportage. For the *Guide,* we scoured ICP's collection of Weegee photographs for images that (even remotely) represented something of New York City's built environment. In addition, the nearly full run of *PM* in the ICP archive provided another set of photographs, some reproduced here. Finally, we reviewed other major Weegee collections, including the Berinson, Pigozzi, and Friedsam collections, all of which made key contributions to the *Guide*. To determine the location and content of the pictures, we relied upon fire insurance maps and city directories from the period, as well as newspaper accounts of incidents and events documented by the photographer.

Weegee reveled in disorder, and his New York is an anarchic place in which anything might go haywire at any moment. He captured the city as an enormous *public* space, its inhabitants navigating through street chaos without the protective shield of mobile devices and earphones. We encourage users of this guide to roam the city in the same way, free of electronic encumbrances and open to reimagining the *mise en scène* that gave rise to Weegee's urban spectacle.

Philomena Mariani
Christopher George

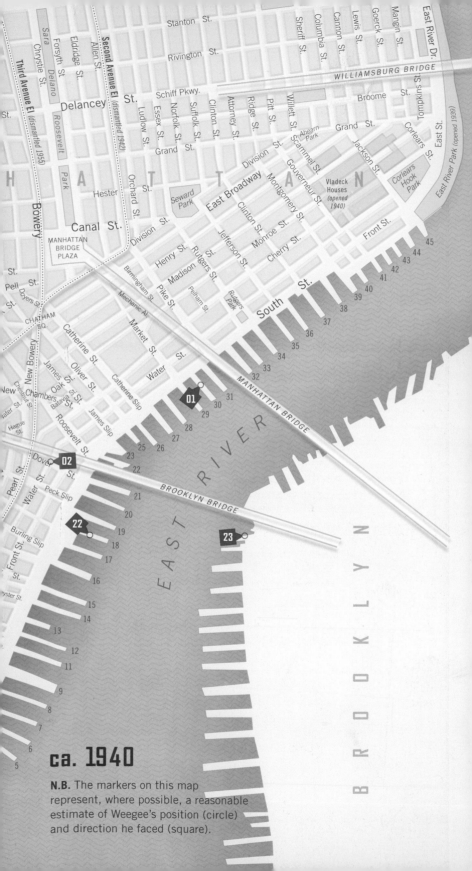

ca. 1940

N.B. The markers on this map represent, where possible, a reasonable estimate of Weegee's position (circle) and direction he faced (square).

01

LOWER
MANHATTAN

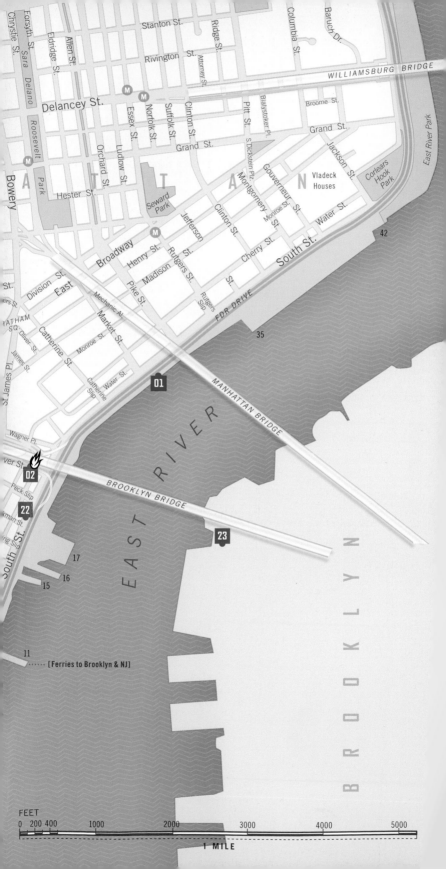

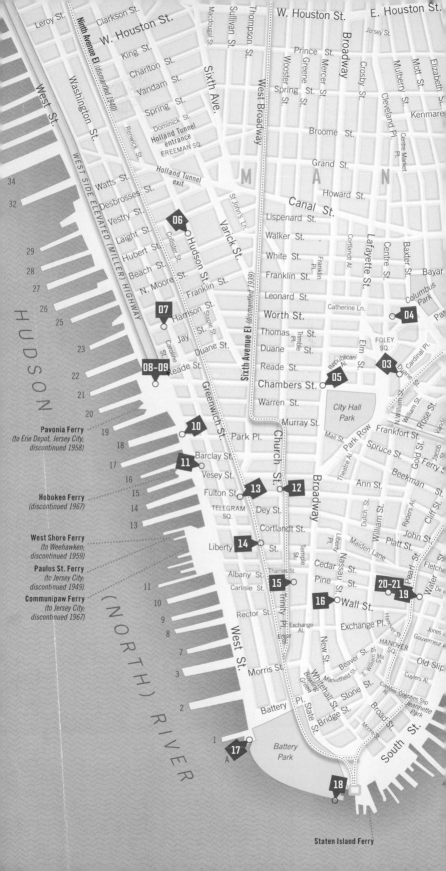

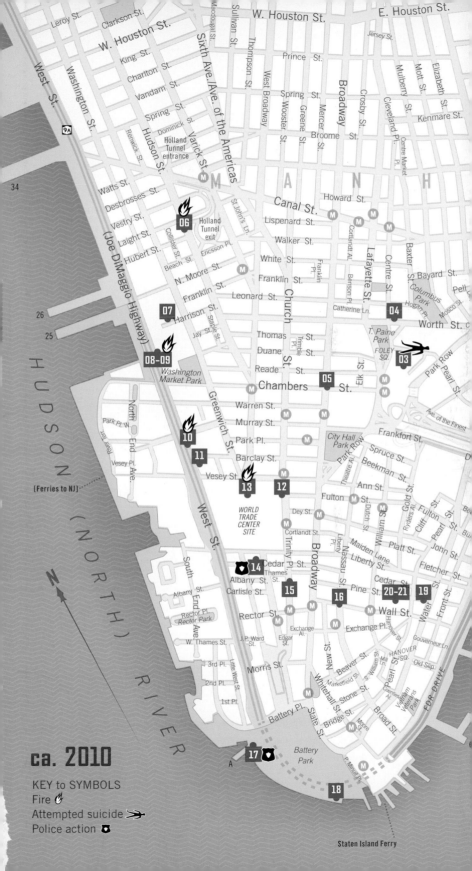

ca. 2010

KEY to SYMBOLS
Fire
Attempted suicide
Police action

01 **LOWER MANHATTAN FROM AN EAST RIVER PIER NORTH OF THE BROOKLYN BRIDGE**
Striking Beauty, July 27, 1940
The three skyscrapers are, from left, City Bank Farmers Trust Co., 20 Exchange Place (built 1931); the City Services (AIG) Building, 70 Pine Street (1932); and the Bank of Manhattan Trust Building (now Trump Building), 40 Wall Street (1930). In the center foreground is the Central Vermont Terminal, Pier 29, the East River. *98.1982*

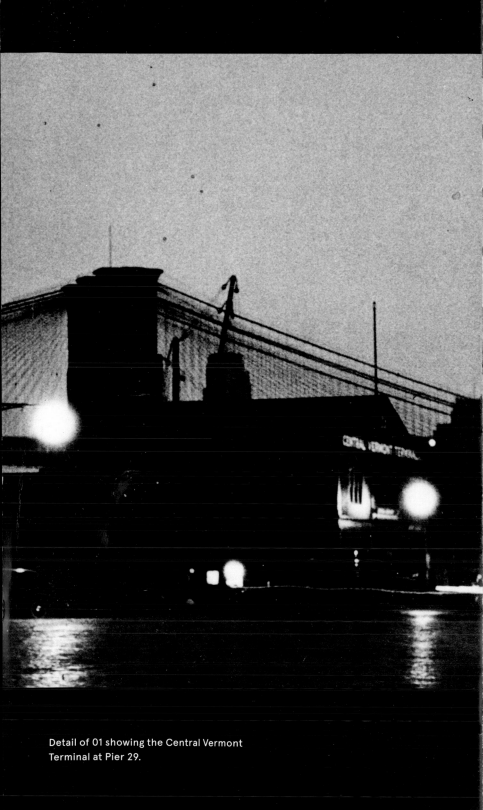

Detail of 01 showing the Central Vermont
Terminal at Pier 29.

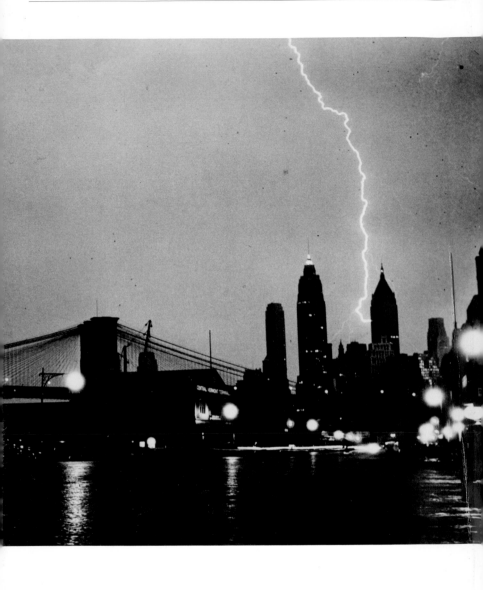

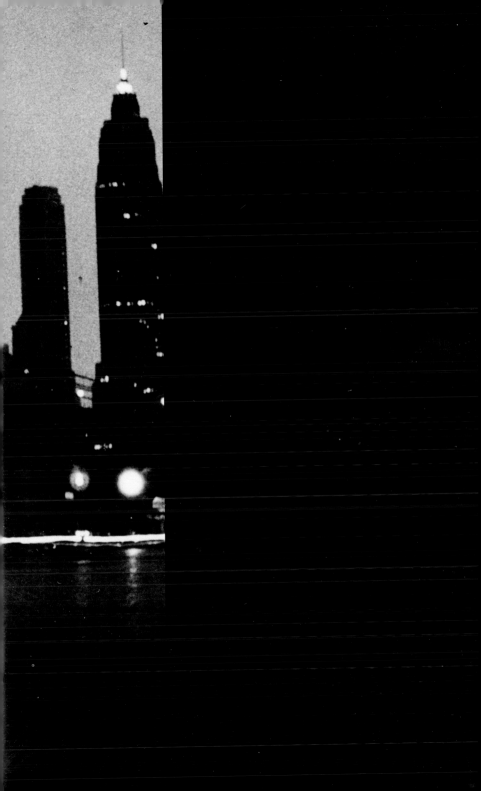

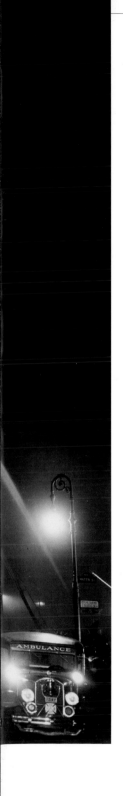

02 **281 WATER STREET AT DOVER, SOUTHEAST CORNER**
Simply Add Boiling Water,
December 18, 1943
The fire occurred at the AMEKO (American Kitchen Products Co.) Building, next to the Brooklyn Bridge (at left). *Minicam Photography,* July 1947, states: "The sign across the center of the building [Simply Add Boiling Water] refers to the frankfurters, not the firemen." Actually, the sign refers to AMEKO's chief product: bouillon cubes. *E.L. 1986.90*

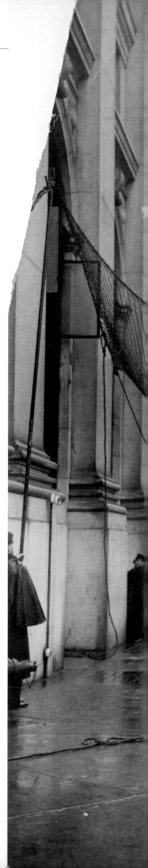

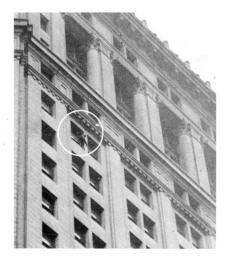

03 **1 CENTRE STREET**
Would be jumper at Municipal Bldg
(detail), August 28, 1940 *14900.1993*

**FORMER SECTION OF DUANE STREET,
LOOKING NORTHWEST TOWARD CENTRE
STREET AND FOLEY SQUARE**
Net for would be suicide,
August 28, 1940 *2458.1993*
Police hoist a suicide net for a "ledge walker"
spotted on the Municipal Building (1 Centre
Street, on the left). The U.S. Courthouse (40
Centre) is at right. Prior to the construction
of the courthouse in 1936, Duane Street
continued east beyond Centre, running between
the rear of the Municipal Building and Saint
Andrew's Catholic Church.

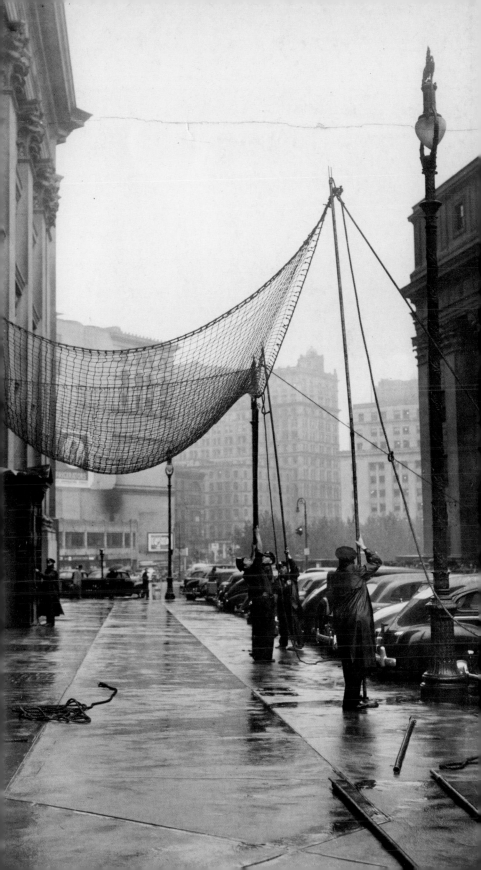

04　**155 WORTH STREET BETWEEN CENTRE AND BAXTER, NORTH SIDE OF BLOCK**
[Rush for auto license plates], January 31, 1943
Looking east along Worth to the Third Avenue Elevated at Chatham Square. The Worth Street entrance to the State Office Building is on the left (aka 80 Centre). The New York Supreme Court Building (60 Centre) is on the right. *15320.1993*

05 **BROADWAY AND CHAMBERS STREET**
Storm, B'way & Chamber[s] St.,
March 8, 1941
In the background: the Sun Building (formerly
A. T. Stewart Dry Goods Store), 280 Broadway at
Chambers Street, northeast corner. *2337.1993*

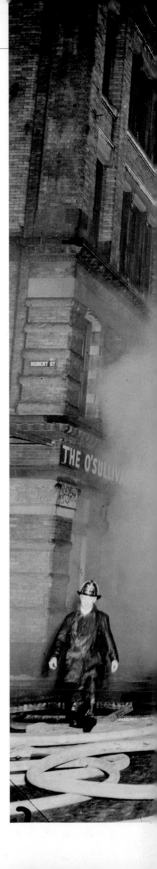

 HUDSON AND HUBERT STREETS,
NORTHWEST CORNER
[Fire in a loft building],
October 25, 1944
The fire is at 153 Hudson Street; the corner
building is No. 151. *14995.1993*

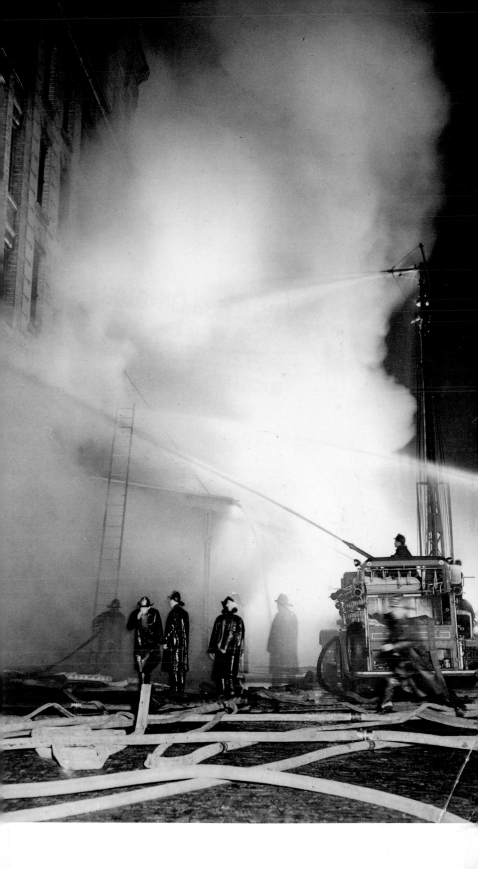

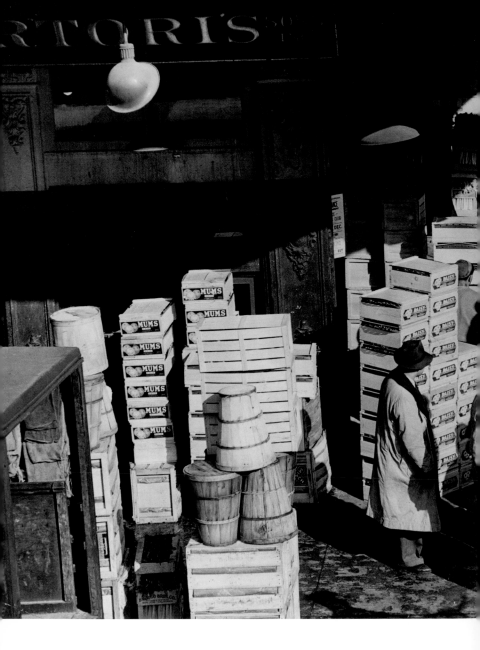

07 **338 WASHINGTON STREET AT HARRISON,**
NORTHWEST CORNER
[Produce piles up at the Washington Market during a
purchasing strike], November 10, 1943
During its heyday in the 1930s and '40s, Washington Market was
the largest produce and fruit exchange in the country. Stretching
from Fulton Street north to Chambers along West, Washington,
and Greenwich Streets, the Market encompassed dozens of ware-
houses, office buildings, and townhouses, with ready access to
Hudson River piers. *2336.1993*

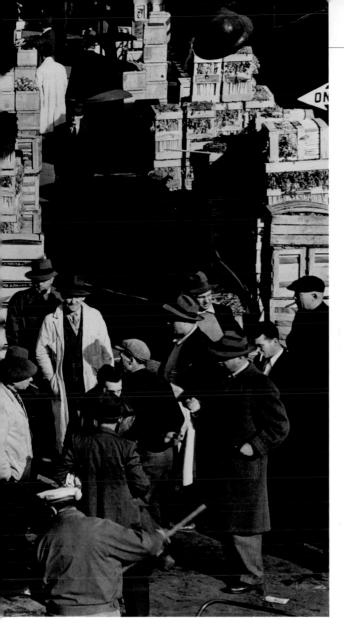

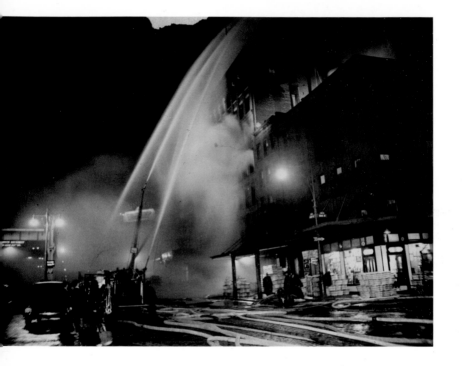

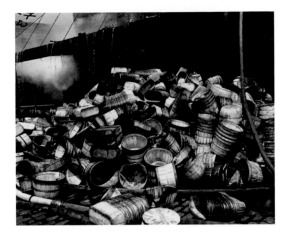

08 **195 WEST STREET BETWEEN DUANE AND JAY, LOOKING NORTH**
[Fire in a loft building], ca. 1943
On the left is the West Side Elevated Highway (now demolished);
the Duane to Canal section of the highway was built in 1938–39.
14989.1993

09 **WEST STREET (EXACT LOCATION UNKNOWN)**
[Debris from a fire],
ca. 1943
Water streams over a section of the West Side Highway (elevated)
behind a pile of produce baskets and fire hoses. The location is
probably the Washington Market area along West Street and the
Hudson River. *14990.1993*

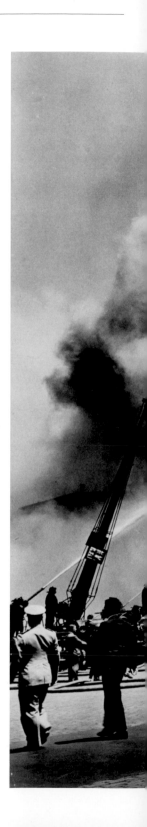

10 **166 WEST STREET BETWEEN MURRAY
AND PARK PLACE**
[Warehouse fire], June 6, 1943
14992.1993

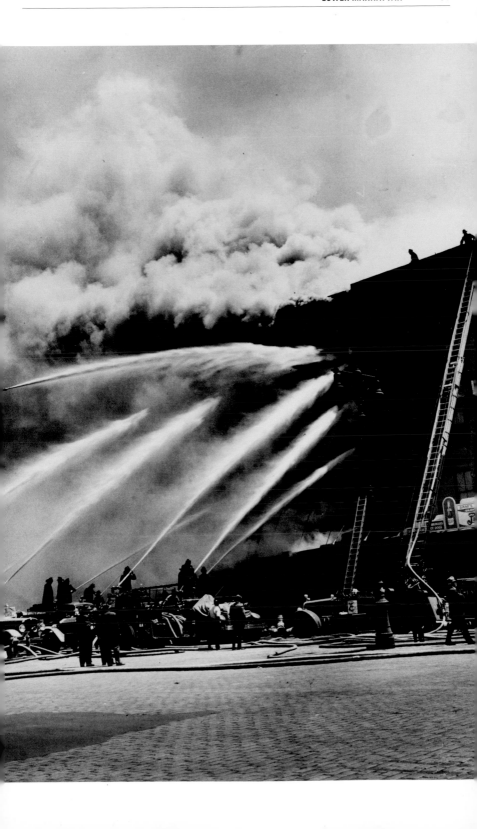

11 BARCLAY AND WEST STREETS
[Barclay Street ferry terminal],
ca. 1940

Looking across West Street from a portal of the Barclay-Vesey
Building (New York Telephone, now Verizon), located at 140 West,
toward the Barclay Street ferry terminal on Pier 16, from which
commuters crossed the Hudson to Hoboken's Erie-Lackawanna
terminal. According to the sign at left, auto customers paid a fare
of 25 cents. *Galerie Berinson, Berlin*

12 **CHURCH AND FULTON STREETS**
[Saint Paul's Chapel],
ca. 1961

Looking east along Fulton from the corner of Church Street. The Park Row Building, 15 Park Row, is in the background left; the new Western Electric Building, directly behind the chapel at 222 Broadway, is in the final stages of construction. *14885.1993*

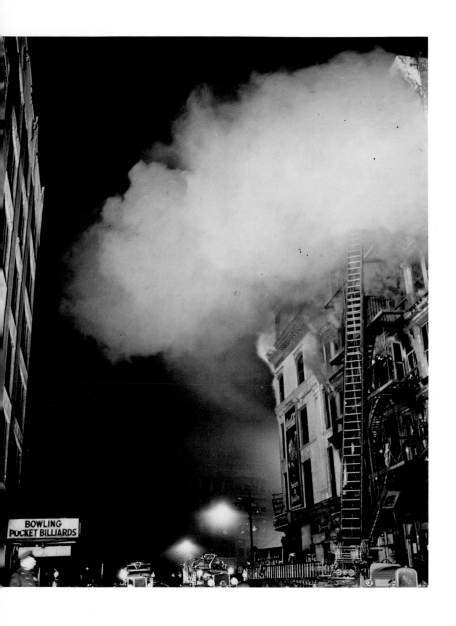

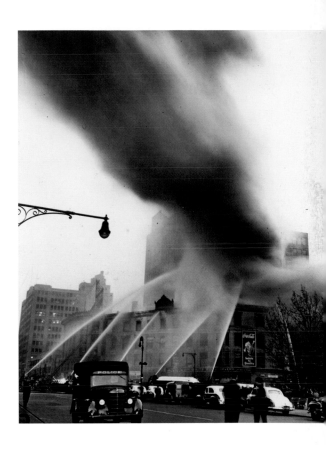

13 **FULTON AND GREENWICH STREETS,
SOUTHEAST CORNER**
[Fire in a loft building], ca. 1946
15005.1993 , 14994.1993

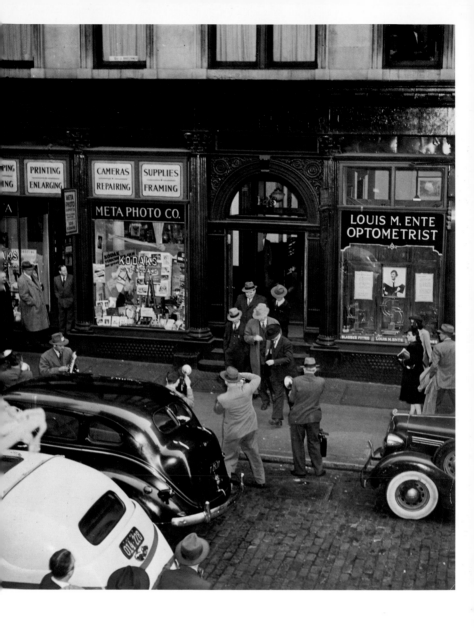

14 126 LIBERTY STREET AT GREENWICH STREET, SOUTHWEST CORNER

[Operators of race wire-service arrested at their headquarters in gambling raid], October 1, 1942

This block of Liberty Street was part of the neighborhood informally known as Radio Row, a warehouse and retail district that catered to the electronics trade. Cortlandt Street was its central axis. The entire area, bounded by Liberty, Barclay, West, and Church Streets, was razed in 1966 to create the superblock that became the World Trade Center. In all, 164 buildings were demolished. The debris was dumped into the Hudson River, forming a landfill that would become Battery Park City. *2342.1993*

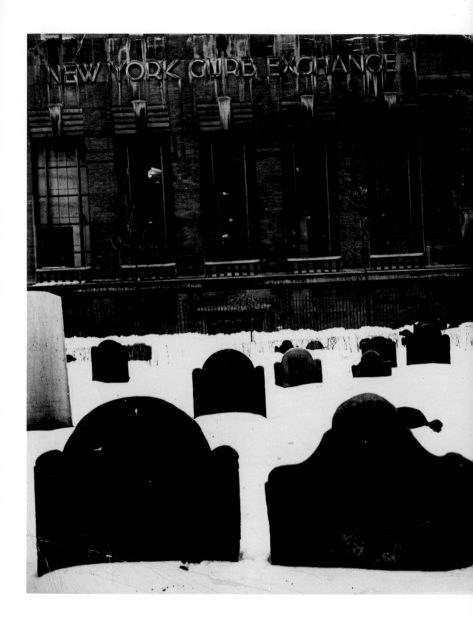

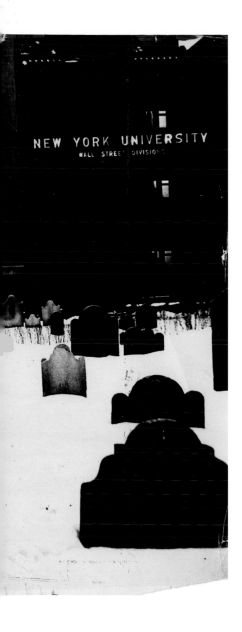

15 **78–90 TRINITY PLACE BETWEEN THAMES AND RECTOR STREETS, WEST SIDE OF BLOCK**
Winter, ca. 1940
Looking across Trinity Church cemetery to the New York Curb Exchange (now NYSE Amex Equities) and New York University Wall Street Divisions (aka New York University School of Commerce).
14891.1993

16 **WALL STREET, LOOKING WEST**
 TOWARD BROADWAY
 [V–E Day], May 1945
Trinity Church is in the background, the
New York Stock Exchange on the left. *15609.1993*

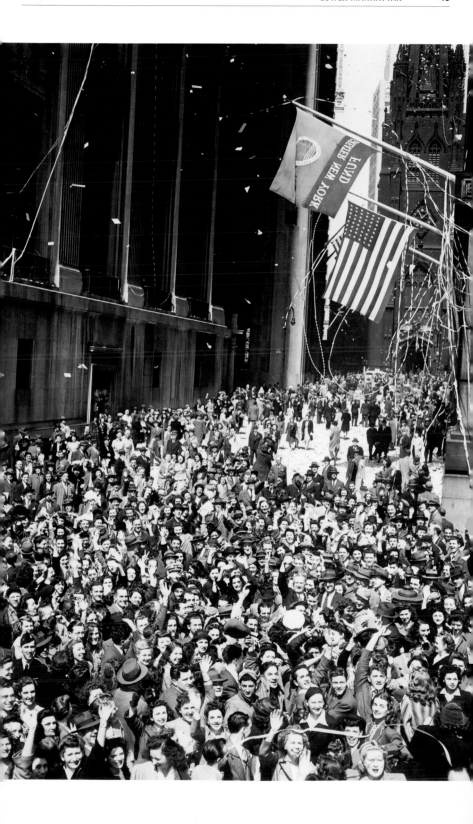

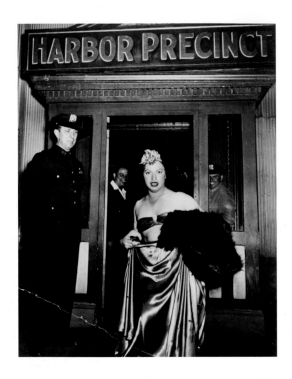

17 **PIER A, THE BATTERY**
[Man arrested for cross-dressing],
ca. 1939
The Harbor Precinct of the New York Police Department was
housed in a now-decrepit building at Pier A on the Battery in Lower
Manhattan. *2294.1993*

18 **BATTERY PARK PROMENADE, SOUTHERN END OF PARK**
They've Landed,
1958
In the near background is the Coast Guard Memorial, dedicated in
1955, in its original location at the southern entrance path to the
park. The landmark skyscrapers: Bank of Manhattan Trust Building
(40 Wall Street; second from left), the City Bank Farmers Trust Co.
(20 Exchange Place; second from right), and the City Services (AIG)
Building (70 Pine Street, right).

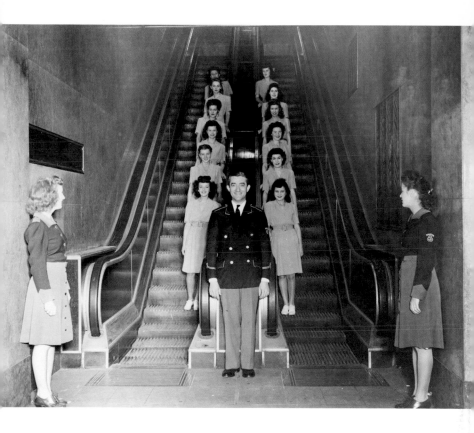

19 70 PINE STREET
The Building,
1945

Looking west on Pine from Water Street. Bounded by Pine, Cedar, and Pearl Streets, the City Services (AIG) Building at 70 Pine was the third tallest building in the world when completed in 1932. The Equitable Building is visible in the far background (right side of Pine). *14893.1993*

20 70 PINE STREET
[Escalators in the lobby of the City Services (AIG) Building], 1945

The building's lower six floors were serviced by escalators. The women in white uniforms are members of the City Services Building's all-female corps of elevator attendants; the man and two women in dark uniforms are elevator operators ("starters"). *16473.1993*

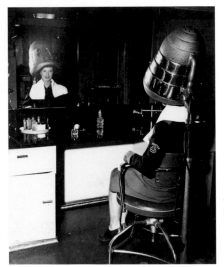 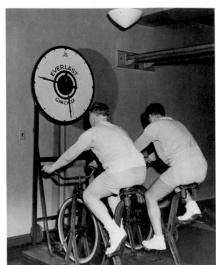

21 70 PINE STREET

[An elevator operator ("starter") has her hair done at the
beauty salon in the City Services (AIG) Building], 1945
[Exercising in the gym at the City Services (AIG) Building],
1945
[A cleaning woman works the night shift at the City
Services (AIG) Building], 1945
16474.1993, 16471.1993, 110.1982

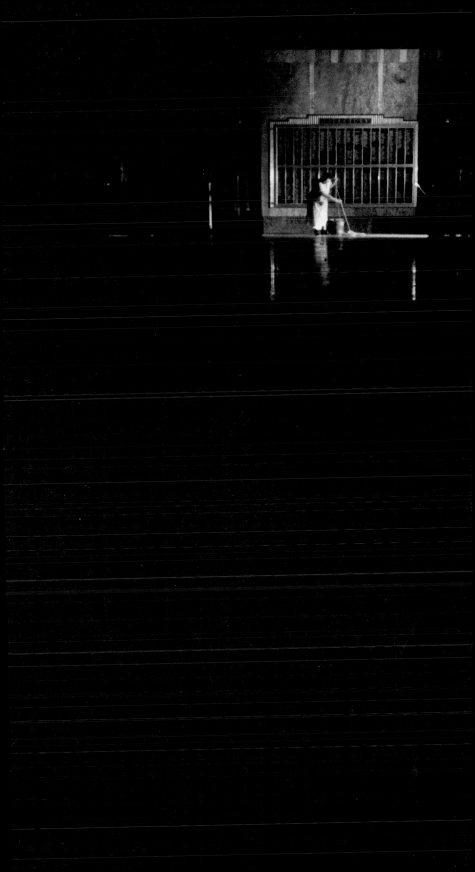

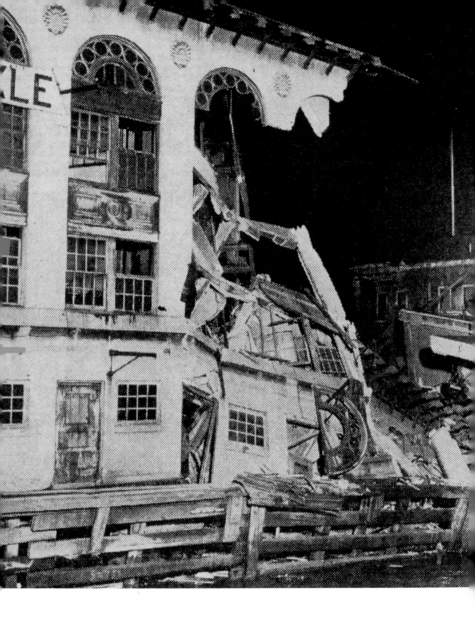

22 SOUTH STREET BETWEEN PECK SLIP AND BEEKMAN ON THE EAST RIVER WATERFRONT, PIERS 17–19

[Collapse of the Fulton Fish Market], August 11, 1936

Just after midnight on August 11, 1936, a 125-foot section of the historic Fulton Fish Market slid into the East River when pilings supporting the structure gave way. One of the oldest continuously operating markets in the United States, the Fulton Fish Market was established in 1822 and remained at the South Street location until 2005, when it relocated to Hunts Point in the Bronx. The market consisted of two large buildings—the Tin Building and the New Building, which in 1939 replaced the structure that had collapsed three years before.

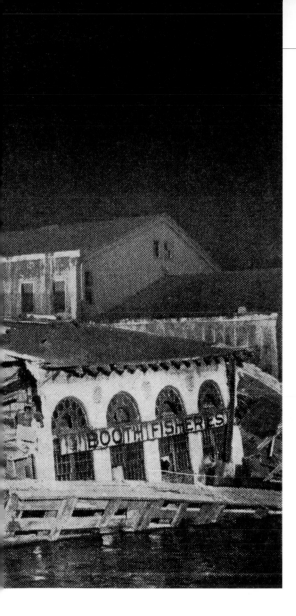

23 OVERLEAF **LOWER MANHATTAN FROM ACROSS THE EAST RIVER SOUTH OF THE BROOKLYN BRIDGE**
[The Lower Manhattan skyline], ca. 1940
The East River waterfront, lined with piers, south of Brooklyn Bridge, and the triumverate of Lower Manhattan skyscrapers, 1930s–40s: the City Services (AIG) Building (70 Pine, center), the Bank of Manhattan Trust Building (40 Wall, directly behind), and the City Bank Farmers Trust Co. (20 Exchange Place, left).
16639.1993

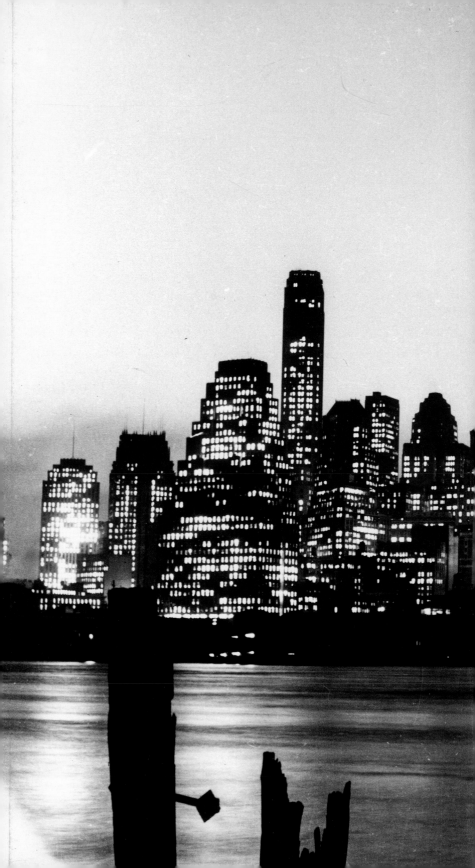

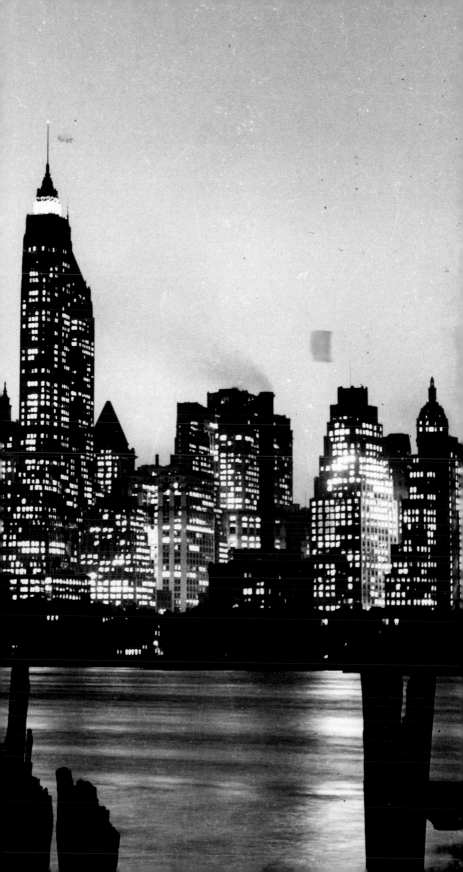

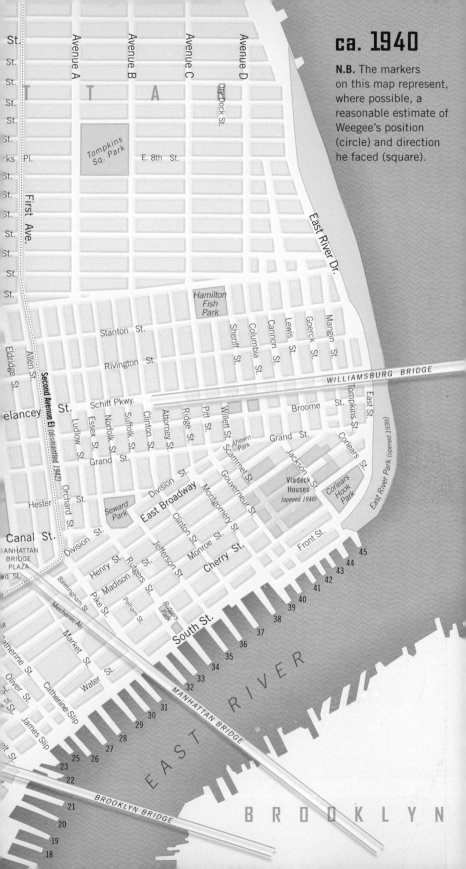

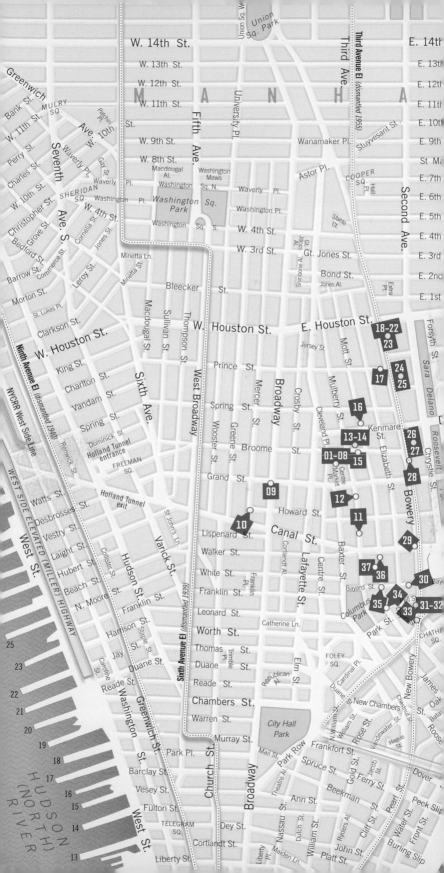

02

CENTRE MARKET PLACE

LITTLE ITALY

THE BOWERY

CHINATOWN

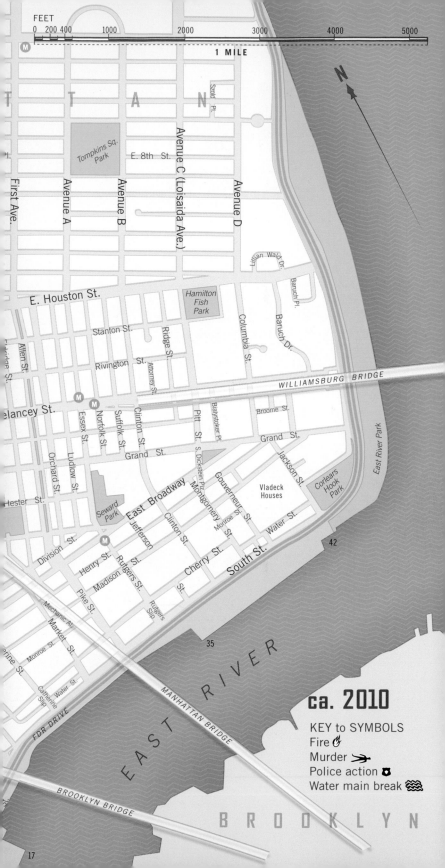

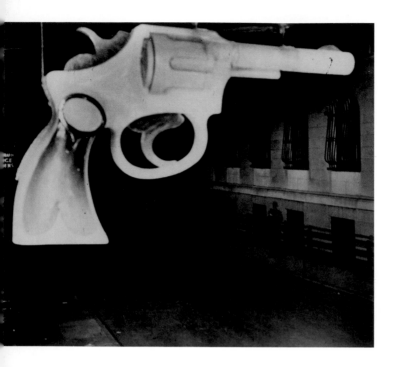

Centre Market Place runs one block between Grand (south) and Broome (north), bounded on the west by the former headquarters of the New York Police Department (240 Centre Street). Shops lining the street on the east side catered to the police trade, selling uniforms, guns, and other equipment.

01 **5 CENTRE MARKET PLACE**
[John Jovino gun shop],
ca. 1942

The oversized gun above the John Jovino police supply store aimed at police headquarters across the street. *154.1982*

02 **5 AND 6 CENTRE MARKET PLACE, EAST SIDE OF BLOCK**
My Police Radio Car,
ca. 1942

Weegee in his car in front of the John Jovino and Frank Lava police supply shops, each of which featured an oversized gun above their storefronts. Weegee's studio was upstairs from the Jovino shop, at 5 Centre Market Place. *19646.1993*

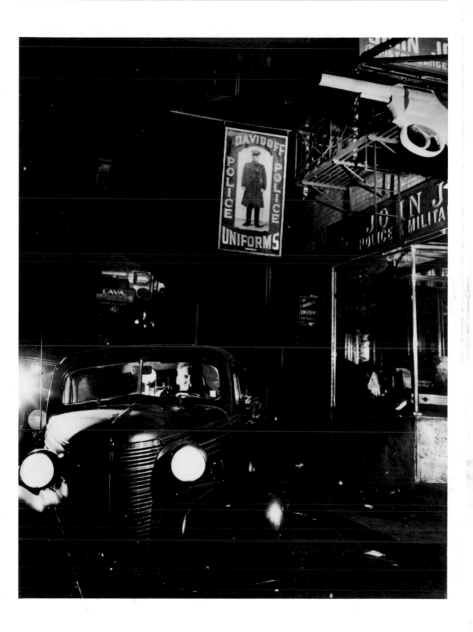

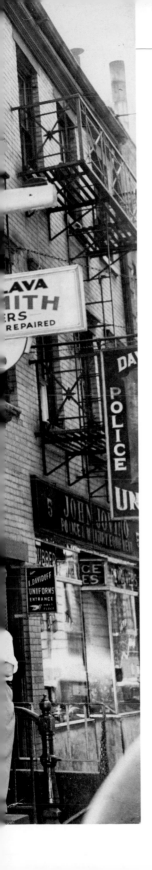

03 **6 CENTRE MARKET PLACE**
[Covering the morning line-up at
police headquarters], ca. 1939
Weegee on a ledge above the Frank Lava
Gunsmith shop, at 6 Centre Market Place,
presumably waiting for some action across the
street at police headquarters. His studio was
located in the building on the right. *E.L. 1986.38*

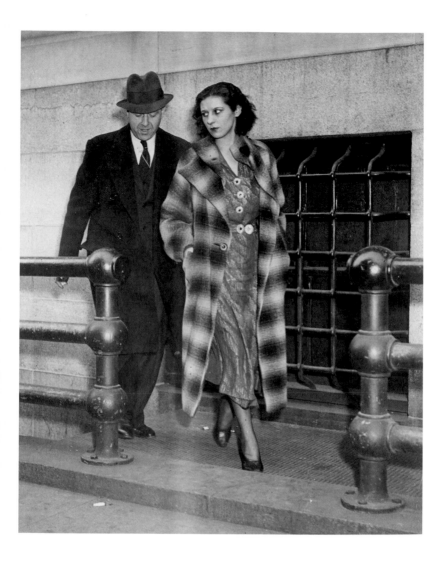

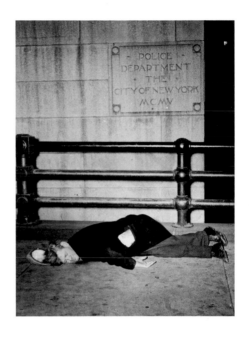

04 **CENTRE MARKET PLACE, WEST SIDE OF BLOCK**
[Norma Parker, aka Nellie Gutowski],
November 1936
Norma Parker, arrested for stabbing a woman during a fight,
is escorted from police headquarters. *13964.1993*

05 **240 CENTRE STREET AT GRAND, NORTHEAST CORNER**
[Derelict sleeping on the sidewalk outside police head-
quarters], ca. 1945
14105.1993

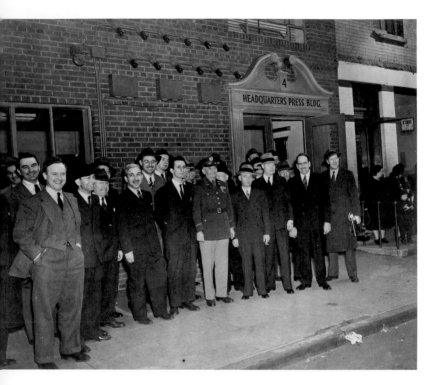

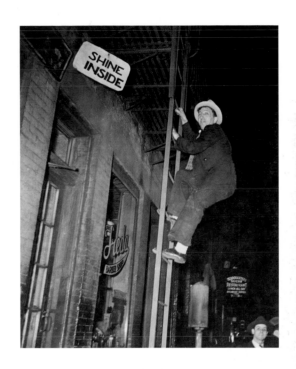

06 **4 CENTRE MARKET PLACE**
[Men posing in front of the Headquarters Press Building],
ca. 1942
The Headquarters Press Building, also known as "The Shack," was
situated across Centre Market Place from police headquarters and
housed reporters on the police beat from 1940 to 1973. Reporters
on the street were alerted to phone calls coming into The Shack
from their newspapers by colored lights on the building facade.
14035.1993

07 **CENTRE MARKET PLACE, EAST SIDE OF BLOCK**
[Freda Barber Shop], ca. 1940
Looking south toward Grand Street and the sign for the
Headquarters Tavern (at 174 Grand). The tavern was a hangout for
police beat reporters, who were stationed at "The Shack." *16667.1993*

08 **CENTRE MARKET PLACE AND GRAND STREET**
[Press photographers outside police headquarters],
ca. 1938 *The Pigozzi Collection*

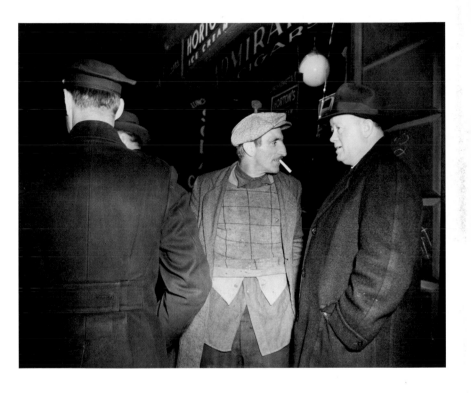

09 **459 BROADWAY AT GRAND STREET, SOUTHWEST CORNER**
[Man caught robbing store], February 16, 1941
973.1993, 975.1993

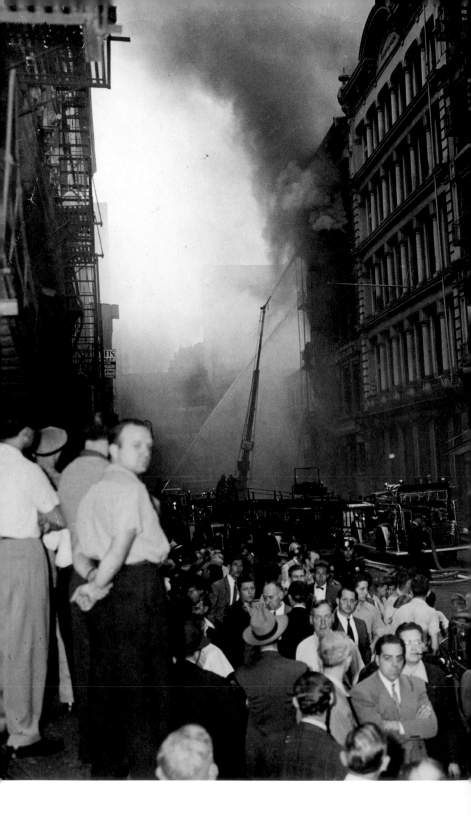

10

5–15 MERCER STREET BETWEEN HOWARD AND CANAL, WEST SIDE OF BLOCK

[Fire on a summer evening], ca. 1940
Looking south along Mercer toward Canal Street.
The fire is at 5 Mercer; the building with the
rounded pediment is the American Hard Rubber
Company at 11 Mercer. *14985.1993*

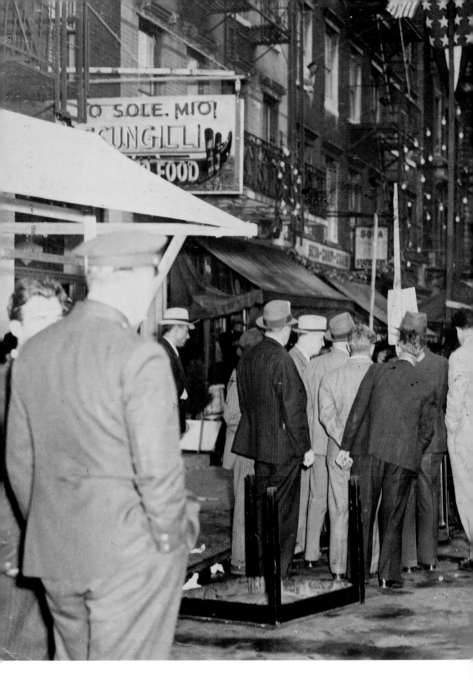

11 119 MULBERRY STREET BETWEEN CANAL AND HESTER, WEST SIDE OF BLOCK

"Fiesta" turns into tragedy, September 21, 1939
Looking north on Mulberry toward Hester Street. O Sole Mio
restaurant is at 119 Mulberry. The victim is racketeer "Little Joe"
La Cava. *14070.1993*

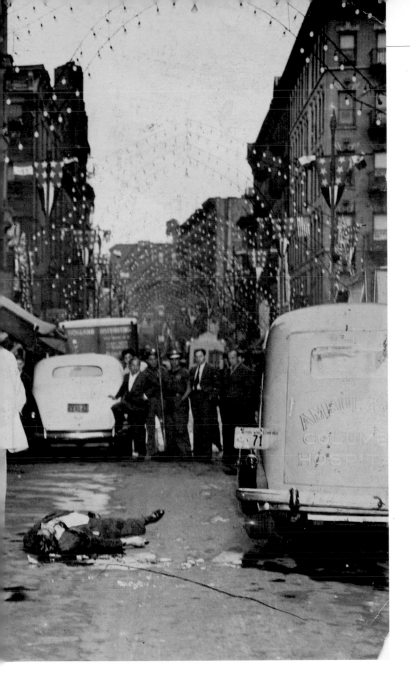

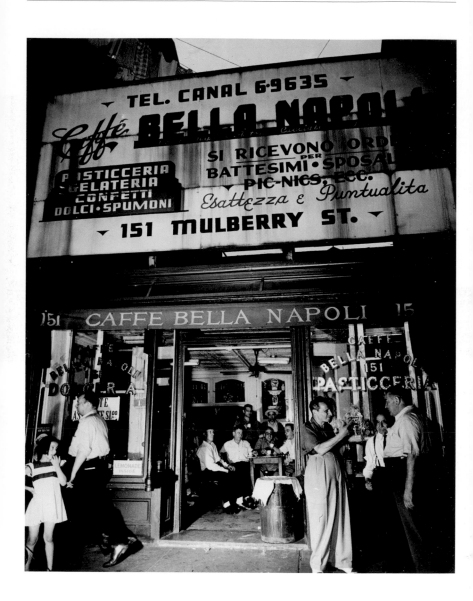

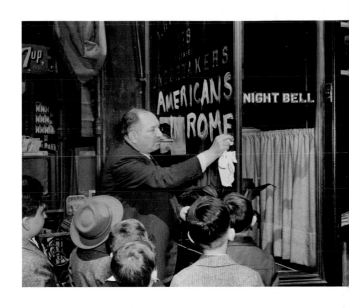

12 151 MULBERRY STREET BETWEEN HESTER AND GRAND,
WEST SIDE OF BLOCK
[Caffé Bella Napoli], July 1944
2006.1993

13 178 MULBERRY STREET AT BROOME, NORTHEAST CORNER
[Little Italy celebrates entry of U.S. troops in Rome],
June 4, 1944
15407.1993

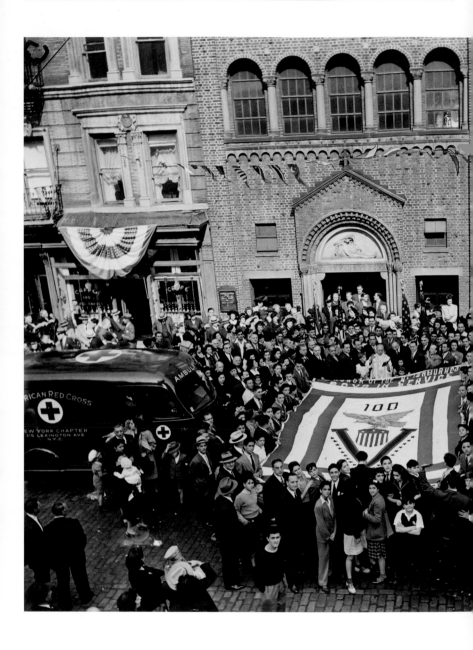

14 376–380 BROOME STREET BETWEEN MOTT AND MULBERRY, NORTH SIDE OF BLOCK

[Blessing a service flag], March 22, 1942

Caffé Golfo di Napoli, on the left, is at 380 Broome. The center building is the Church of the Most Holy Crucifix. *15249.1993*

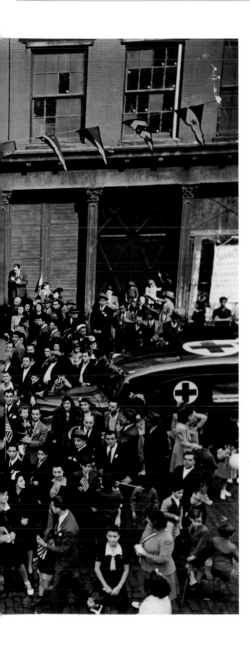

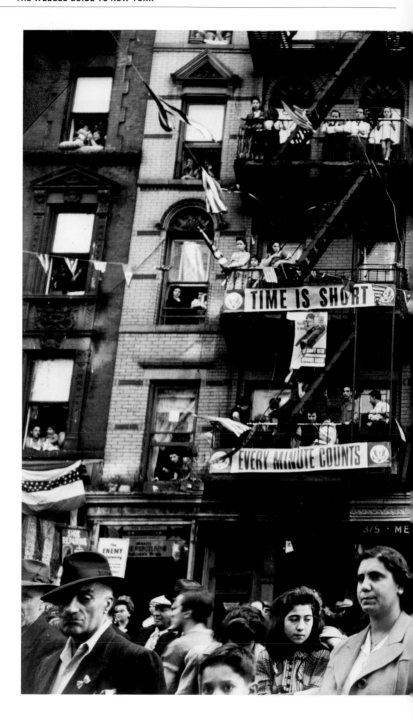

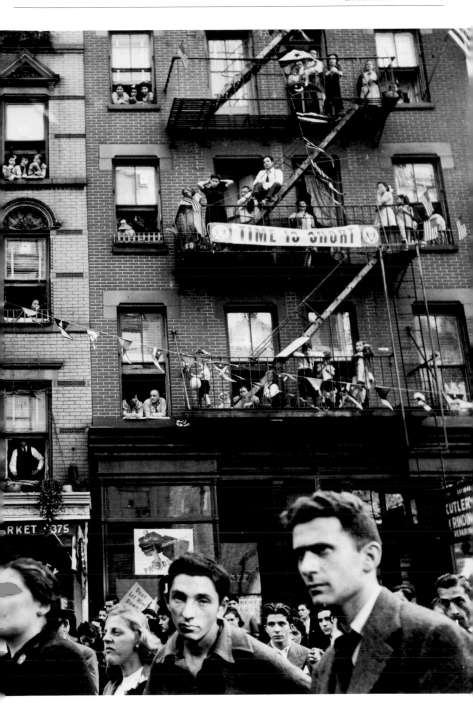

15 **375 BROOME STREET BETWEEN MOTT AND MULBERRY,
SOUTH SIDE OF BLOCK**
Time Is Short, 1942
Weegee portfolio 43

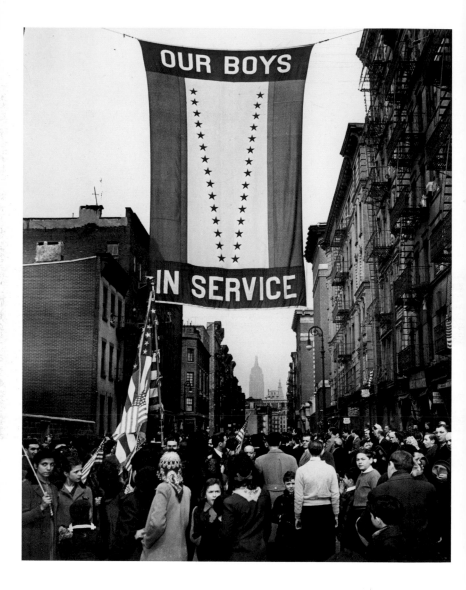

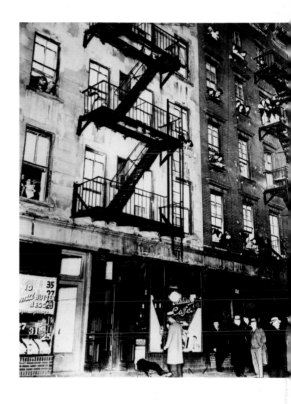

16 **MOTT STREET FROM KENMARE**
[Our Boys in Service],
ca. 1942
Looking north up Mott to its terminus at Bleecker Street. P.S. 21 is
about halfway up the block on the east side (222 Mott). In the dis-
tance: the Met Life Tower at Madison Square and the Empire State
Building at 34th Street and Fifth Avenue. *15268.1993*

17 **10 PRINCE STREET BETWEEN ELIZABETH AND THE BOWERY,
SOUTH SIDE OF BLOCK**
[Police and bystanders with body of Angelo Greco on the
steps of his Italian café], November 16, 1939
2056.1993

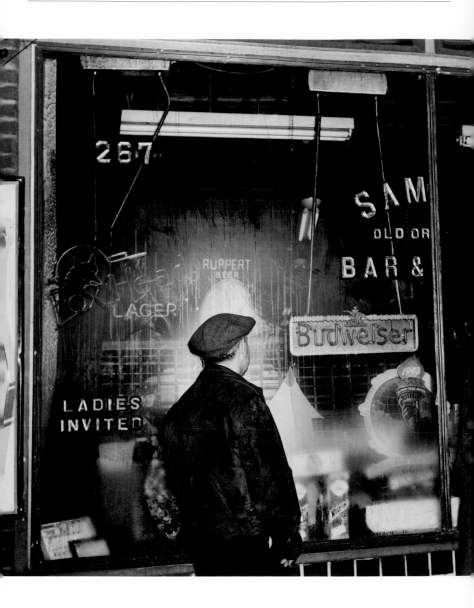

18 267 BOWERY BETWEEN EAST HOUSTON AND STANTON STREETS, EAST SIDE OF BLOCK

[In front of Sammy's Bar on the Bowery], ca. 1943

Sammy Fuchs opened his bar in 1934 at 267 Bowery, where it continued to operate until 1970, a year after his death. Originally just a saloon with a jukebox, Sammy's soon featured vaudeville entertainment and the cabaret shows—"Sammy's Bowery Follies"—drew record crowds. Sammy's catered to 100,000 patrons annually during World War II and the postwar years—celebrities and drifters, Bowery denizens and swells all mingled in the Gay Nineties atmosphere. Fuchs himself was involved in community affairs; he established a dental clinic for children on the Lower East Side, regularly fed the derelicts who wandered past his establishment, and sponsored many a rehabilitation, earning him the unofficial title "Mayor of the Bowery." *14335.1993*

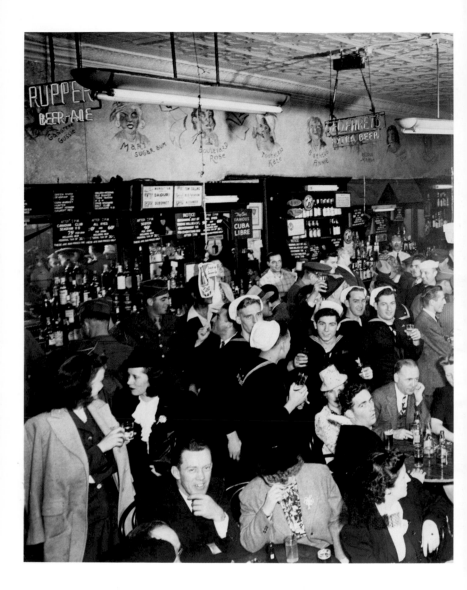

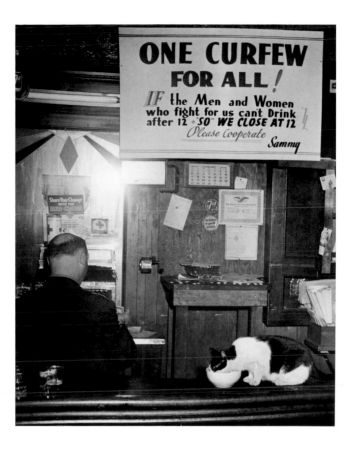

19 267 BOWERY BETWEEN EAST HOUSTON AND STANTON
STREETS, EAST SIDE OF BLOCK
[Sammy's Bar on the Bowery], December 1944
2020.1993

20 267 BOWERY BETWEEN EAST HOUSTON AND STANTON
STREETS, EAST SIDE OF BLOCK
[One Curfew for All!],
April 1, 1945
Interior of Sammy's Bar on the Bowery, with owner Sammy Fuchs at
the cash register. *14304.1993*

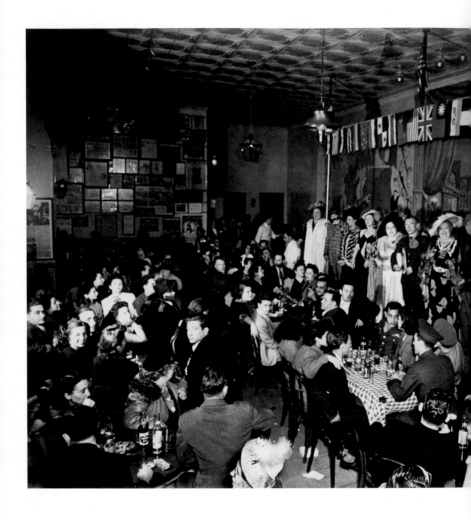

21 **267 BOWERY BETWEEN EAST HOUSTON AND STANTON STREETS, EAST SIDE OF BLOCK**
[Sammy's Bar on the Bowery], ca. 1945
Performers in Sammy's Bowery Follies include Sammy regulars
Norma Devine and Billie Dauscha, standing on stage in front of a
mural depicting the Bowery. *2032.1993*

22 [Penny cigarette machine at Sammy's Bar on the
Bowery], ca. 1944
14349.1993

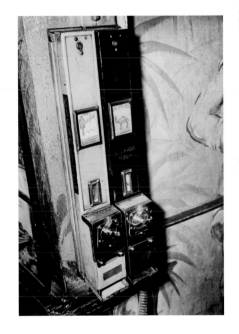

23 **263 BOWERY BETWEEN EAST HOUSTON
AND STANTON STREETS,
EAST SIDE OF BLOCK**
[U.S. Hotel on the Bowery], ca. 1944
2386.1993

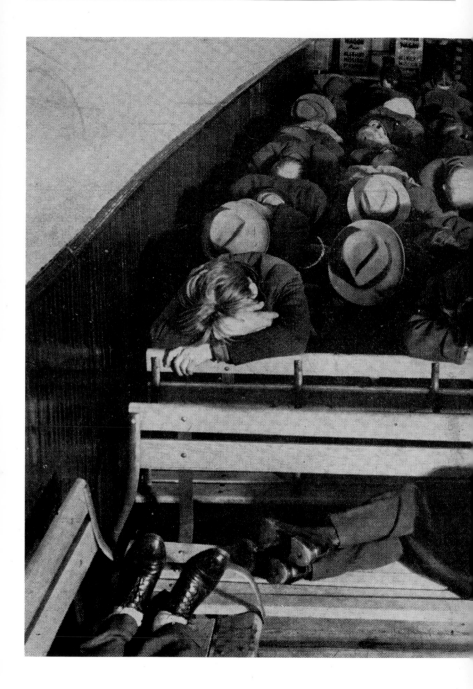

24 **227–229 BOWERY BETWEEN RIVINGTON AND PRINCE STREETS, EAST SIDE OF BLOCK**

[Seeking shelter at the Bowery Mission], *PM Daily*, January 21, 1941

The Bowery Mission has been in continuous operation since 1879, first at 36 Bowery, then, from 1909 on, at Nos. 227–229.

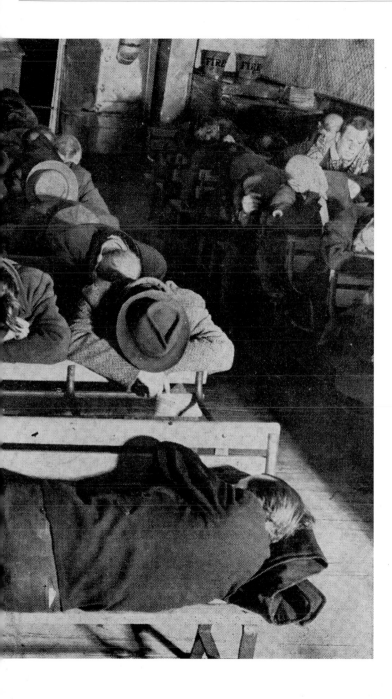

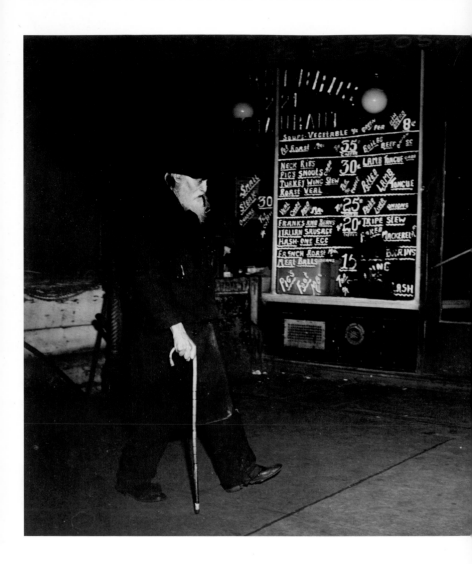

25 **221 BOWERY BETWEEN RIVINGTON AND PRINCE STREETS, EAST SIDE OF BLOCK**

[Meat on the menu in wartime New York], 1943

During World War II, shortages compelled the federal government to institute a system of rationing for many food items, including sugar, dairy products, coffee, and meat. To counter the restrictions, restaurants offered many "variety meats"—a term coined by the U.S. Office of Price Information for the parts of slaughtered animals usually disposed of: organs, head, tail, tongue, and tripe. The menu of the Fuerst Brothers restaurant on the Bowery offers pig snout, turkey wing stew, neck ribs, tripe stew, lamb's tongue, and brains (type unspecified). *14399.1993*

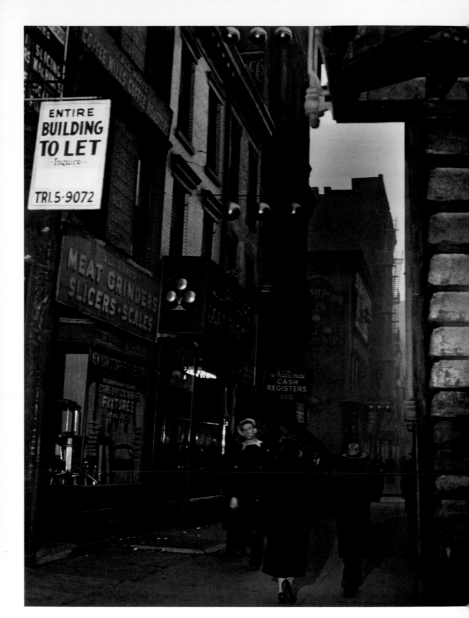

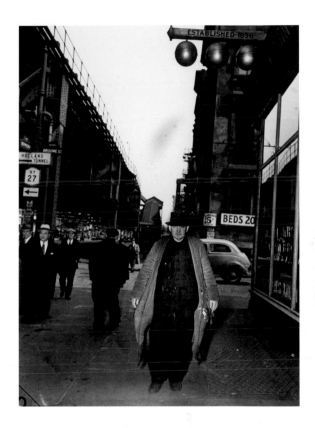

26 **155–157½ BOWERY BETWEEN DELANCEY AND BROOME STREETS, EAST SIDE OF BLOCK**
[Under the Third Avenue Elevated], ca. 1943
Looking south on the Bowery across Broome at William Simpson and Co., pawnbrokers (151 Bowery). The structure across the sidewalk from the New York Store Fixture Corp. (157½ Bowery) and the National Cash Register sign (155 Bowery) is the Third Avenue Elevated. *14512.1993*

27 **151 BOWERY AT BROOME STREET, SOUTHEAST CORNER**
The Bowery by day...where only the El makes music,
ca. 1943
Looking north on the Bowery across Broome toward Delancey. To the right is William Simpson and Co., pawnbrokers, at 151 Bowery. The Third Avenue Elevated is at left, with an arrow pointing west to the Holland Tunnel. *14395.1993*

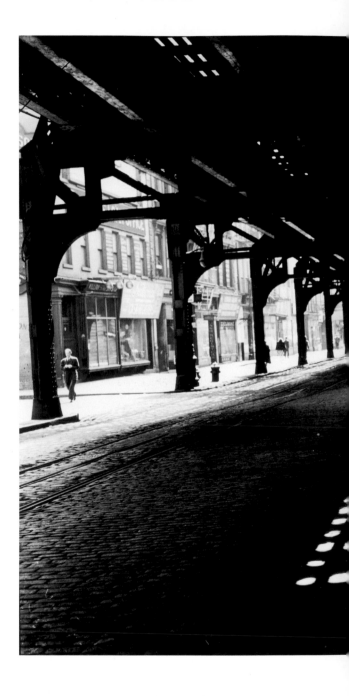

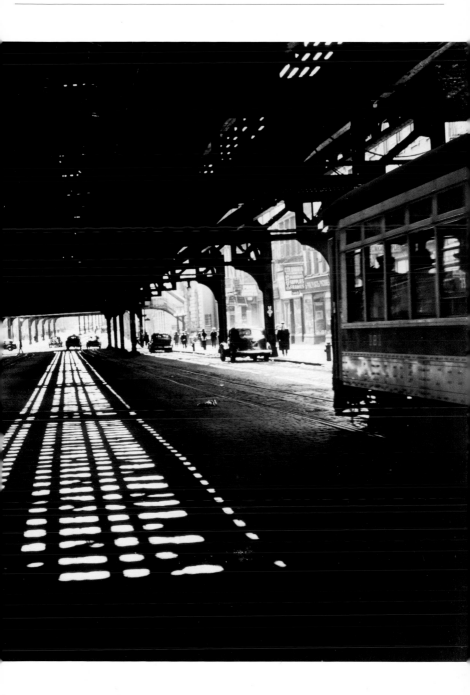

28 **THE BOWERY BETWEEN BROOME AND GRAND STREETS**
[Under the Third Avenue Elevated],
1938
Looking south from Broome to the Grand Street Station of the
Third Avenue Elevated and the Bowery Savings Bank (No. 130).
Weegee portfolio 35

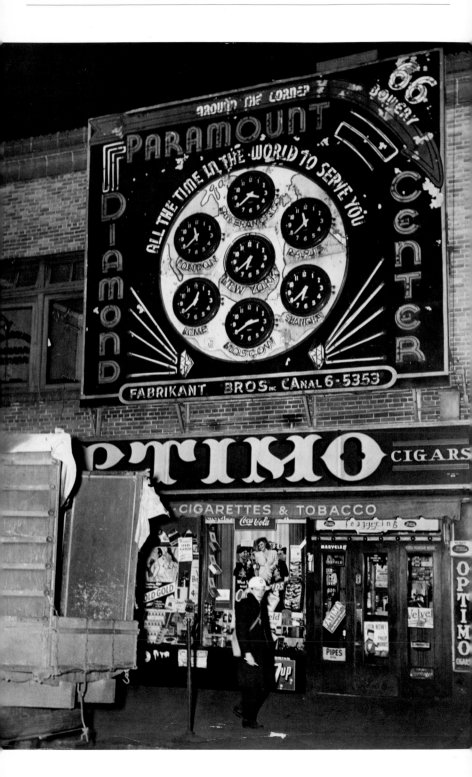

29 **66 BOWERY AT CANAL STREET, NORTHWEST CORNER**
[All the Time in the World to Serve You],
ca. 1944
The Fabrikant Brothers established the Paramount Diamond
Center in 1931 and operated at Canal and the Bowery until 1960,
when they opened the International Diamond Center at 1200
Avenue of the Americas. *15494.1993*

30 **30 BOWERY AT BAYARD STREET**
[Traffic under the Third Avenue Elevated],
ca. 1940
Standing on Bayard Street, looking east, facing the intersection
with the Bowery. The Third Avenue Elevated is above; the area
behind the Manhattan Bridge Plaza is in the background. *14520.1993*

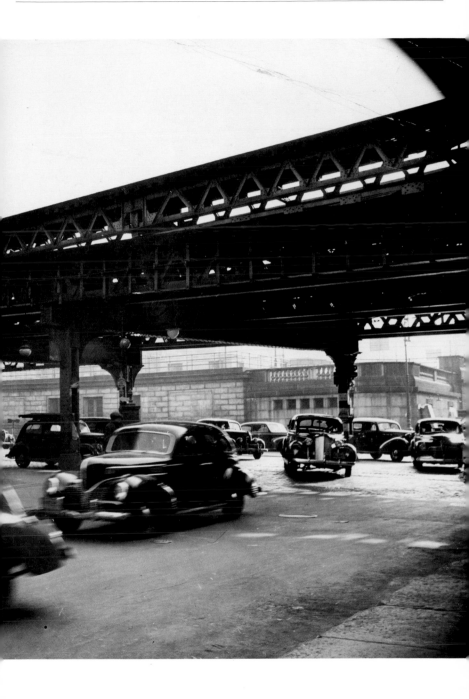

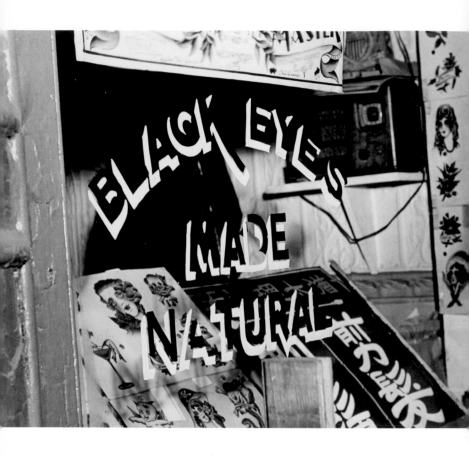

31 **16 BOWERY NEAR PELL STREET, WEST SIDE OF BLOCK**
[Black Eyes Made Natural], ca. 1943
[Shave 10¢, Haircut 20¢, Black Eye Specialist], ca. 1943
[Barbershop sign on the Bowery], January 18, 1943
Patching up black eyes was a barbershop specialty and apparently
much in demand on the Bowery. *17796.1993, 17799.1993, 15366.1993*

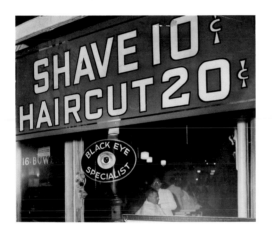
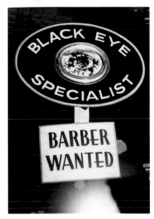

32 **8 BOWERY BETWEEN PELL AND DOYERS STREETS,
WEST SIDE OF BLOCK**
[Christmas morning at a Bowery mission],
December 25, 1940
The interior of the All Night Mission on the Bowery. *1073.1993*

33 DOYERS STREET
[Chinatown fire],
PM Daily, January 17, 1941

Chinatown's Doyers Street runs one block with a sharp turn in
the middle—the "Bloody Angle," so called for the number of Tong
battles that occurred there well into the 1930s. At eighteen feet
wide, Doyers is also one of the city's narrowest streets. Seventy-
five firemen battled the blaze that engulfed two 100-year-old
wooden structures at the Angle—Nos. 6–8 and 10–12 (on the right)—
on January 16, 1941. The Nom Wah Tea Parlor, in operation since
1927, is in the background, at No. 13.

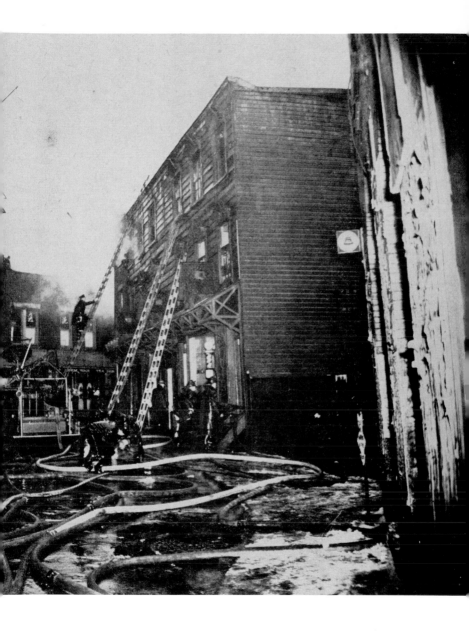

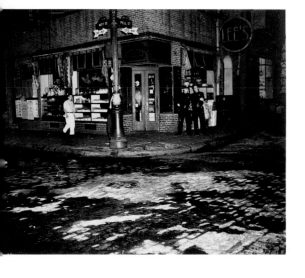

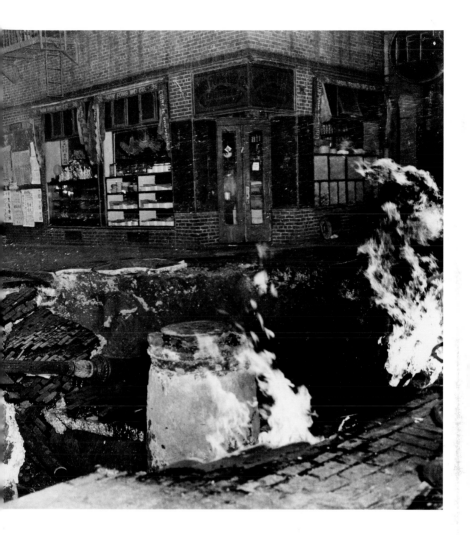

34 36 PELL STREET AT MOTT, NORTHEAST CORNER
[Before and after a water main explosion
in Chinatown], July 5, 1944

As *PM Daily* described the incident: "Weegee Knew Something
Was Brewing...and It Was! A water main burst at Mott and Pell Sts.,
Chinatown, at 2:30 a.m. yesterday, routing 500 people from their
homes. Weegee, our psychic photographer, not only made the
scene after the explosion, but before as well. This is the scene
as Weegee shot it before the blast; he said his psychic bone told
him something would happen. Then...something happened, all
right—the street fell in. Note the fallen street post and the flames
bursting from the main." *2040.1993, 2041.1993*

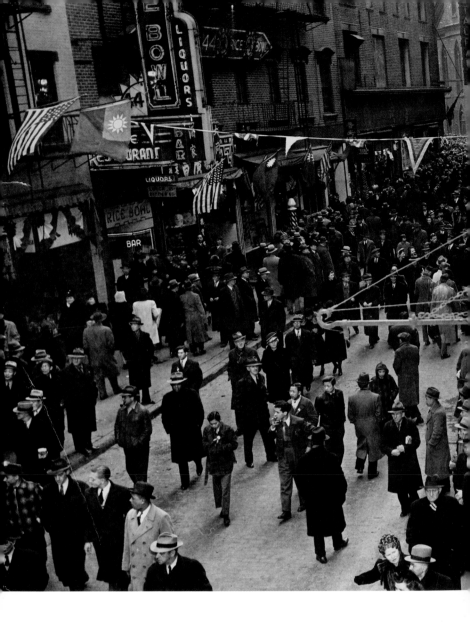

35 **MOTT STREET, LOOKING SOUTH PAST PELL**
[Crowds in Chinatown],
ca. 1942
The Rathskeller Restaurant at 45 Mott (sign at upper right) was
a Chinatown institution for forty years, from 1939 until its doors
closed in 1979. The Church of the Transfiguration is in the back-
ground. *15454.1993*

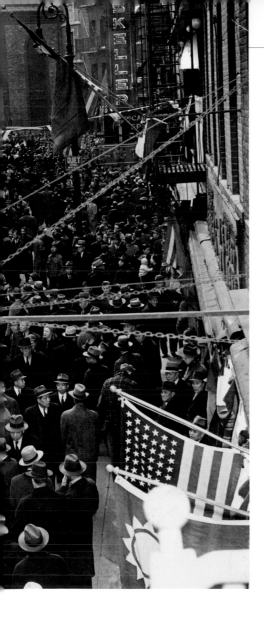

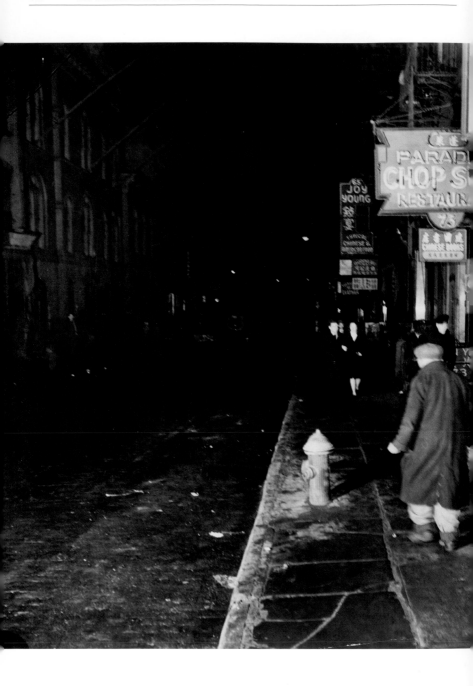

36 65–73 MOTT STREET BETWEEN BAYARD AND CANAL,
WEST SIDE OF BLOCK
[Restaurants in Chinatown], ca. 1943
14543.1993

37 63 MOTT STREET BETWEEN BAYARD AND CANAL,
WEST SIDE OF BLOCK
[Victory], August 1945
15635.1993

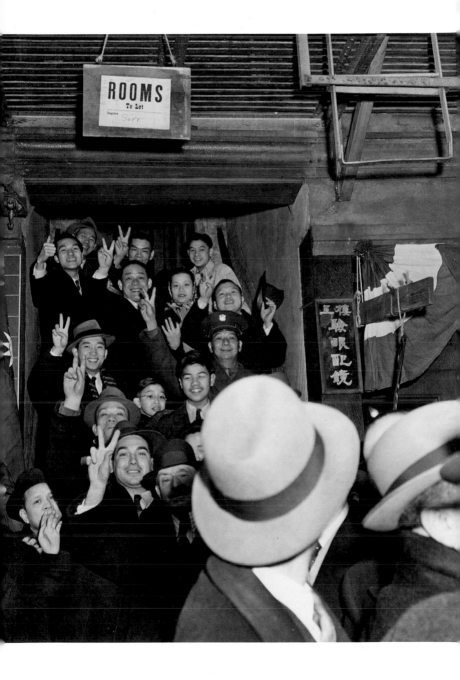

ca. 1940

N.B. The markers on this map represent, where possible, a reasonable estimate of Weegee's position (circle) and direction he faced (square).

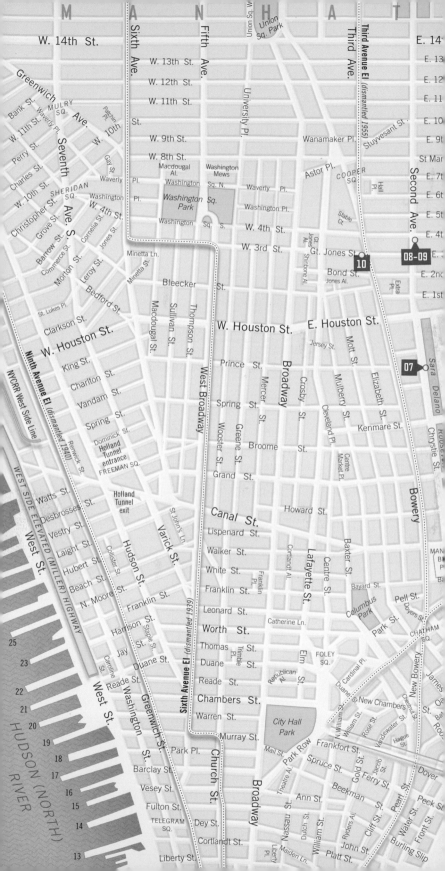

03 THE LOWER EAST SIDE

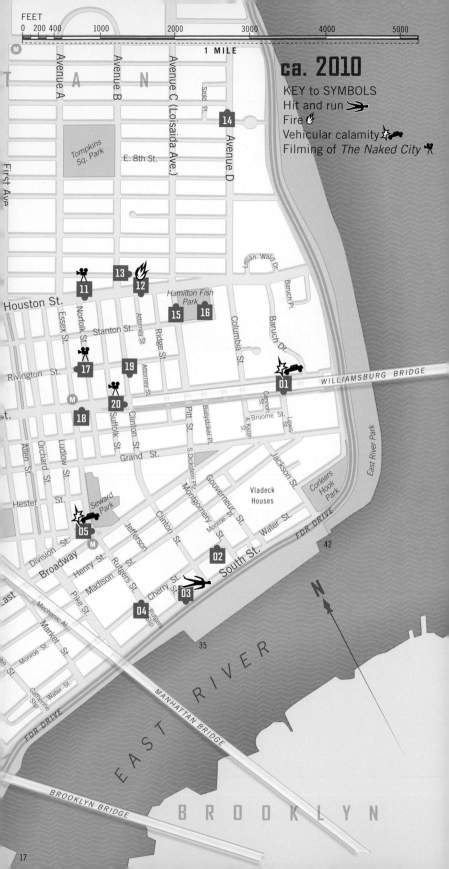

FEET

0 200 400 1000 2000 3000 4000 5000

1 MILE

ca. 2010

KEY to SYMBOLS

Hit and run 🏃
Fire 🔥
Vehicular calamity 🚗
Filming of *The Naked City* 🎥

Avenue A
Avenue B
Avenue C (Loisaida Ave.)
Avenue D

Szold Pl.

14

Tompkins Sq. Park

E. 8th St.

First Ave.

Lillian Wald Dr.

Baruch Pl.

13 12

Hamilton Fish Park

Baruch Dr.

11

15 16

Houston St.

Essex St.
Norfolk St.
Attorney St.
Ridge St.

Stanton St.

Columbia St.

Cannon St.

01 WILLIAMSBURG BRIDGE

Rivington St.

17

19

Attorney St.

A. Kazan St.

Broome St.

Lewis

East River Park

M

20

18

Ludlow St.
Orchard St.
Allen St.

Suffolk St.
Clinton St.

Grand St.

Pitt St.

Bialystoker Pl.

S. Dickstein Plz.

Gouverneur St.

Vladeck Houses

Jackson St.

Corlears Hook Park

Hester St.

Seward Park

Monroe St.

Water St.

FDR DRIVE

42

05

Jefferson St.

Clinton St.

Montgomery St.

02 South St.

Division St.

Broadway

M

Henry St.
Madison St.
Rutgers St.
Cherry St.

03

N

04 Rutgers Slip

35

Mechanic Al.

Monroe St.
Market St.
Water St.
Catherine Slip

Pike St.

FDR DRIVE

E A S T R I V E R

MANHATTAN BRIDGE

BROOKLYN BRIDGE

B R O O K L Y N

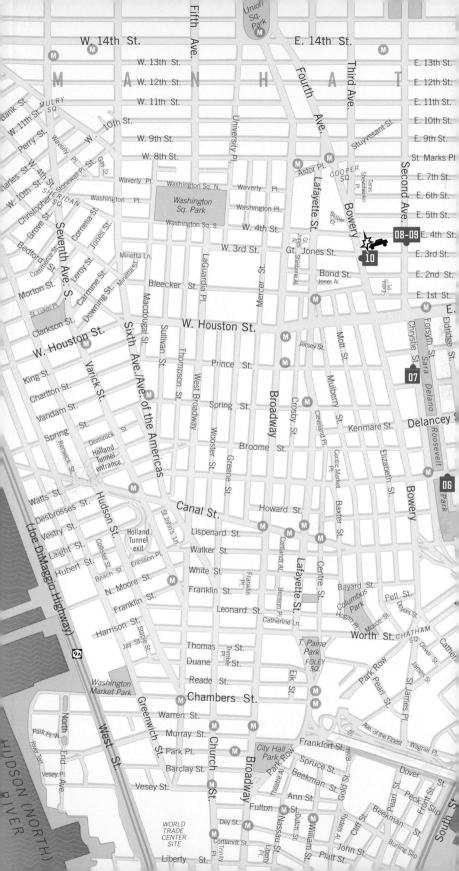

01 DELANCEY AND LEWIS STREETS
[Location where policeman's car catapulted truck driver to his death], August 21, 1936

Looking north on Lewis Street. The dotted line shows the trajectory of Charles Schlanger's vehicle as it fell from the Williamsburg Bridge to Delancey Street after a car driven by inebriated police officer William F. Glendinning struck it. In the background: a Consolidated Edison gasholder at East 11th Street and Avenue D.

The Pigozzi Collection

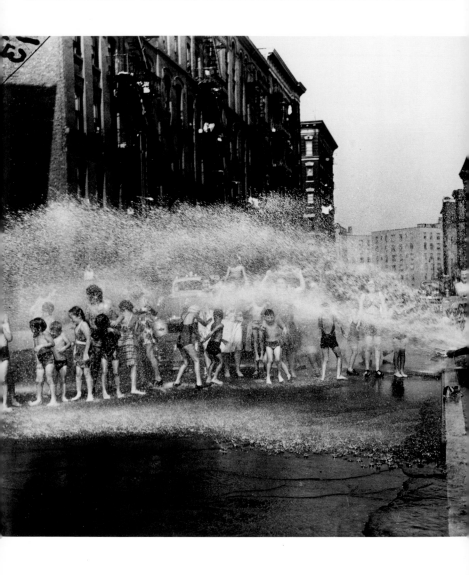

02 **CHERRY STREET BETWEEN CLINTON AND MONTGOMERY**
[Children playing in water sprayed from open fire
hydrant], July 19, 1942
Looking northeast along Cherry Street to the Vladeck Houses (in
the background), a public housing project that opened in August
1940. The complex was named for Baruch Vladeck, co-founder of
the Jewish Labor Committee and general manager of the Yiddish-
language socialist newspaper, *The Forward*. *880.1993*

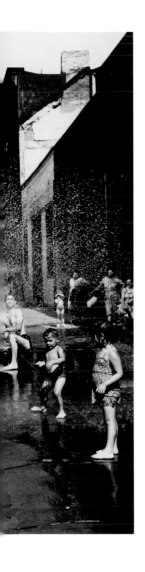

Unidentified Photographer, *Vladeck Houses*,
July 14, 1941. *Library of Congress*

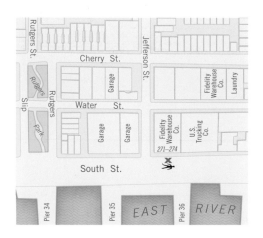

03 **271–274 SOUTH STREET AT JEFFERSON,**
 NORTHEAST CORNER
 Hit & Run, South St., August 15, 1938
 14165.1993

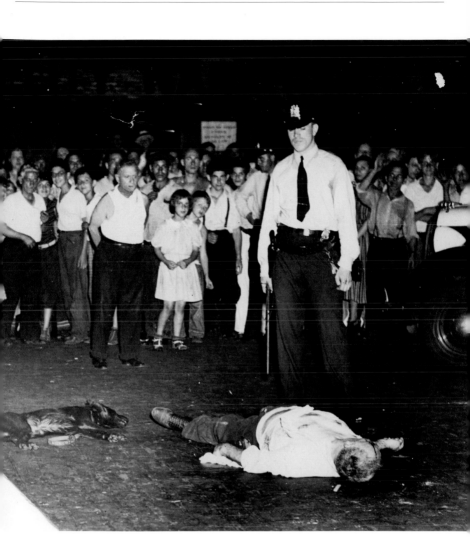

04 **CHERRY STREET AND RUTGERS SLIP**
Don't Waste Water,
August 18, 1944

Looking southwest along Cherry Street to the Manhattan Bridge.
Rutgers Slip lies at the bottom of Rutgers Street. A slip is a rect-
angular inlet or harbor, about the size of a city block, in which
freighters unloaded cargo. The slips that once lined the East River
of Lower Manhattan—Whitehall, Exchange, Coenties, Pike, etc.—
date back to the days of Dutch New Amsterdam. Almost all of the
East River slips had been filled in by the mid-nineteenth century,
but the cobblestone streets that replaced them retained their
original names. *14502.1993*

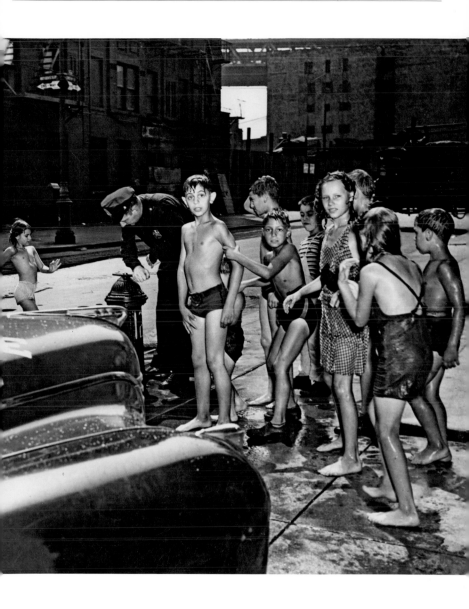

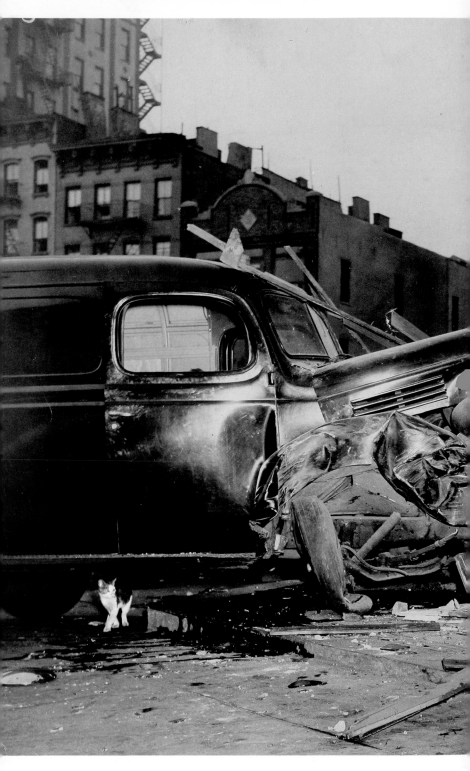

05 **26 CANAL STREET AT RUTGERS**
The Curious Cat, 1941
Galerie Berinson, Berlin

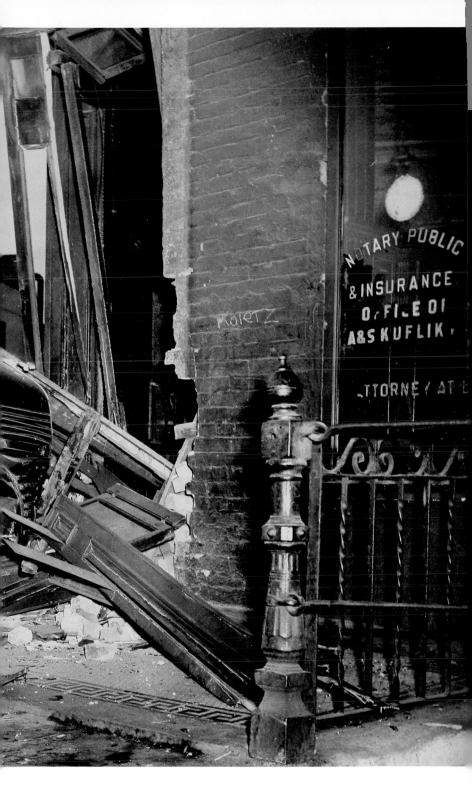

06 271 GRAND STREET AT FORSYTH, SOUTHEAST CORNER
[Storm damage to a bridal shop], September 14, 1944
16274.1993

07 201 CHRYSTIE STREET BETWEEN STANTON AND RIVINGTON,
WEST SIDE OF BLOCK
[Fire exercise], ca. 1945
Levine Bros. Glass is at 201 Chrystie Street. A fire department fuel
depot stood next to it, at 199 Chrystie. *15009.1993*

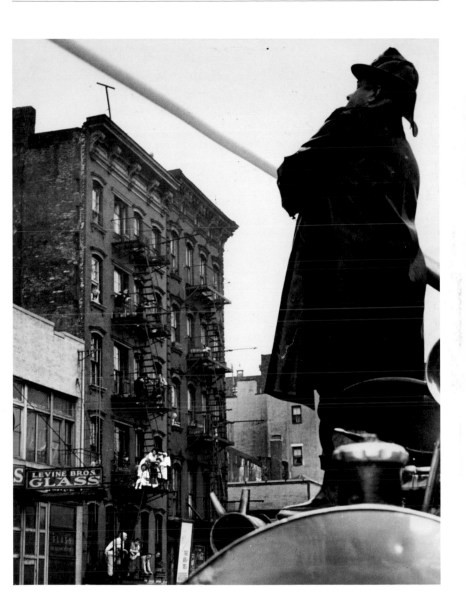

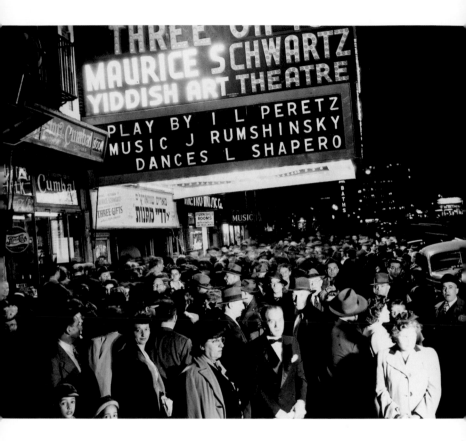

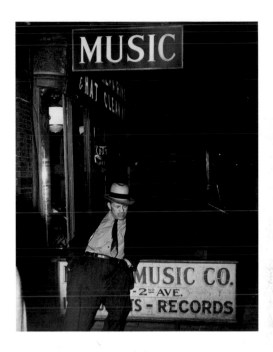

08 **66 SECOND AVENUE BETWEEN EAST 3RD AND 4TH STREETS, EAST SIDE OF BLOCK**
[Outside the Yiddish Art Theatre], October 1, 1945
Looking south on Second Avenue along the Yiddish Rialto, the center of the Yiddish theater scene from the early twentieth century through the late 1940s. Maurice Schwartz was a renowned Yiddish actor and founder/director of the Yiddish Art Theatre. The musical *Three Gifts* opened there in October 1945. The lighted structure in the right background is the Second Avenue Theatre, which offered a mixed program of Yiddish plays and film screenings. *1068.1993*

09 **64 SECOND AVENUE BETWEEN EAST 3RD AND 4TH STREETS, EAST SIDE OF BLOCK**
[Man sleeping in front of a music store], ca. 1945
This is the Metro Music store, next door to the Yiddish Art Theatre (08). *14473.1993*

10 THE BOWERY UNDER THE THIRD AVENUE ELEVATED AT EAST 3RD AND GREAT JONES STREETS

[Collision on the Bowery], June 15, 1943 *15222.1993*

When a truck and trolley car collided under the Third Avenue
Elevated on the Bowery, both vehicles and parts of the elevated
structure burst into flames. The truck driver burned to death;
trolley passengers rushed off the car as the exterior blistered
from the heat.

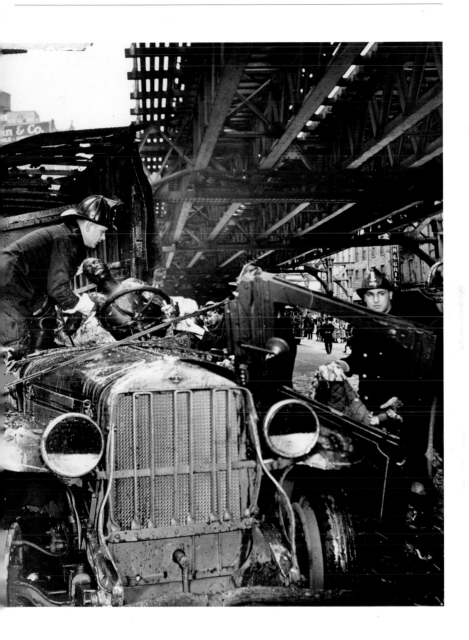

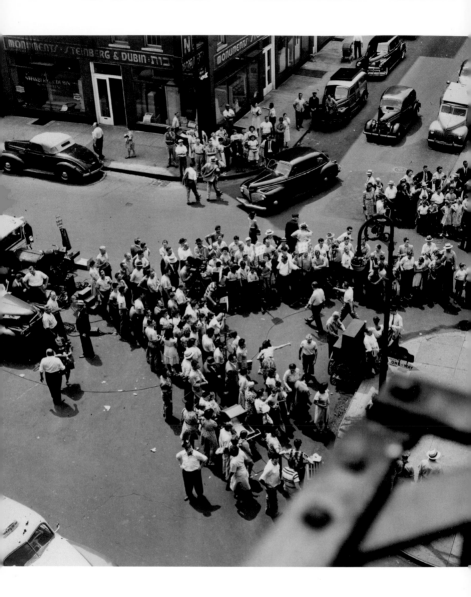

11 INTERSECTION OF EAST HOUSTON, NORFOLK, AND EAST 1ST STREETS

[Filming *The Naked City*], 1947

Weegee accompanied the film crew of *The Naked City,* which was inspired by his book *Naked City,* published in 1945. The photo was taken from a fire escape above East 1st looking down at the trian-gular plaza formed by the intersection of East Houston and East 1st, and south down Norfolk. The playground at the upper right belongs to Public School No. 13. *7572.1993*

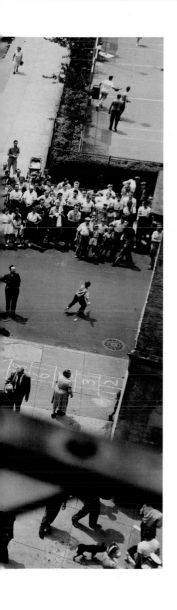

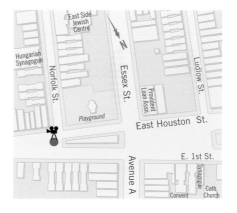

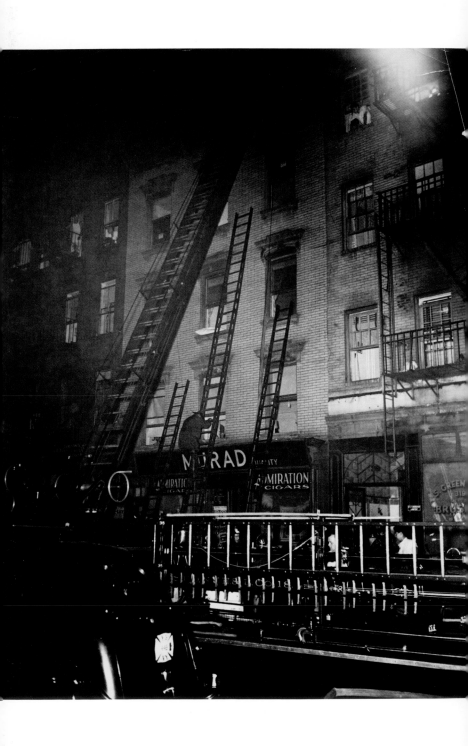

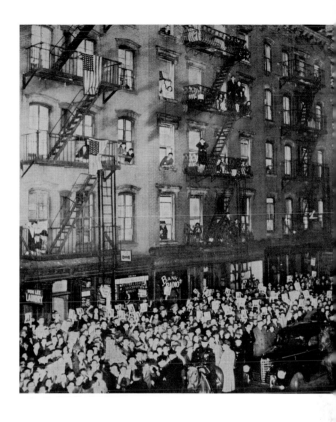

12 **319–321 EAST HOUSTON STREET AT ATTORNEY,**
SOUTHEAST CORNER
[Tenement fire], July 27, 1941
15127.1993

13 **EAST 2ND STREET BETWEEN AVENUES B AND C,**
SOUTH SIDE OF BLOCK
[Lower East Side crowd listens to Wilkie speech],
PM Daily, October 24, 1940
Presidential candidate Wendell Wilkie campaigned on the Lower
East Side, delivering a speech at Lenox Hall at 256 East 2nd Street,
between Avenues B and C. The turnout was so large that loud-
speakers were set up in the streets. The people pictured here wave
pro-FDR signs as they listen to Wilkie's speech.

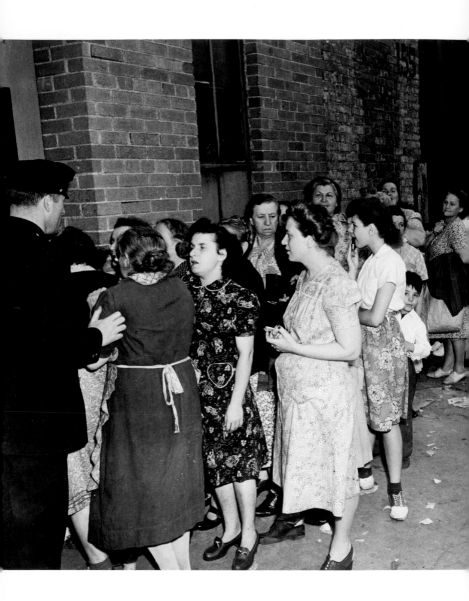

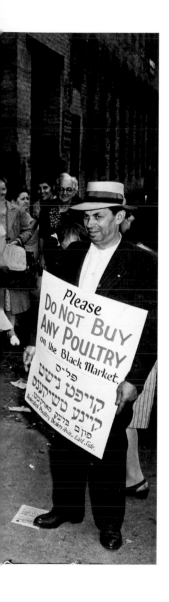

14 **153 AVENUE D BETWEEN EAST 10TH AND 11TH STREETS, WEST SIDE OF BLOCK**
[Lower East Side shoppers cross poultry strike line], July 1, 1943
Shoppers are standing in front of M. Binder & Sons poultry market at 153 Avenue D. *15395.1993*

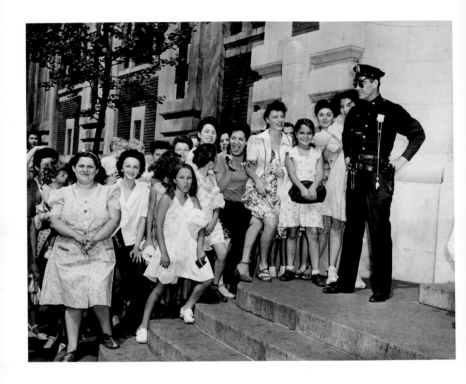

15 **HAMILTON FISH PARK, PITT STREET ENTRANCE**
[Lining up for the pool at Hamilton Fish Park],
July 10, 1944
Completed in 1900, Hamilton Fish Park features a Beaux Arts–style
pavilion designed by Carrère & Hastings. The pool was one of
eleven built with WPA funds in New York City, all opening in 1936.
905.1993

16 **HAMILTON FISH PARK POOL**
"Cooling Off on the East Side," *PM Daily*,
June 14, 1943
Hamilton Fish Park is bounded by East Houston, Pitt, Sheriff, and
Stanton streets. In the background here is Sheriff Street (east side
of the park).

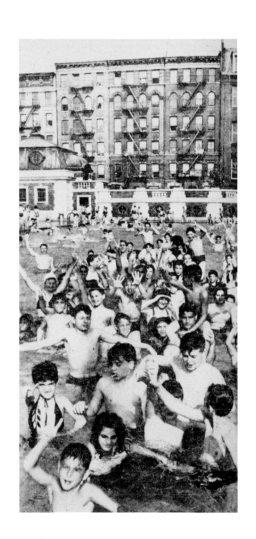

17 **RIVINGTON STREET BETWEEN NORFOLK
AND ESSEX, NORTH SIDE OF BLOCK**
[The Juggler], 1947
Looking east on Rivington Street toward Norfolk.
The office of Moritz Goldstein (sign on left) is at
128 Rivington. Vaudeville juggler Bill Brown was
hired to distract passersby from the set of *The
Naked City*, shooting nearby. *2008.1993*

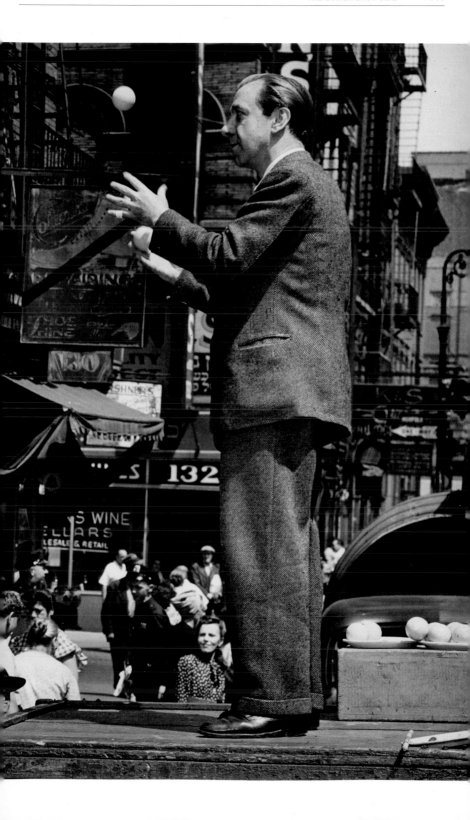

18 125 DELANCEY STREET BETWEEN ESSEX AND NORFOLK,
SOUTH SIDE OF BLOCK
[Wartime rationing: crowds at a dairy store try to beat an
impending freeze on butter], March 21, 1943
15547.1993

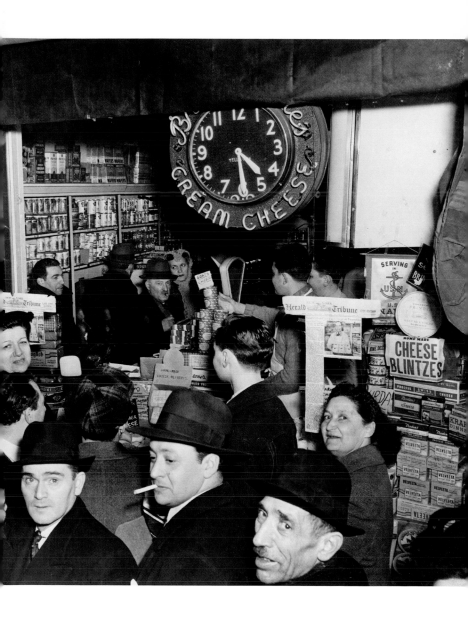

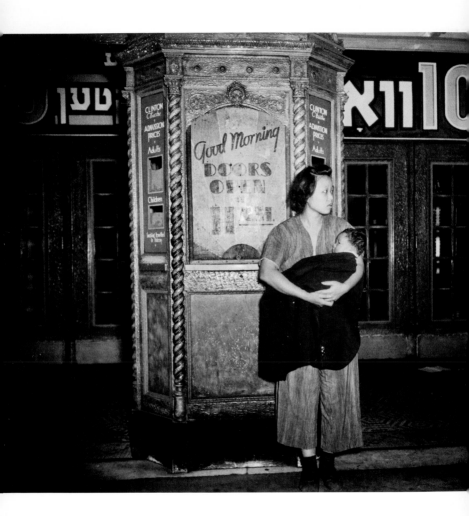

19

80–82 CLINTON STREET BETWEEN RIVINGTON AND DELANCEY, EAST SIDE OF BLOCK

Not waiting for the movie theatre to open...but a refugee from a fire, ca. 1944

The woman is standing in front of the Clinton Theatre, which programmed a mix of Yiddish vaudeville and film. The theater opened in 1917, closed in 1950. *Weegee portfolio 15*

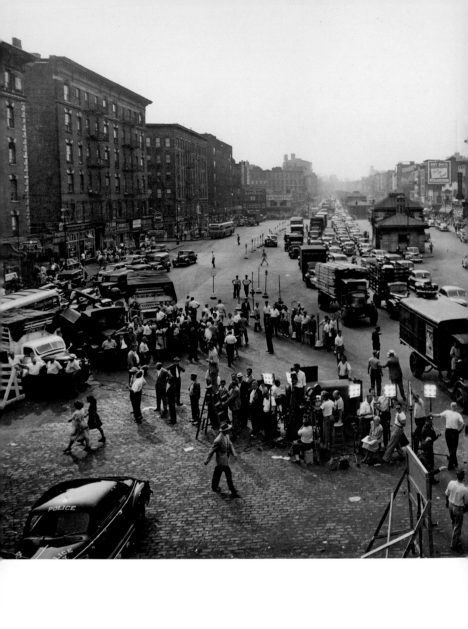

20 **DELANCEY STREET, APPROACH TO WILLIAMSBURG BRIDGE**
[Filming *The Naked City*],
1947

Looking west on Delancey from the approach to the Williamsburg
Bridge. At the time, this stretch of the thoroughfare was also called
Schiff Parkway. Loew's Delancey movie theater is on the upper
right (at the northwest corner of Suffolk Street). The kiosks in the
center of Delancey (now demolished) led to the subway and the
underground trolley terminal. A film crew sets up the final scene of
The Naked City, a dramatic chase to the top of the bridge. *7574.1993*

Detail of 20 showing the Loew's
theater at 146 Delancey.

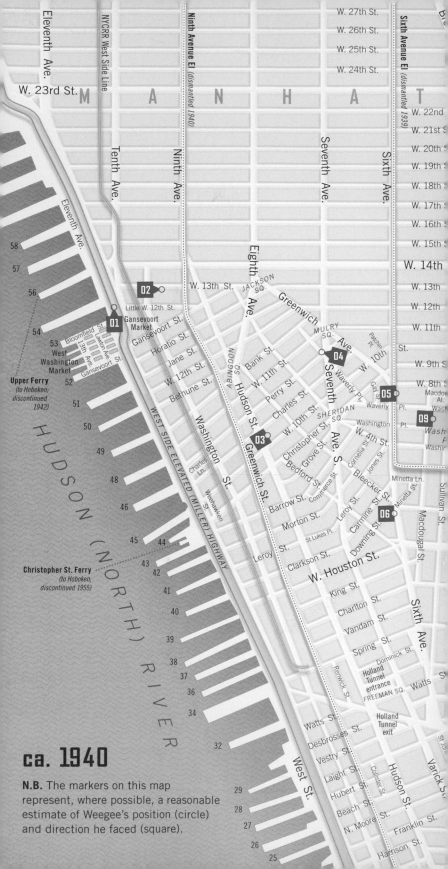

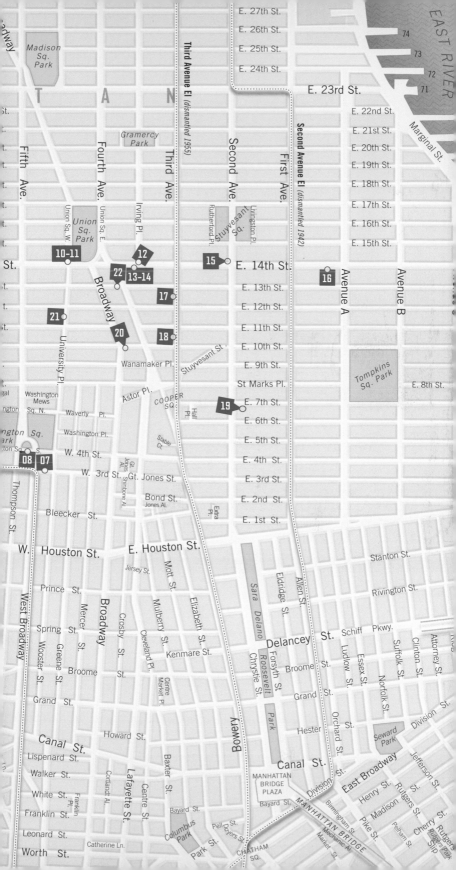

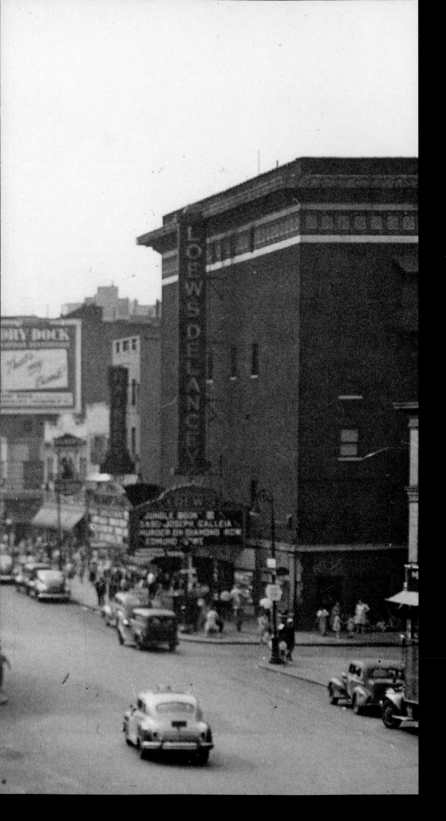

04 THE VILLAGE

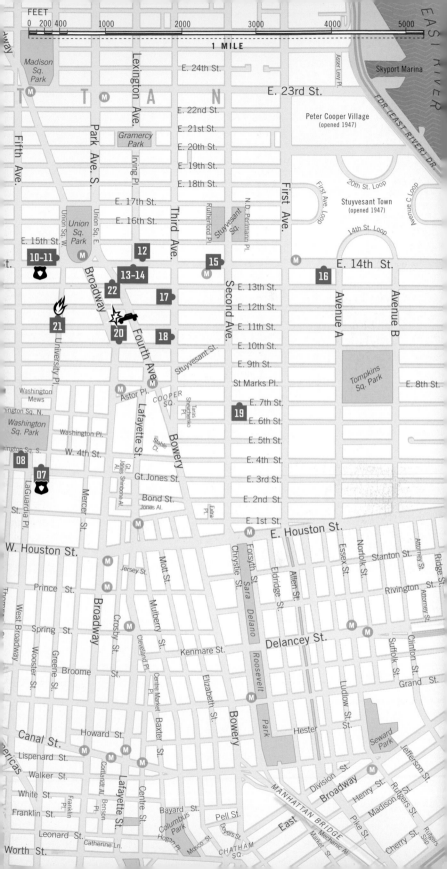

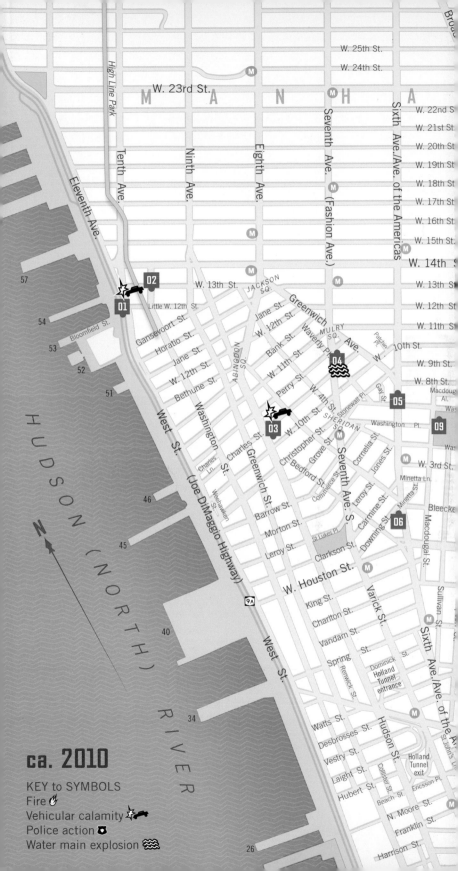

ca. 2010

KEY to SYMBOLS
Fire 🔥
Vehicular calamity 💥🚗
Police action 🛡
Water main explosion ≋

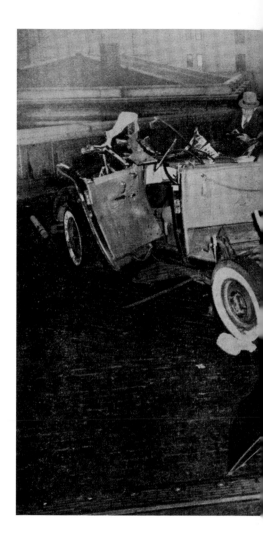

01

THE WEST SIDE ELEVATED HIGHWAY AT LITTLE WEST 12TH STREET

["Murderous curve" on the West Side Elevated Highway],
PM Daily, October 14, 1941

The West Side Elevated Highway looking south. The highway was
built between 1929 and 1937 (Canal to West 72nd Street), with
southern extensions (Canal to the Battery) added from the mid-
1930s onward. The section of the highway between Gansevoort and
Little West 12th—which included the "murderous curve"—collapsed
in 1973. The West Side Elevated Highway should not be confused
with the West Side Line (see 02). The buildings in the background
are part of Gansevoort Market, originally bounded by Little West
12th, Gansevoort, West, and Washington, but eventually expanding
north to West 16th Street and east to Ninth Avenue.

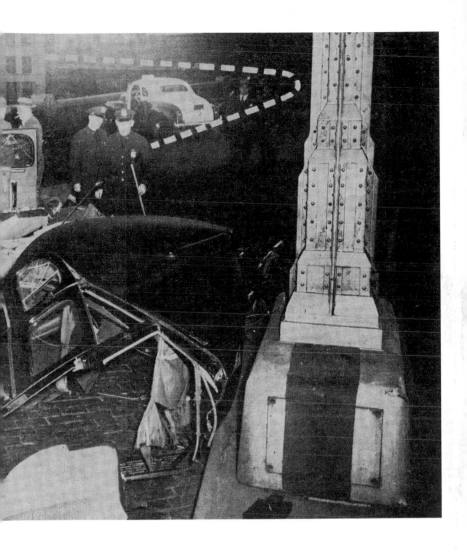

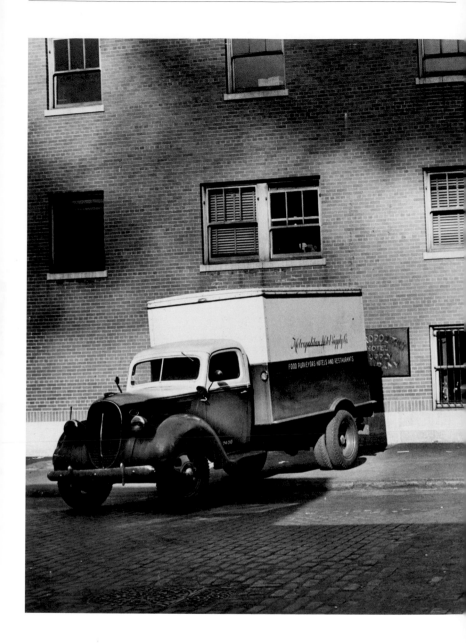

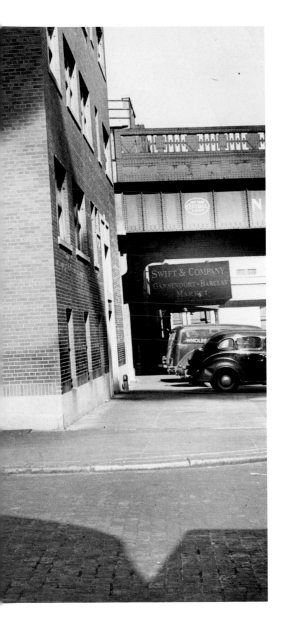

02

WEST 13TH AND WASHINGTON STREETS, SOUTHWEST CORNER
[Gansevoort Market in the West Village],
ca. 1945

Washington Street is in the foreground. Looking west along West
13th to the West Side Line (above the Swift & Company sign), an
elevated freight line built in the mid-1930s that cut through the
second and third floors of many buildings along its route. Part
of the West Side Line has been transformed into the High Line
elevated park. *17821.1993*

03 **527 HUDSON STREET BETWEEN CHARLES AND WEST 10TH, WEST SIDE OF BLOCK**
[Truck fire], April 18, 1938
15030.1993

04 **SEVENTH AVENUE SOUTH AND
PERRY STREET**
[Water main explosion in the Village],
September 10, 1941
The corner building, half-hidden by steam, is
12 Perry Street. *1090.1993*

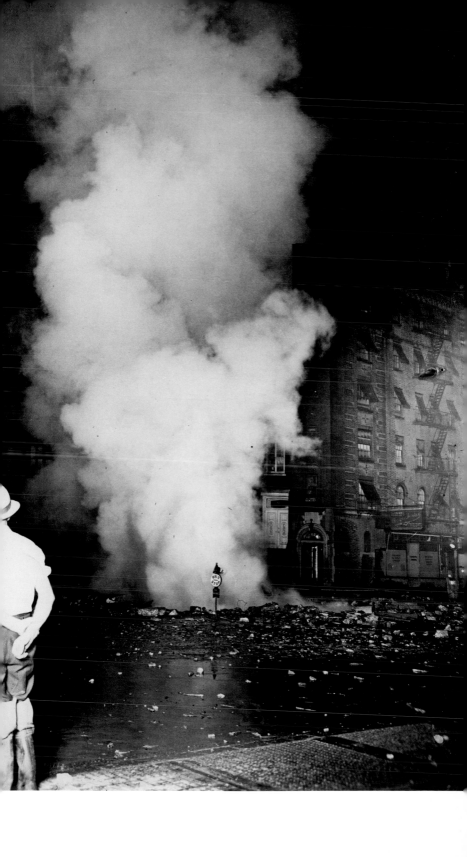

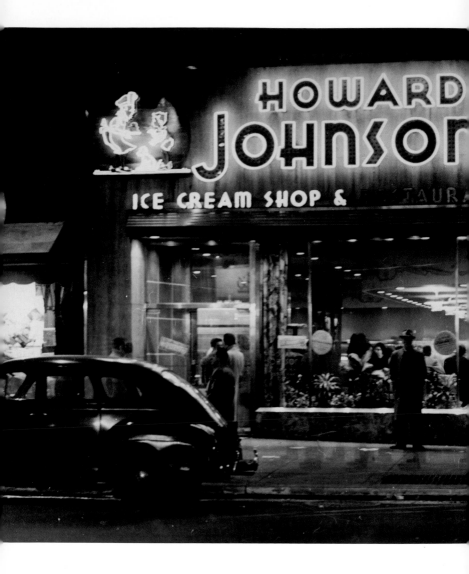

05 405 SIXTH AVENUE BETWEEN GREENWICH AVENUE AND WAVERLY PLACE, WEST SIDE OF BLOCK

Winchell in his column called it "Harriet" Johnson, 1955

In his memoirs, George Birimisa recounts an episode that launched his career as a playwright and, coincidentally, also explains Weegee's cryptic caption for this photograph. Birimisa was working at the Village Howard Johnson as a soda jerk when, one night in 1955, Walter Winchell showed up after the restaurant had closed and demanded that he and his gang of friends be served. Knowing that Winchell was a right-wing homophobe, Birimisa refused. In his *Daily Mirror* column the next day, Winchell attempted to exact revenge, lambasting "Harriet" Johnson in the Village as a gay watering hole and calling it "vag-lewd." But what was intended as a smear campaign in fact turned the establishment into a popular gay hangout. *14730.1993*

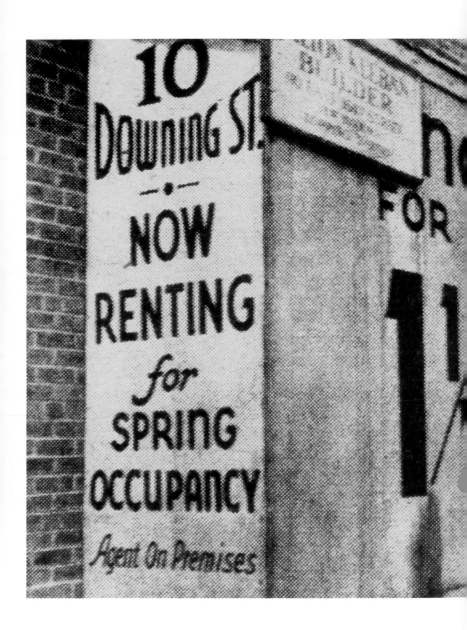

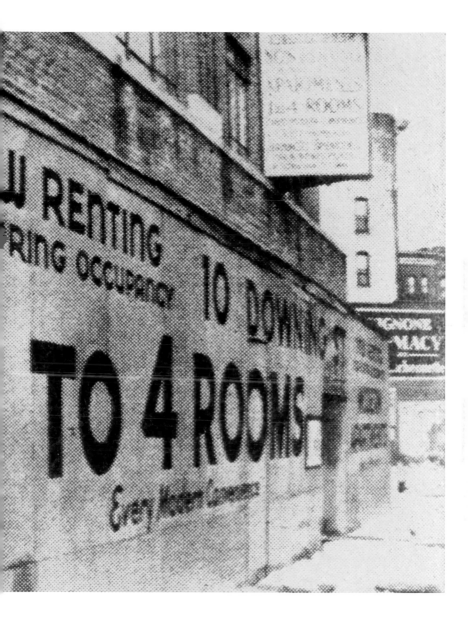

06 **10 DOWNING STREET AT SIXTH AVENUE, SOUTHWEST CORNER**
[Now Renting], *PM Daily,* January 27, 1941

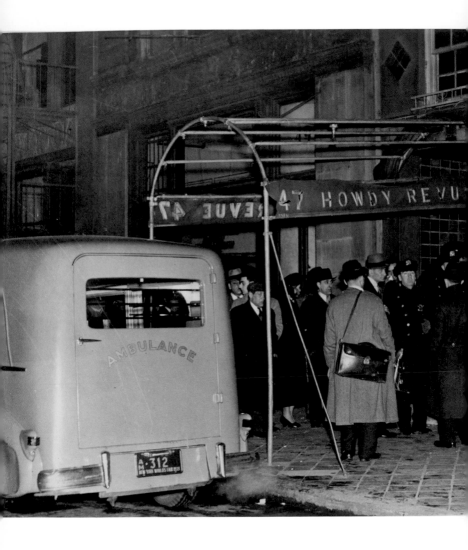

07 **47 WEST 3RD STREET NEAR WOOSTER,
NORTH SIDE OF BLOCK**
[Incident at the Howdy Revue],
April 1938

On April 12, 1938, at four o'clock in the morning,
three men attempted to rob the sixty patrons
and employees of the Howdy Revue. Police
arrived and in the ensuing shootout one cop was
injured. Weegee captured the aftermath here.
Reputedly a lesbian hangout, the Howdy Revue
featured colorful floor shows and risqué acts
that ultimately brought harassment from the vice
squad. The club was hit with a morals charge in
1944 and forced to suspend its cabaret shows. By
1945, musician Eddie Condon had taken over the
club and operated it as a jazz venue for the next
twenty years. *2192.1993*

08 **61 WASHINGTON SQUARE SOUTH**
[Exterior of the Gamut Arts Club with a sign for "Murders by Weegee"], 1942–45

Known as the House of Genius for the number of writers, musicians, and artists who had boarded there over the years, 61 Washington Square South was the focus of one of the first preservation campaigns in New York City. Village residents lost the battle and the House of Genius, along with the other rowhouses between Thompson Street and West Broadway, was demolished in 1948. The Gamut Arts Club was a leftist cultural organization led by Hendrik Glintenkamp (1887–1946) and Isobel Walker Soule (1898–1972). Printmaker and illustrator Glintenkamp was a regular contributor to *The Masses* and later worked for the WPA. Soule, a social worker, journalist, and labor organizer in the Transport Workers Union, published *The Vigilantes Hide Behind the Flag* (International Labor Defense, 1937), an attack on antilabor organizations. *20023.1993*

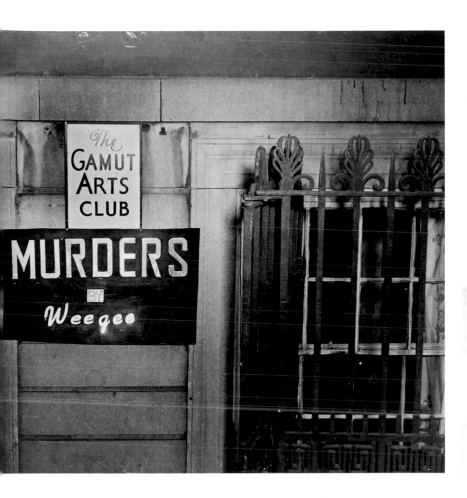

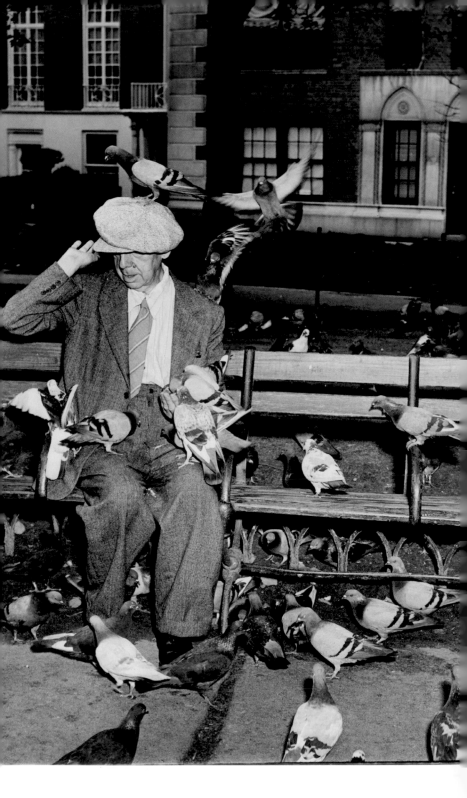

09 WASHINGTON SQUARE WEST BETWEEN
WAVERLY AND WASHINGTON PLACE
[Man feeding pigeons in Washington
Square Park], ca. 1946
246.1996

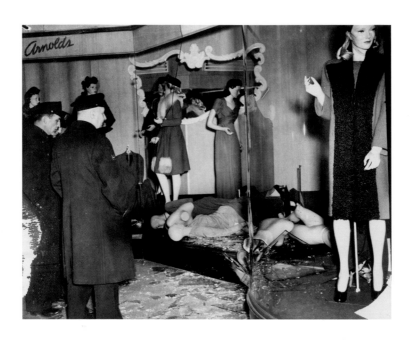

10 **1 UNION SQUARE WEST**
[Arnold's apparel shop after a burglary],
March 1944
2303.1993

11 **UNION SQUARE WEST AT UNIVERSITY PLACE,
NORTHWEST CORNER**
[Morris Goodovitch, owner of Arnold's apparel shop,
carrying mannequin from burgled store], March 1944
2301.1993

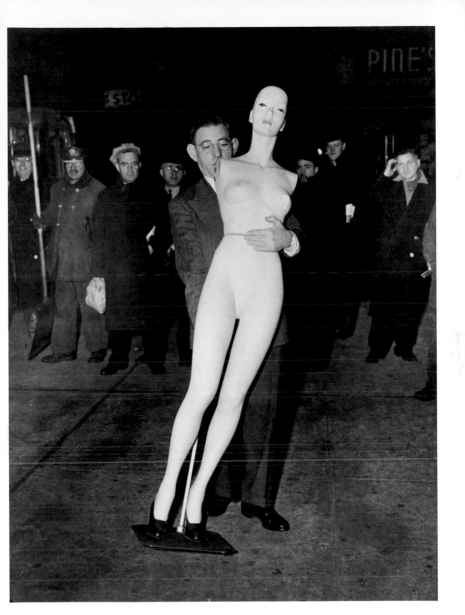

12 **4 IRVING PLACE AT EAST 14TH STREET,
NORTHEAST CORNER**
[The Con Edison Tower], ca. 1943
Galerie Berinson, Berlin

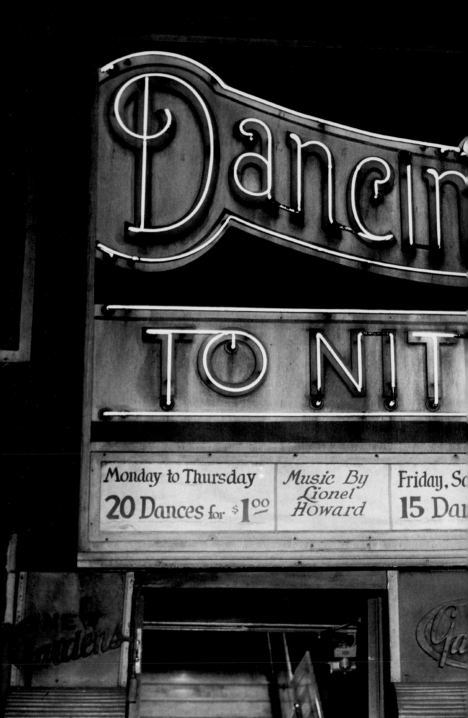

13 116 EAST 14TH STREET BETWEEN THIRD AND FOURTH AVENUES, SOUTH SIDE OF BLOCK

[Dancing To Nite], ca. 1944

The New Gardens Ballroom was located near the Academy of Music (14). Part of the City Theatre marquee is visible on the upper right (114 East 14th). Note the fragment of poster at the lower right, advertising a Soviet film distributed by Artkino Pictures. During the war years, Soviet films drew large crowds, but attendance flagged once our wartime ally became our postwar nemesis. *2446.1993*

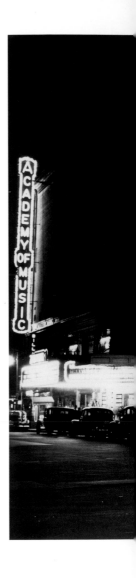

14 **EAST 14TH STREET BETWEEN THIRD AND FOURTH AVENUES, SOUTH SIDE OF BLOCK**

[New York lights up as the brownout is lifted following V-E Day], May 1945

Looking east along East 14th Street: the City Theatre (No. 114); the Sculpta Hosiery store (No. 116), below the New Gardens Ballroom (see 13); the Biltmore Cafeteria (No. 120); and the Academy of Music (No. 126). On the City Theatre marquee: *These Were the Nazis, After Mein Kampf, Hitler Beast of Berlin,* and *Inside Nazi Death Camps*.

15608.1993

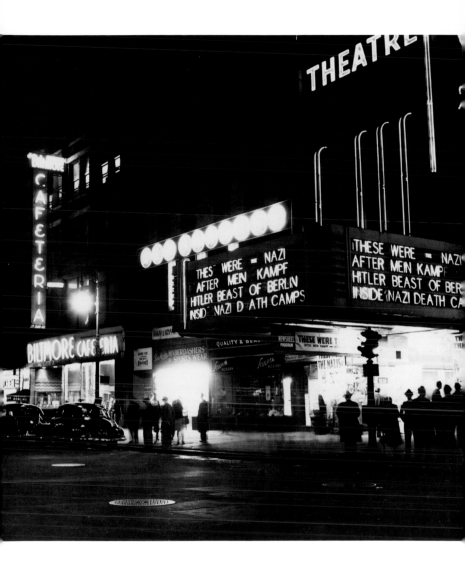

15 **EAST 14TH STREET, LOOKING WEST FROM SECOND AVENUE**

[Air raid wardens], May 7, 1945
South side of block: Jefferson Theatre RKO (No. 214). North side of block: marquee of the Arrow Theatre (No. 235), later the notorious Metropolitan porn theater. The Third Avenue Elevated is visible in the distance. *15503.1993*

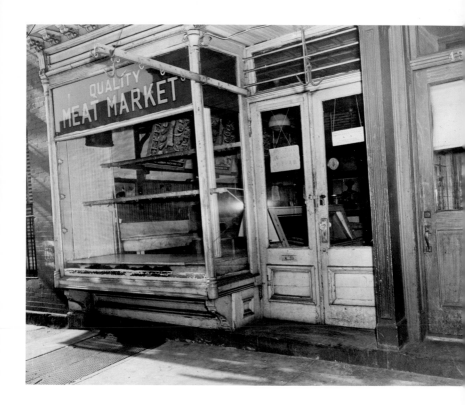

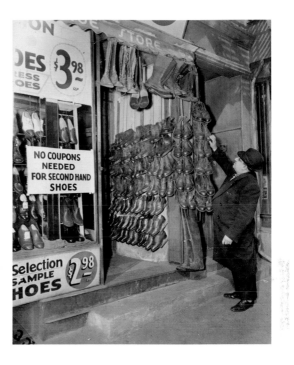

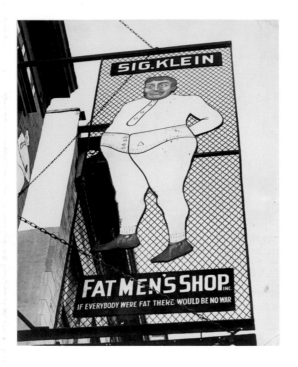

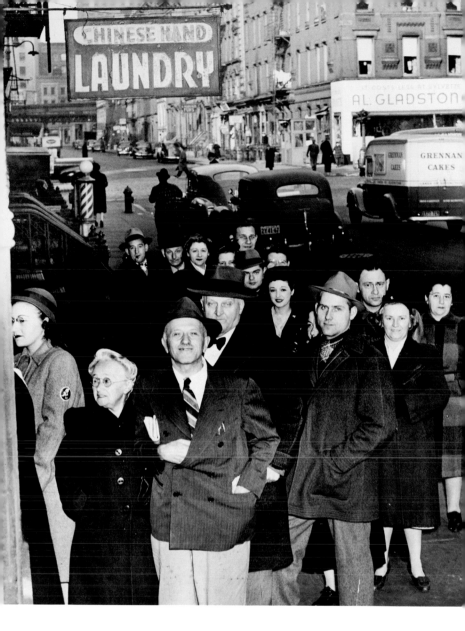

18 **52 THIRD AVENUE BETWEEN EAST 10TH AND 11TH STREETS, WEST SIDE OF BLOCK**
[Fat Men's Shop. If Everybody Were Fat There Would Be No War], ca. 1942
15474.1993

19 **EAST 7TH STREET BETWEEN FIRST AND SECOND AVENUES**
[Wartime rationing: crowd in front of store], ca. 1943
Looking west along East 7th Street to the Third Avenue Elevated.
15551.1993

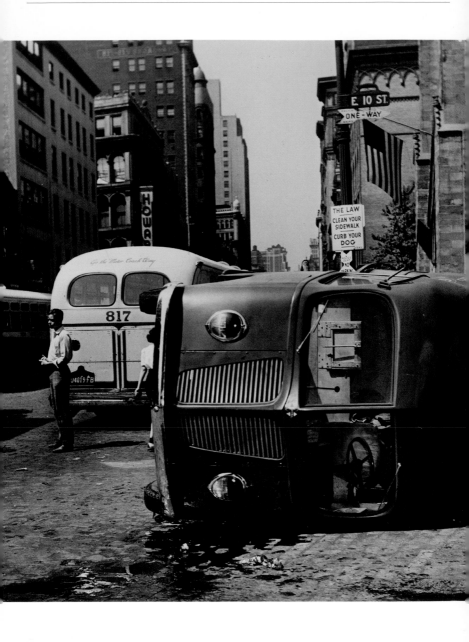

20 **BROADWAY AND EAST 10TH STREET, NORTHEAST CORNER**
[Truck crash],
1940s
Looking north up Broadway. Grace Church is on the right (800
Broadway). *14163.1993*

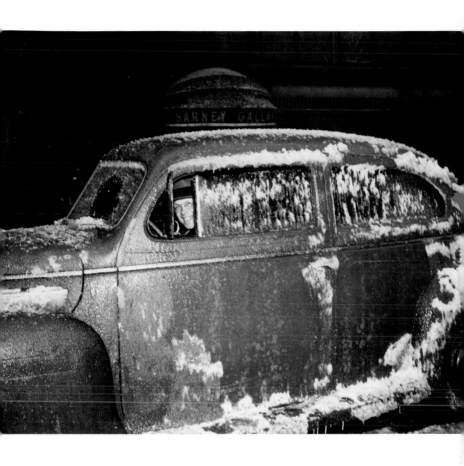

21 86 AND 88 UNIVERSITY PLACE BETWEEN EAST 11TH AND
12TH STREETS, WEST SIDE OF BLOCK
[Fire and ice], February 16, 1943
[Man in ice-covered car, after a fire], February 16, 1943
Firemen here douse a blaze in temperatures below ten degrees.
The fire broke out in a factory building at 84 University Place. Next
door, at No. 86, is Barney Gallant's restaurant (note awning in the
picture at right). A long-time denizen of bohemian Greenwich
Village, Gallant ran a number of clubs dating back to speakeasy
days. *15008.1993, 15213.1993*

22 **FOURTH AVENUE AND EAST 13TH STREET,
NORTHWEST CORNER**
[Man reading a newspaper], ca. 1941
Looking northeast across Fourth Avenue to the
Central Savings Bank at the corner of East 14th
Street. *2437.1993*

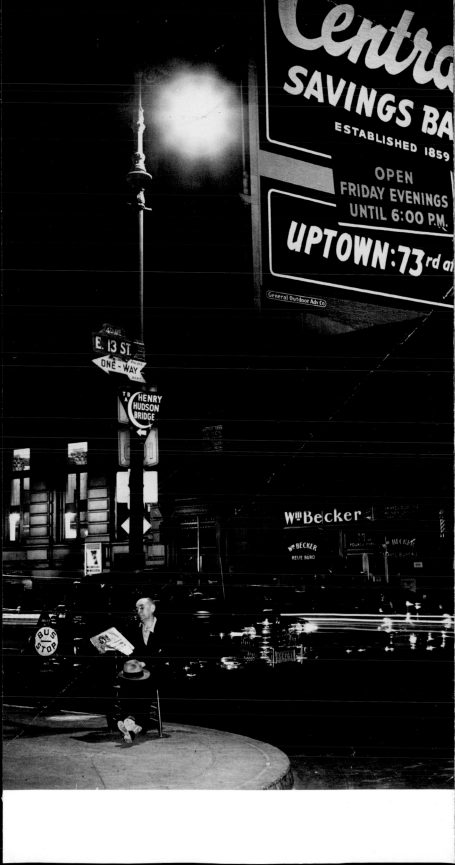

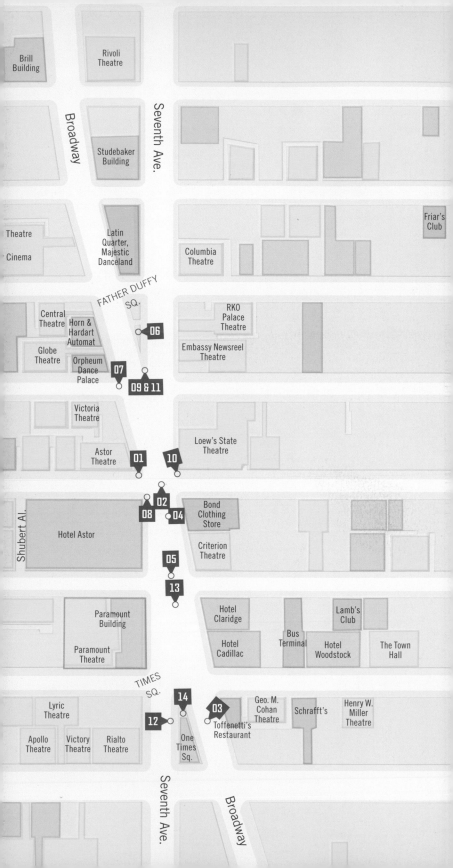

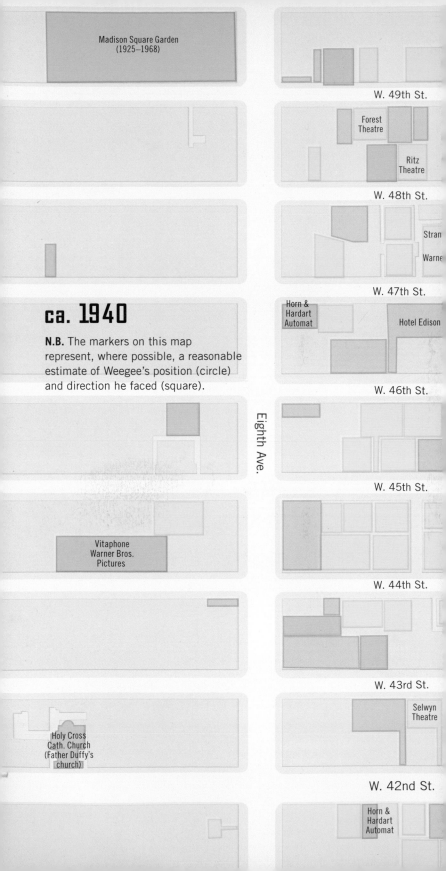

Madison Square Garden
(1925–1968)

W. 49th St.

Forest
Theatre

Ritz
Theatre

W. 48th St.

Stran

Warne

W. 47th St.

Horn &
Hardart
Automat

Hotel Edison

W. 46th St.

ca. 1940

N.B. The markers on this map represent, where possible, a reasonable estimate of Weegee's position (circle) and direction he faced (square).

Eighth Ave.

W. 45th St.

Vitaphone
Warner Bros.
Pictures

W. 44th St.

W. 43rd St.

Selwyn
Theatre

Holy Cross
Cath. Church
(Father Duffy's
church)

W. 42nd St.

Horn &
Hardart
Automat

05 TIMES SQUARE

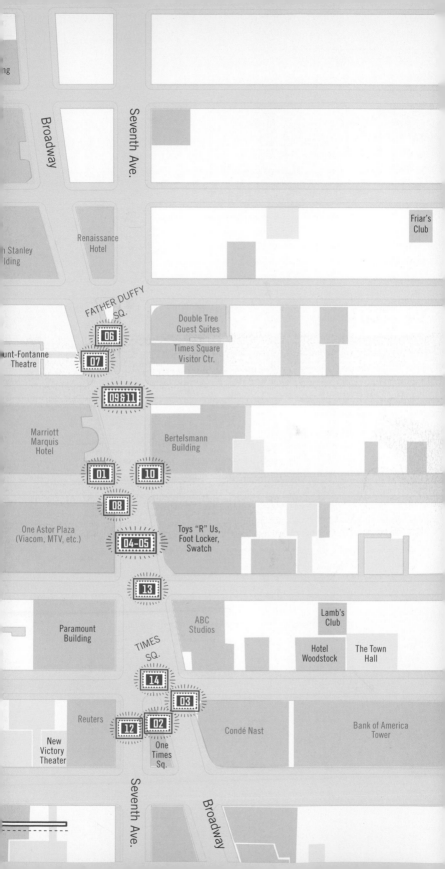

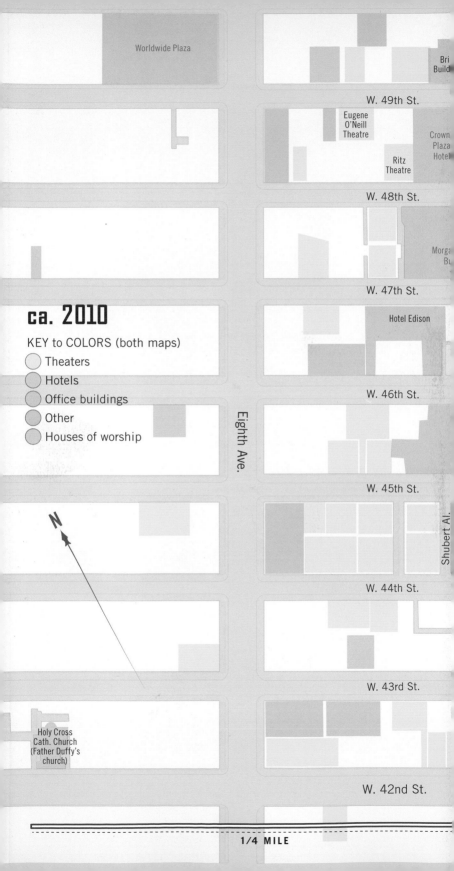

Worldwide Plaza

Bri
Build

W. 49th St.

Eugene
O'Neill
Theatre

Crown
Plaza
Hotel

Ritz
Theatre

W. 48th St.

Morga
Bu

W. 47th St.

Hotel Edison

ca. 2010

KEY to COLORS (both maps)
◯ Theaters
◯ Hotels
◯ Office buildings
◯ Other
◯ Houses of worship

Eighth Ave.

W. 46th St.

W. 45th St.

Shubert Al.

N

W. 44th St.

W. 43rd St.

Holy Cross
Cath. Church
(Father Duffy's
church)

W. 42nd St.

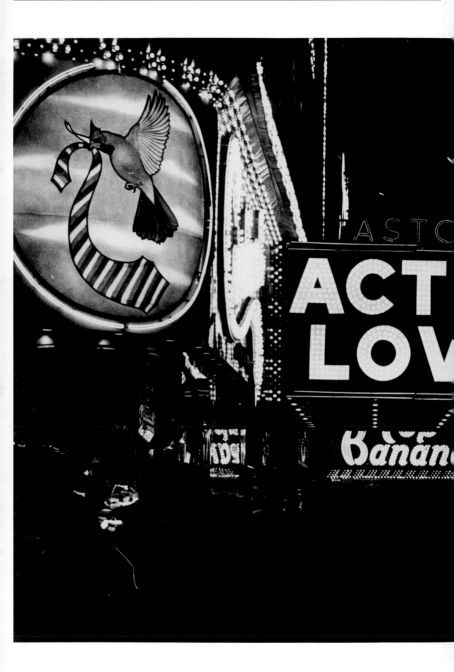

01 TIMES SQUARE, LOOKING NORTH FROM BROADWAY AND
WEST 45TH STREET, NORTHWEST CORNER
[Act of Love, Astor Theatre], 1954
2353.1993

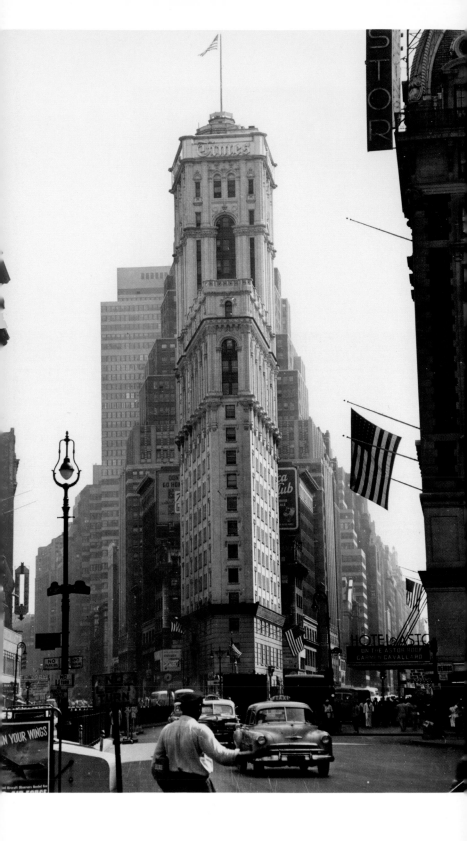

02 ONE TIMES SQUARE
[The Times Building],
1952

One Times Square was built in 1904 as the headquarters of the *New York Times* at what was then called Longacre Square. The area was renamed Times Square at the behest of the newspaper's owner, Arthur Ochs, who also persuaded Mayor McClellan to construct a subway station there. The tradition of dropping the New Year's Eve Ball from the building's roof began in 1907 and continues to this day. Sold to Allied Chemical in 1963, the building was extensively renovated and the facade's granite and terracotta elements were replaced with a sheer wall of marble and concrete. Today, the building is virtually vacant; its exterior is used for giant billboards that generate enormous advertising revenues for the owners.

14710.1993

03 TIMES SQUARE AT BROADWAY AND WEST 43RD STREET, SOUTHEAST CORNER

[Toffenetti Restaurant], ca. 1945

Billed as the "Cathedral of All Restaurants," Toffenetti was in business from 1940 to 1968. Its architecture, however, was anything but cathedral-like. Owner Dario Toffenetti hired Skidmore, Owings & Merrill to design the glass-fronted streamline-moderne structure. *15636.1993*

04 BROADWAY BETWEEN WEST 44TH AND 45TH STREETS, EAST SIDE OF TIMES SQUARE

[A maintenance man changes the bulbs on the Wrigley Spearmint Gum sign], August 5, 1941

Wrigley's neon billboard sat atop the Bond clothing emporium and Loew's Criterion Theatre (at 1514 Broadway), spanning the roofline between West 44th and 45th Streets. An earlier incarnation of the sign had included a giant figure of Neptune, here replaced by a more streamlined pack of gum. Wrigley's billboard soon gave way to Bond's flamboyant contribution to Times Square signage (see 11 overleaf). *2097.1993*

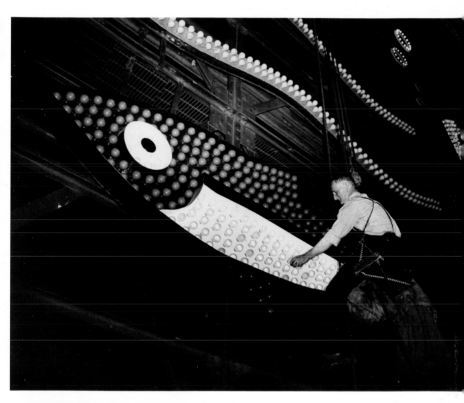

Unidentified Photographer,
Wrigley Spearmint Gum sign, 1941

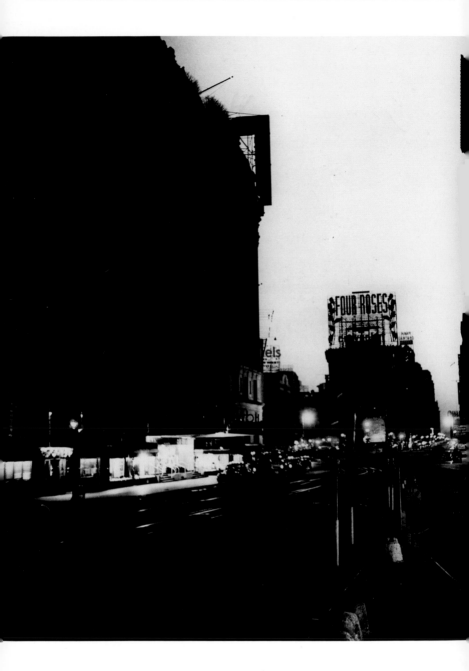

05 TIMES SQUARE, LOOKING NORTH FROM WEST 44TH STREET
[Early evening on Times Square],
1941

On the left: Hotel Astor. On the right: Loew's Criterion Theatre
(1514 Broadway) and the Wrigley's gum neon sign above (not yet
lighted). In the center background: the Four Roses and Planters
Peanuts billboards. *3059.1993*

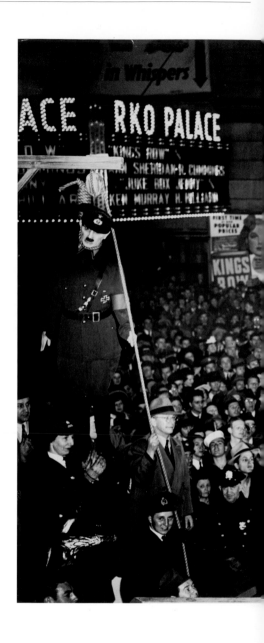

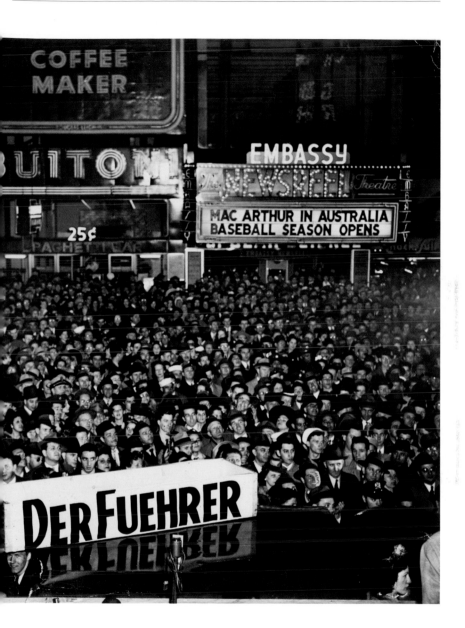

06 **TIMES SQUARE BETWEEN WEST 46TH AND 47TH STREETS, FACING EAST**

[Hitler hung in effigy at a war bonds rally], April 20, 1942
In the background is the Buitoni Spaghetti Bar (center) and the
Embassy Newsreel Theatre (right), which was the first movie house
in the United States to feature all-newsreel programming. In 1997,
the landmarked interior was renovated and became the Times
Square Visitors Center. The RKO Palace (left) is barely visible today
under a giant hotel and a mass of billboards. *2098.1993*

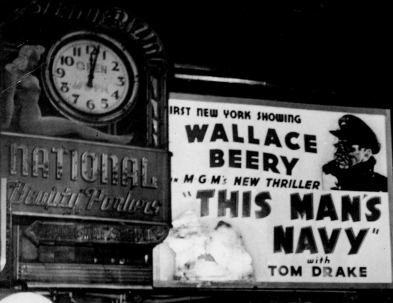

FIRST NEW YORK SHOWING
**WALLACE
BEERY**
in M·G·M's NEW THRILLER
**"THIS MAN'S
NAVY"**
with
TOM DRAKE

NATIONAL
Beauty Parlors

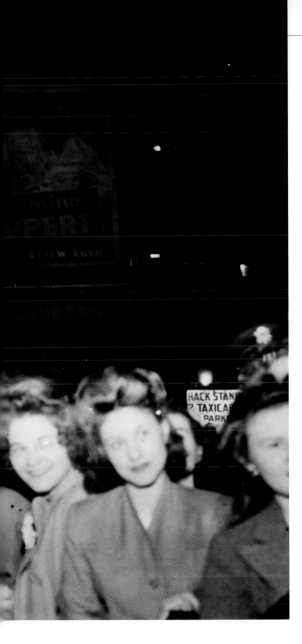

07 **TIMES SQUARE AT BROADWAY AND WEST 46TH STREET, FACING NORTH**
[This Man's Navy], 1945
Standing in front of the Orpheum Dance Palace and the Globe Theatre, the north end of Times Square in the background. *15637.1993*

Detail of 07 showing the National Beauty Parlors Clock and a fragment of the Orpheum Dance Palace sign.

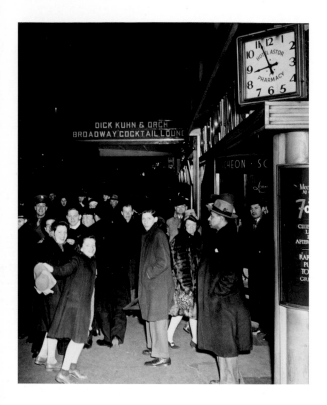

08 **TIMES SQUARE AT BROADWAY AND WEST 44TH STREET**
[Crowds respond to air raid drill],
March 2, 1943
The Hotel Astor Cocktail Lounge and pharmacy, at the southwest
corner of Broadway and West 45th. *15345.1993*

09 **TIMES SQUARE, LOOKING SOUTH FROM ABOVE WEST
45TH STREET**
[Target on Times Square], 1952
Looking south at the Times Building. The top of the Paramount
Building, the iconic Art Deco structure built in 1926, is visible on
the right; Loew's State Theatre is on the left. *5830.1993*

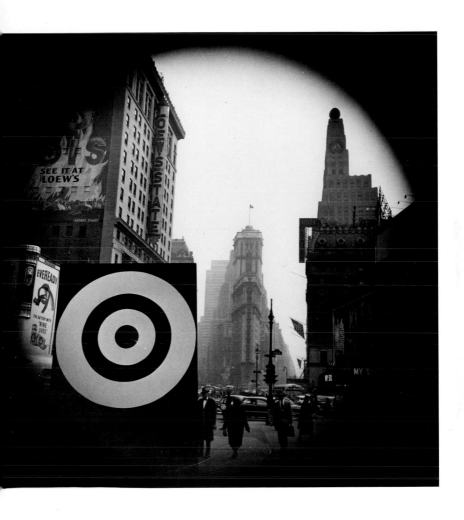

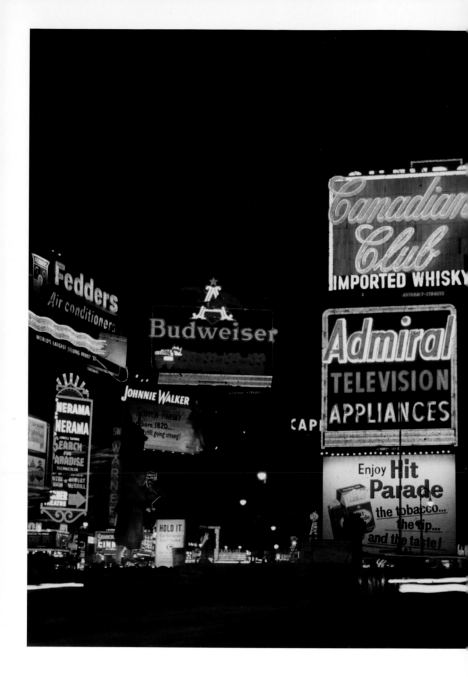

10 **TIMES SQUARE, LOOKING NORTHWEST FROM BROADWAY AND WEST 45TH STREET, NORTHEAST CORNER**

[Neon billboards on Times Square], September 1957
Standing under the marquee (upper right) of Loew's State Theatre at Broadway and West 45th Street. The Seventh Avenue side of the Rivoli Theatre (at West 49th Street) is visible in the right background. The marquee at the left advertises the Cinerama travelogue *Search for Paradise* (1957) playing at the Warner Theatre (formerly the Strand) at West 47th Street and Broadway (northwest corner).

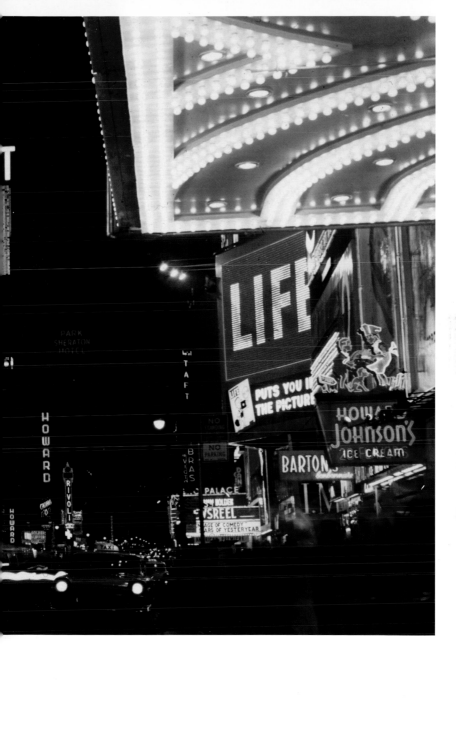

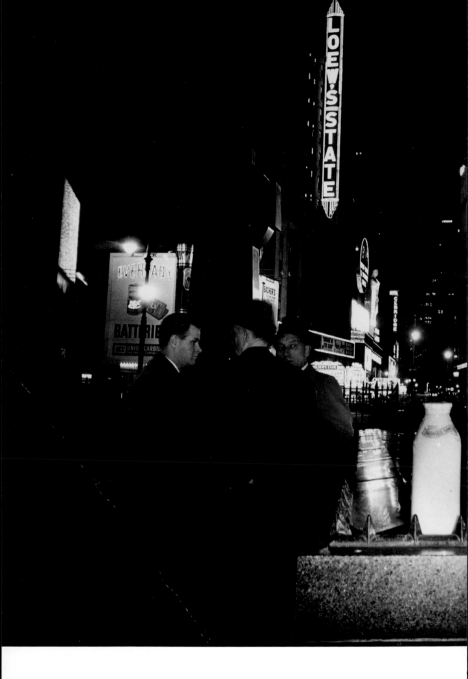

11 **TIMES SQUARE, LOOKING SOUTH FROM WEST 46TH STREET**
[Times Square],
1952
The Times Building is in the far background. The seven-story statue
above the Bond clothing store (1530 Broadway) is visible between
Loew's State and Hotel Claridge (see overleaf). *14712.1993*

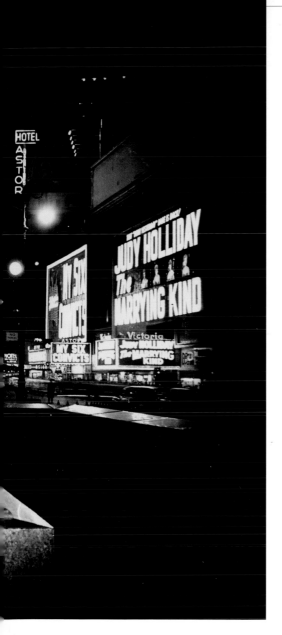

Detail of 11 showing one of the two statues above the Bond clothing store. Bond opened at the location in 1940, displacing the short-lived International Casino for which the streamline-moderne building had been constructed in the early 1930s. In the extravagant signage above the store, mounted in 1948, the statues bookended a 132-foot wide waterfall (with genuine recirculating water), backing the name Bond, and an enormous digital clock, all sitting atop a block-long zipper sign with scrolling messages.

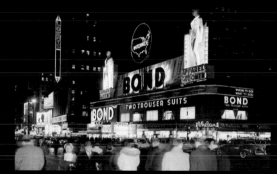

Unidentified Photographer, *Bond Clothing Spectacular, New York City*, 1954. *Douglas Leigh Papers, Archives of American Art, Smithsonian Institution*

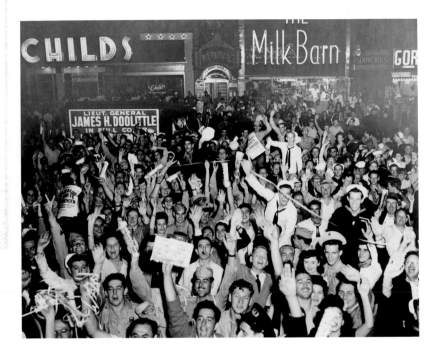

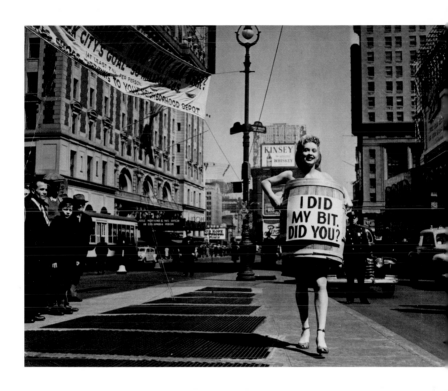

12 **TIMES SQUARE BETWEEN WEST 42ND AND 43RD STREETS, FACING WEST**

Tuesday Morning—Times Square, August 1945

Samuel and William Childs (sign in upper left) opened their flagship restaurant in 1889 at 41 Cortlandt Street in the Financial District. Over the next thirty years, the business expanded into a dining chain noted for progressive employee relations and impeccable architectural design. William Van Alen and McKim, Mead, and White were among the architects commissioned to design Childs restaurants. *15627.1993*

13 **TIMES SQUARE, LOOKING NORTH FROM WEST 44TH STREET**
[I Did My Bit. Did You?], 1944

14707.1993

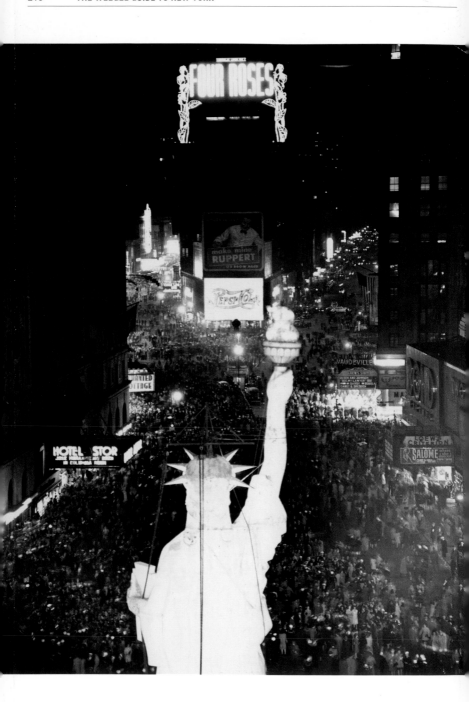

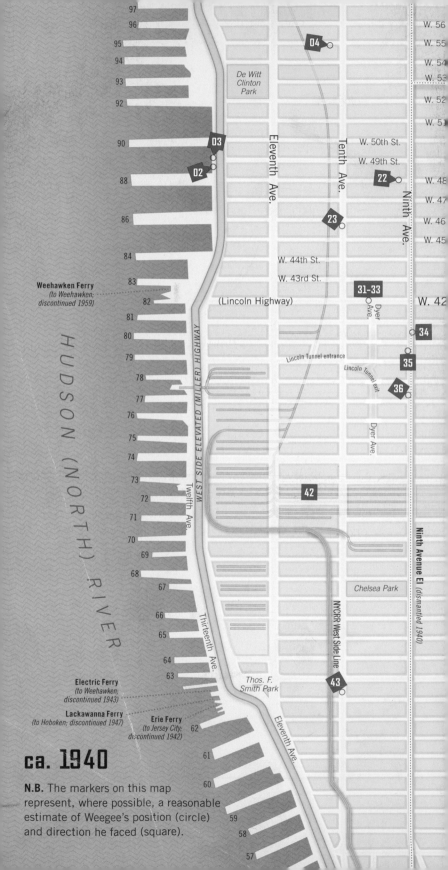

HUDSON (NORTH) RIVER

97
96
95
94
93
92
90
88
86
84
83
82
81
80
79
78
77
76
75
74
73
72
71
70
69
68
67
66
65
64
63
62
61
60
59
58
57

De Witt Clinton Park

Eleventh Ave.

Tenth Ave.

Ninth Ave.

W. 56
W. 55
W. 54
W. 53
W. 52
W. 51

W. 50th St.
W. 49th St.
W. 48
W. 47
W. 46
W. 45

W. 44th St.
W. 43rd St.
W. 42

(Lincoln Highway)

WEST SIDE ELEVATED (MILLER) HIGHWAY

Twelfth Ave.

Thirteenth Ave.

Eleventh Ave.

Dyer Ave.

Lincoln Tunnel entrance

Lincoln Tunnel exit

Dyer Ave.

Chelsea Park

NYCRR West Side Line

Ninth Avenue El (dismantled 1940)

Thos. F. Smith Park

04
03
02
22
23
31–33
34
35
36
42
43

Weehawken Ferry
(to Weehawken; discontinued 1959)

Electric Ferry
(to Weehawken; discontinued 1943)

Lackawanna Ferry
(to Hoboken; discontinued 1947)

Erie Ferry
(to Jersey City; discontinued 1942)

ca. 1940

N.B. The markers on this map represent, where possible, a reasonable estimate of Weegee's position (circle) and direction he faced (square).

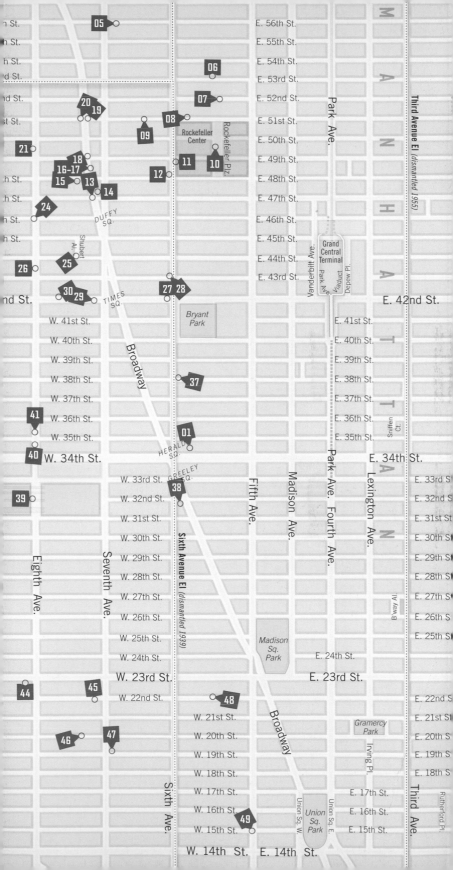

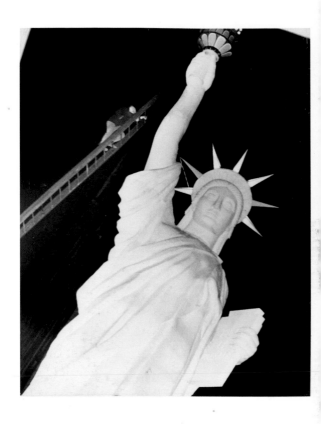

14 **TIMES SQUARE, LOOKING NORTH**
[Sixth War Loan Drive],
November 30, 1944

During the Sixth War Loan Drive held at Times Square, the plastic
Statue of Liberty erected for the event nearly lost its torch. In the
photo at right, a man climbs an 85-foot latter to secure it.
15440.1993, 15443.1993

06

MIDTOWN WEST

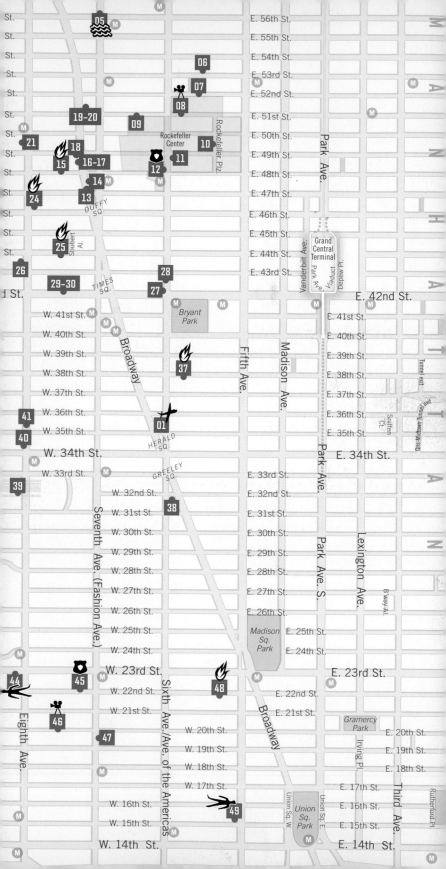

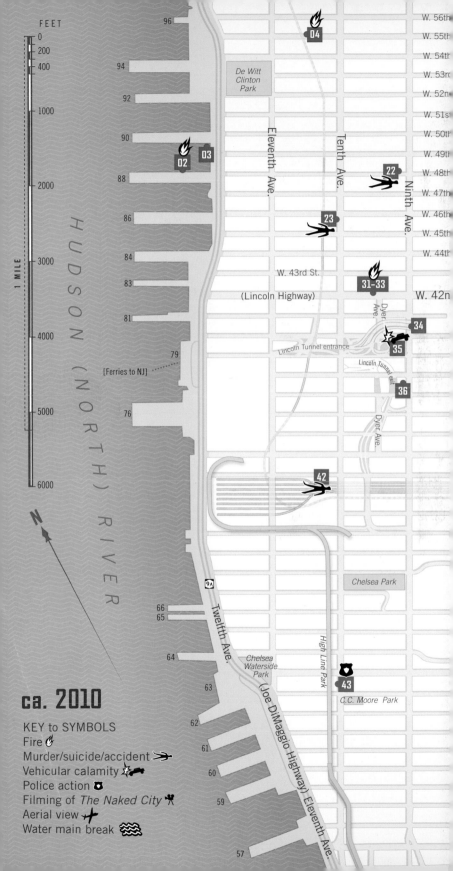

01 **MIDTOWN MANHATTAN FROM WEST 35TH TO 41ST STREETS**
[Aerial view of Midtown Manhattan after a snowstorm],
PM Daily, January 26, 1941

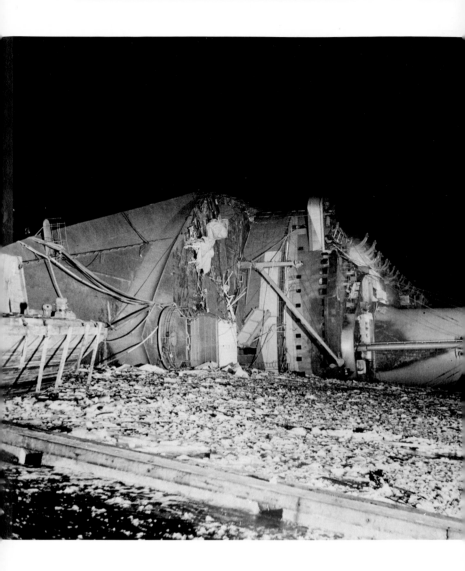

02 PIER 88, HUDSON RIVER AT THE FOOT OF WEST 48TH STREET

[The *Normandie* capsizes]

February 10, 1942

The SS *Normandie*, a French luxury liner, was seized by U.S. authorities in 1942. During conversion to a troopship, the *Normandie* caught fire and capsized in the Hudson River.

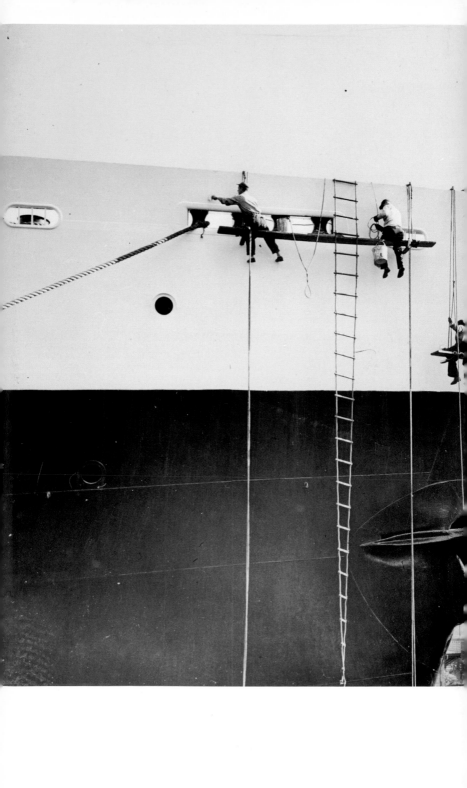

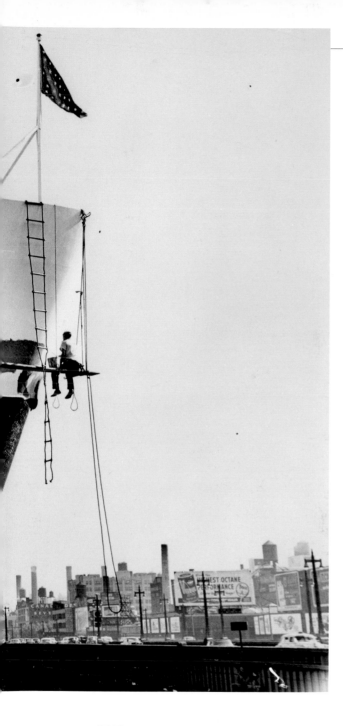

03 **WEST SIDE ELEVATED HIGHWAY**
[Maintenance men make repairs on a ship at Pier 90
on the Hudson River], ca. 1943
Looking north on the West Side Elevated Highway toward West
54th Street. *16427.1993*

04 WEST 55TH STREET BETWEEN TENTH AND ELEVENTH AVENUES, NORTH SIDE OF BLOCK

[Garage fire], April 4, 1942

Looking west along West 55th Street to Pier 95 on the Hudson River. The fire occurred at the West Side Garage (513–517 West 55th Street). Much of the neighborhood industry serviced Automobile Row on Eleventh Avenue, which stretched from West 43rd to 57th Street. Visible in the left background: (on the right) REO Service Station, at 625 West 55th near Twelfth Avenue; (on the left) Pier 95 buildings across the West Side Highway. In the right background: the stacks of the IRT Powerhouse at West 59th. *2370.1993*

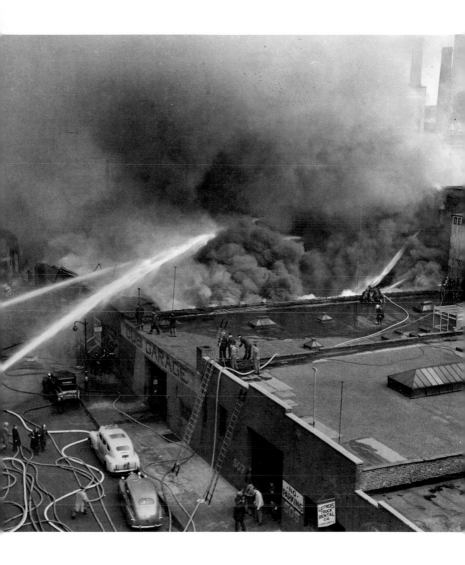

Detail of 04 showing the terminus of West 55th Street at the Hudson River.

05 **WEST 56TH STREET AND SEVENTH AVENUE**

[Geyser at the site of a water main break], May 9, 1940

Looking west on West 56th Street across Seventh Avenue. Weegee was standing next to Carnegie Hall (visible at the right edge of the photo). The ornate architectural detailing of the Broadway Tabernacle is seen at top right. The Park Central Hotel is on the left (880 Seventh Avenue).

15227.1993

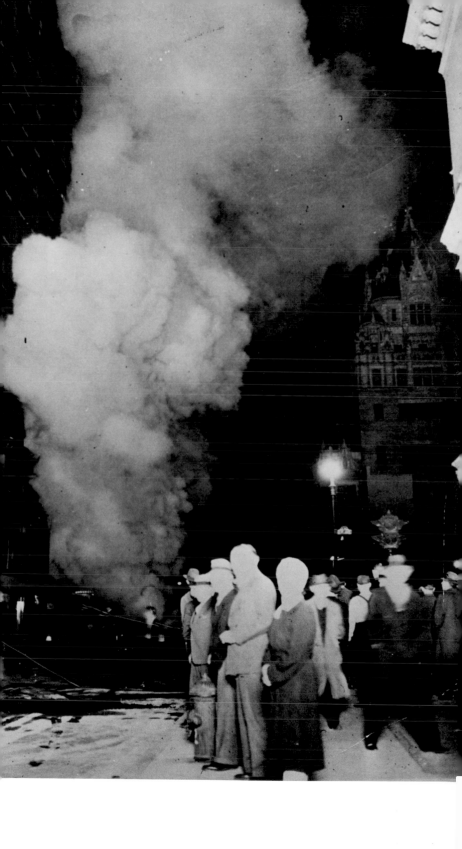

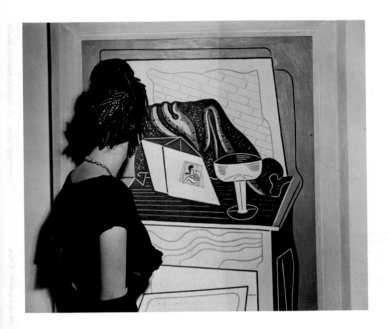

06 **THE MUSEUM OF MODERN ART, 11 WEST 53RD STREET**
[Woman looking at a Stuart Davis painting],
1945
Weegee covered the opening of MoMA's Stuart Davis retrospective
in 1945. The painting shown here is *Super Table* from 1925. *16686.1993*

07 **WEST 52ND STREET BETWEEN FIFTH AND SIXTH AVENUES**
[Wartime ban on pleasure driving empties nightclub
row], January 10, 1943
Jazz clubs along "Swing Street," looking west. On the north side:
"51" Club (No. 51), Jimmy Ryan's (No. 53), Onyx (No. 57), Cy Walter's
Night Cap. On the south side: Club Samoa (No. 62), The Famous
Door (No. 66). *15312.1993*

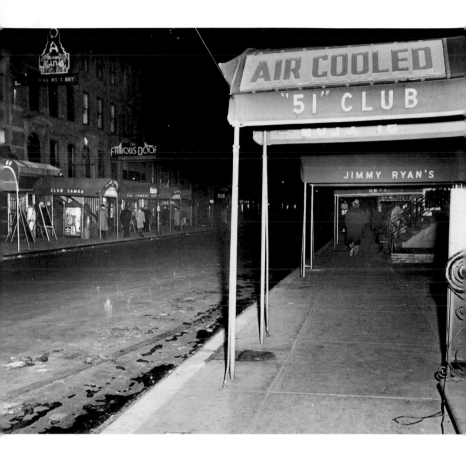

08 **WEST 51ST STREET AND SIXTH AVENUE**
[Filming *The Naked City*],
1947

Looking west along West 51st Street toward Sixth Avenue. The
Radio City Music Hall marquee is to the left. Alexander's Café sits
at 1279 Sixth Avenue at the southwest corner of West 51st. *7565.1993*

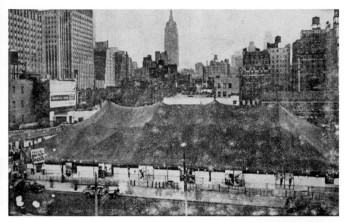

09 **WEST 51ST STREET BETWEEN SIXTH AND SEVENTH AVENUES, SOUTH SIDE OF BLOCK**
[Big Top Circus], *PM Daily,*
June 28, 1943
[At the circus], ca. 1943
2135.1993

Looking south from West 51st Street, the Empire State Building in the distance. Larry Sunbrock's Big Top Circus opened in Manhattan on June 3, 1943; the tent was pitched in an abandoned lot behind the Roxy Theatre (located to the right, outside the picture frame).

10 30 ROCKEFELLER PLAZA BETWEEN WEST 49TH AND 50TH STREETS

[Scene inside 30 Rockefeller Plaza during an elevator operator strike], September 23, 1943

14766.1993

[Outside 30 Rockefeller Plaza], September 23, 1943

14764.1993

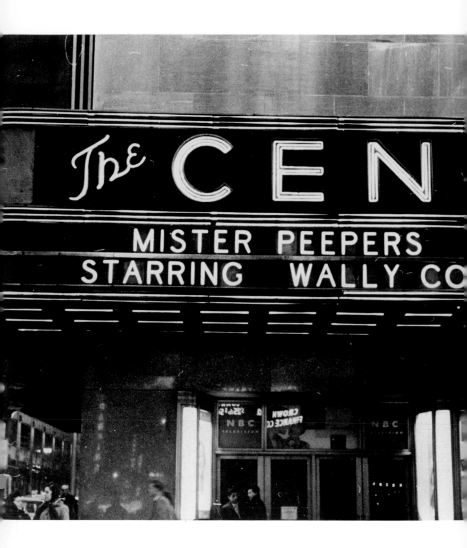

11 1230 SIXTH AVENUE AT WEST 49TH STREET, SOUTHEAST CORNER

[Mister Peepers], 1953

Built in 1932, the elegant Art Deco–styled Center Theatre was part of Rockefeller Center and the only building in the complex to be demolished. The theater originally operated as a venue for films (under the short-lived name RKO Roxy), but switched to live shows and ice spectaculars in the 1940s. NBC leased the theater in 1950 as a television studio for productions such as *Mister Peepers* and *Your Show of Shows*. The building was torn down in 1954 and replaced by a nineteen-story office tower. *14769.1993*

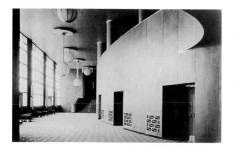

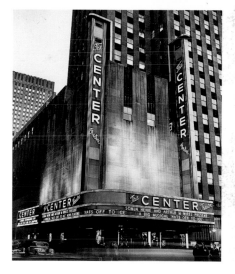

Unidentified Photographer, *Foyer of the Center Theatre,* ca. 1935
Unidentified Photographer, *The Center Theatre,* 1946

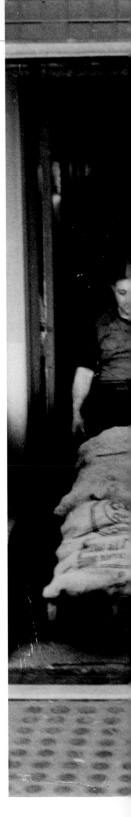

12 **1221 SIXTH AVENUE AT WEST 48TH STREET, NORTHWEST CORNER**
[17,000 pounds of black market potatoes seized from barbershop],
May 18, 1943
13985.1993

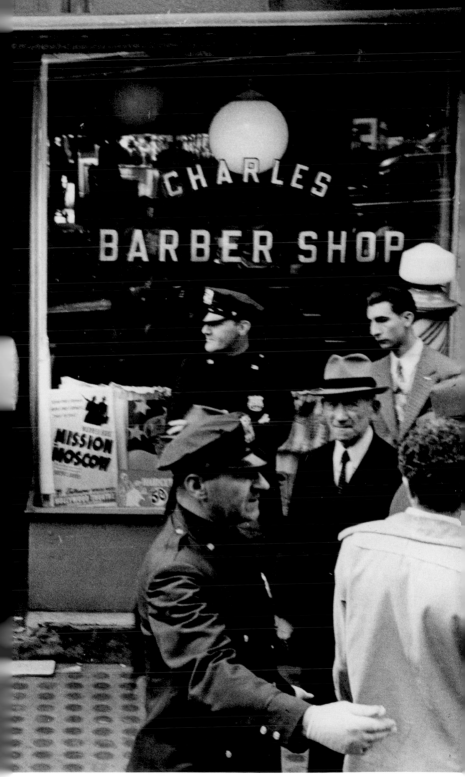

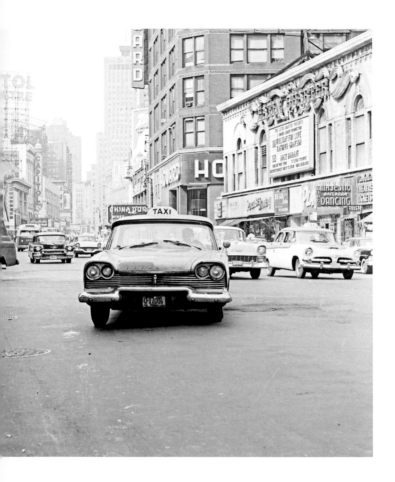

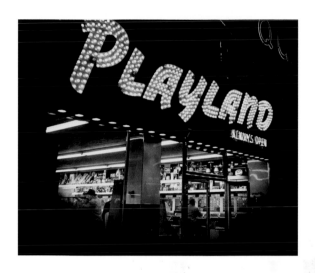

13 BROADWAY, LOOKING NORTH FROM WEST 47TH STREET
[Traffic on Broadway],
1958

In its long history, 1580 Broadway, the wedge-shaped building on the right, was home to a number of nightclubs, including the Palais Royale, Moulin Rouge (with interiors designed by Norman Bel Geddes), and the Cotton Club; its southern side functions as the northern terminus of Times Square. Here, its tenants are the Latin Quarter nightclub, Playland (see 14), and Majestic Danceland. The Latin Quarter, opened in 1942, featured headline acts such as Frank Sinatra and Milton Berle. Majestic Danceland was one of many venues on Seventh Avenue and Broadway that offered the services of "taxi-dancers," or dime-a-dance girls, celebrated in the hit song by Rodgers and Hart (by the late 1950s, when this photo was taken, the actual cost of a dance had risen considerably). In 1964, New York City License Commissioner Bernard J. O'Connell launched a campaign to put the dance halls out of business, charging that the girls were "lewd" and "offensive to public decency." Among the venues whose licenses were revoked were the Majestic and the New Gardens Ballroom (see 04.13). The Capitol Theatre (left background), opened in 1919 at 1645 Broadway and West 51st Street, was one of the first movie palaces in the city, with a seating capacity of 4,000. It was demolished in 1968.

14 1580 BROADWAY BETWEEN WEST 47TH AND 48TH STREETS, EAST SIDE OF BLOCK
[Playland, Always Open], 1953–54
17927.1993

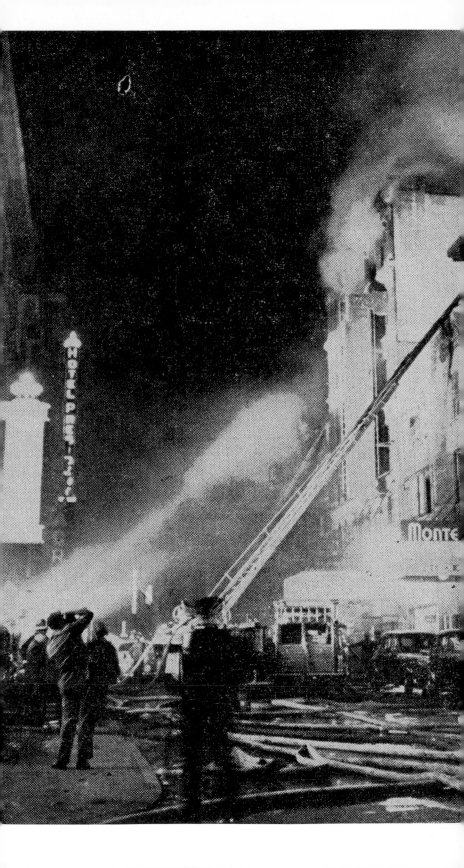

15 **WEST 48TH STREET BETWEEN BROADWAY AND EIGHTH AVENUE**
[Fire in Tin Pan Alley], *PM Daily,*
July 11, 1940
West 48th Street looking west toward Eighth
Avenue. The fire is in the Selva Theatrical Shoe
and Costume Company (No. 209), on the north
side of the block. Hotel President (No. 234) is
on the south side.

16 **1595 BROADWAY BETWEEN WEST 48TH AND 49TH STREETS, WEST SIDE OF BLOCK**
[Men in windows at end-of-war celebrations], 1945
15622.1993

17 **1599–1603 BROADWAY BETWEEN WEST 48TH AND 49TH STREETS, WEST SIDE OF BLOCK**
[Franklin Delano Roosevelt on an open-car tour of New York City], October 28, 1944
15444.1993

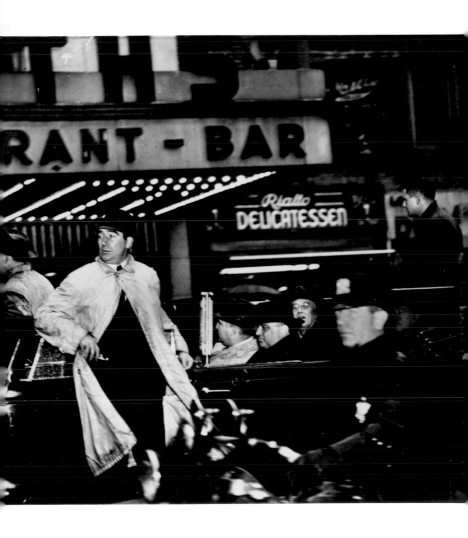

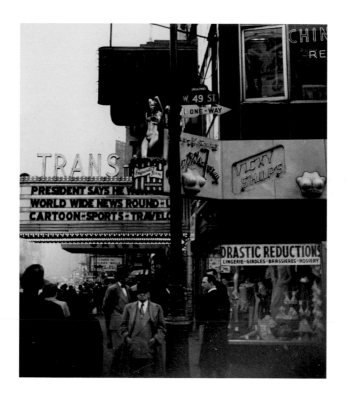

18 **BROADWAY AND WEST 49TH STREET, SOUTHWEST CORNER**
[Exquisite Form],
1952

Looking south on Broadway from West 49th Street. The marquee
behind the Trans-Lux theater advertises the Sadler's Wells Ballet
Company, which opened its first New York City engagement in
March 1952 at the Warner Theatre, 1579 Broadway at West 47th
Street. *14714.1993, 14725.1993*

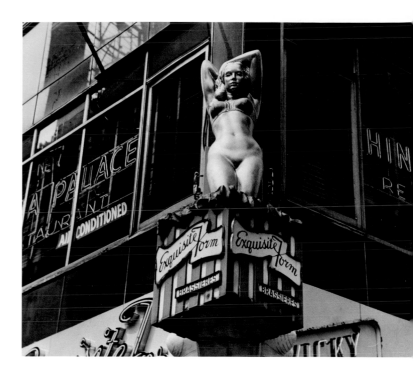

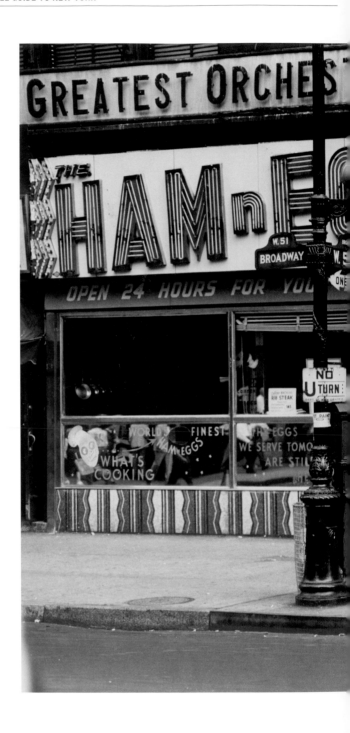

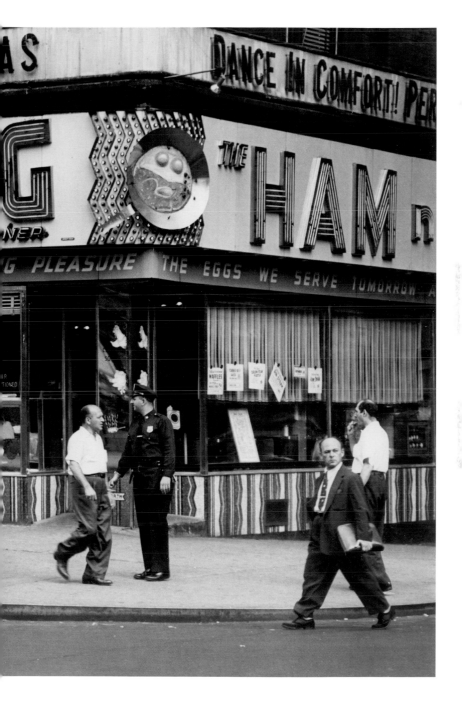

19 1652 BROADWAY AT WEST 51ST STREET, NORTHEAST CORNER
[The Ham n Egg], 1953–54
2179.1993

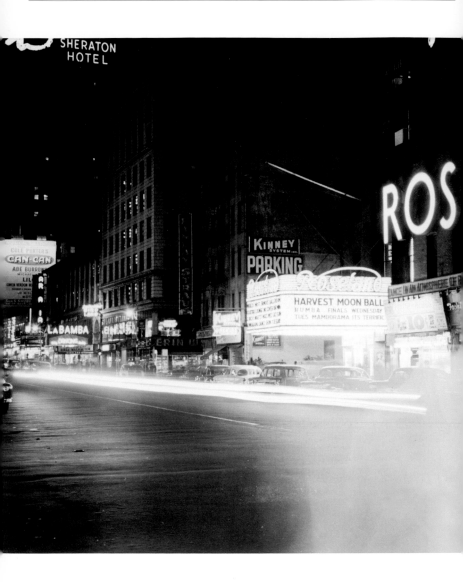

20

1658 BROADWAY AT WEST 51ST STREET, NORTHEAST CORNER
[The Roseland Ballroom],
1953–54

Roseland's original home also housed the Ham n Egg (at right; see 18). The Roseland marquee promotes New York's Harvest Moon Ball, an annual dance competition that officially began in 1935 and continued until the early 1980s. Ed Sullivan emceed many of the earlier competitions.

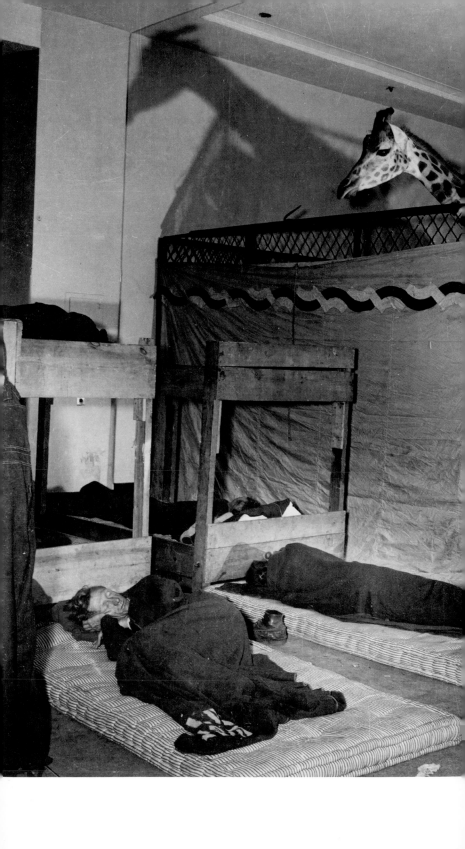

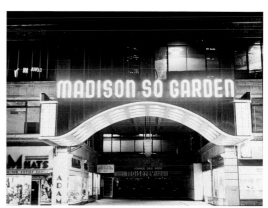

Unidentified Photographer, *Madison Square Garden*, 1958

21 **EIGHTH AVENUE BETWEEN WEST 49TH AND 50TH STREETS, WEST SIDE OF BLOCK**
Caretakers, Madison Square Garden, 1944

Interior of Madison Square Garden. The third incarnation of the Garden, a frequent circus venue, was located at Eighth Avenue between West 49th and 50th Streets from 1925 to 1968.

2140.1993

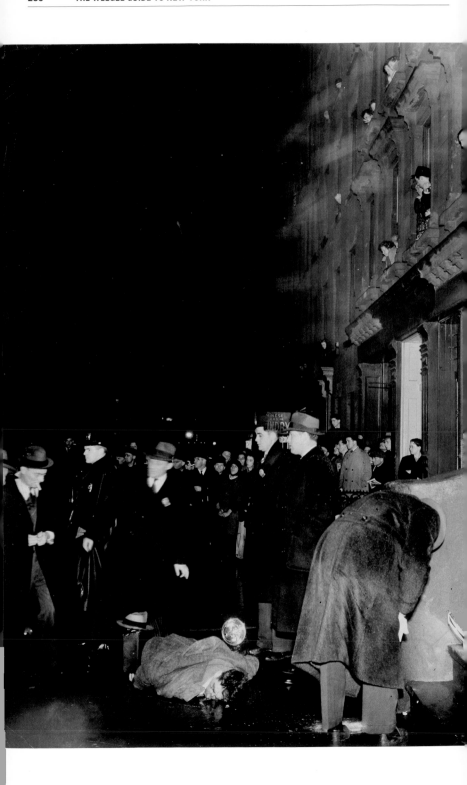

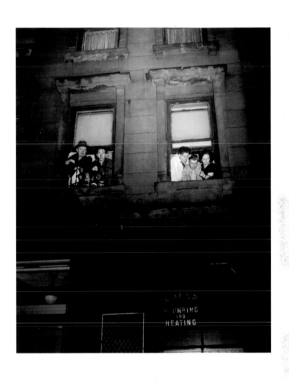

22 **415 WEST 48TH STREET BETWEEN NINTH AND TENTH AVENUES, NORTH SIDE OF BLOCK**
[Police and spectators surround the body of murdered longshoreman Emil Nizich], February 7, 1941
Galerie Berinson, Berlin
[Residents observe police investigating the murder of longshoreman Emil Nizich], February 7, 1941

23 651 TENTH AVENUE AT WEST 46TH STREET,
SOUTHWEST CORNER
On the Spot, December 9, 1939
141.1982

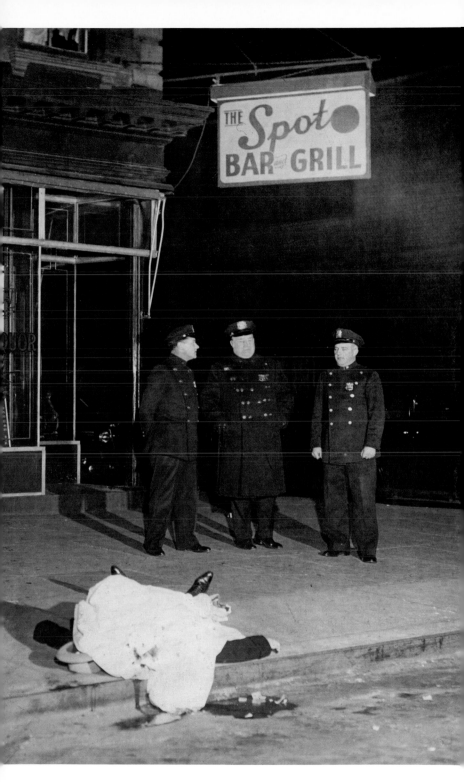

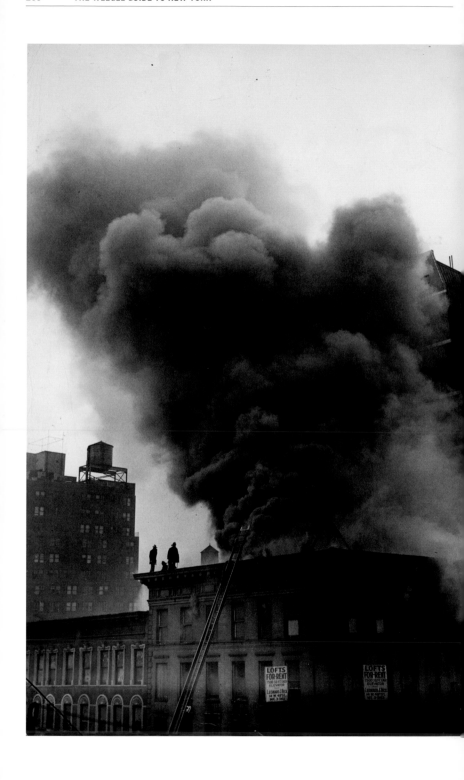

24 247 WEST 46TH STREET AT EIGHTH AVENUE, NORTHEAST CORNER

[Fire in a loft building], ca. 1947
The west side of the Paramount Hotel overlooks the burning building at 247 West 46th Street, formerly the property of Baumann furniture company. Weegee photographed from a roof on the southwest corner of West 46th Street and Eighth Avenue. *14984.1993*

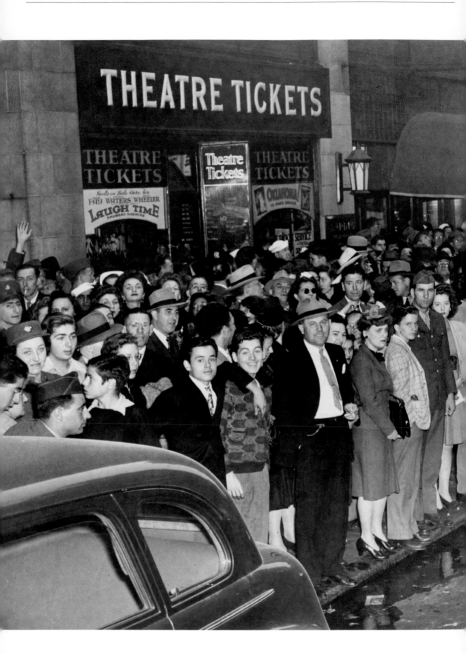

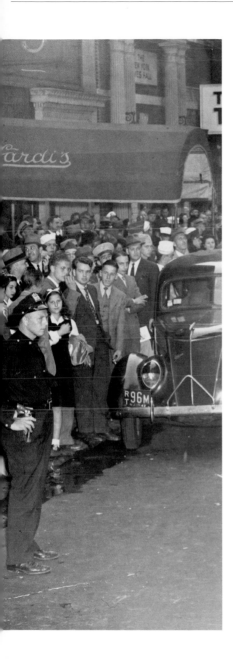

25 **234 WEST 44TH STREET BETWEEN SEVENTH AND EIGHTH AVENUES, SOUTH SIDE OF BLOCK**
[Theatergoers wait out a fire in front of Sardi's Restaurant], September 19, 1943
15202.1993

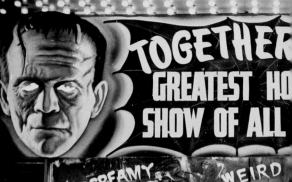
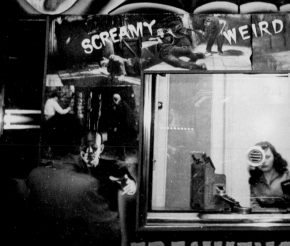

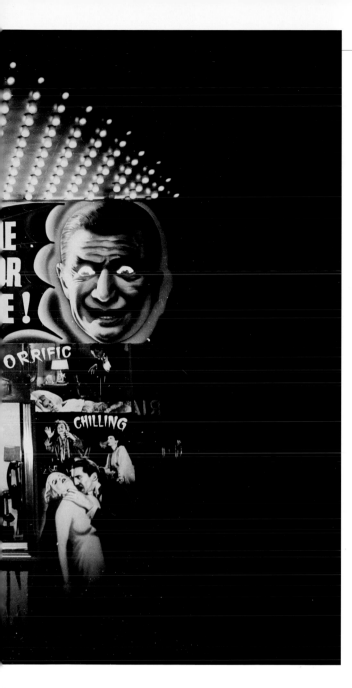

26 693 EIGHTH AVENUE BETWEEN WEST 43RD AND 44TH STREETS, WEST SIDE OF BLOCK

[TOGETHER The Greatest Horror Show of All Time!], January 1944

The Squire Theatre programmed this revival of Boris Karloff's *Frankenstein* and Bela Lugosi's *Dracula* (both made in 1931). Originally the Ideal Theatre, opened in 1916, the Squire ended its days as the Playpen, which screened porn flicks, before it was demolished in December 2007.

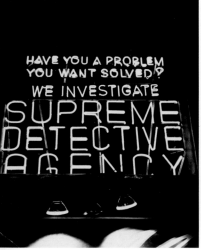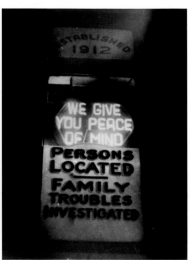

27 **101 WEST 42ND STREET AT SIXTH AVENUE,
NORTHWEST CORNER**
[Supreme Detective Agency], ca. 1943
17911.1993
LOCATION UNKNOWN
[We Give You Peace of Mind], ca. 1943
17905.1993

28 **SIXTH AVENUE BETWEEN WEST 42ND AND 43RD STREETS**
Empire State Bldg.,
ca. 1943
Looking south on Sixth Avenue from the southwest corner of West
43rd Street. The Bryant Park Building is on the left, the Empire
State Building in the background. *16586.1993*

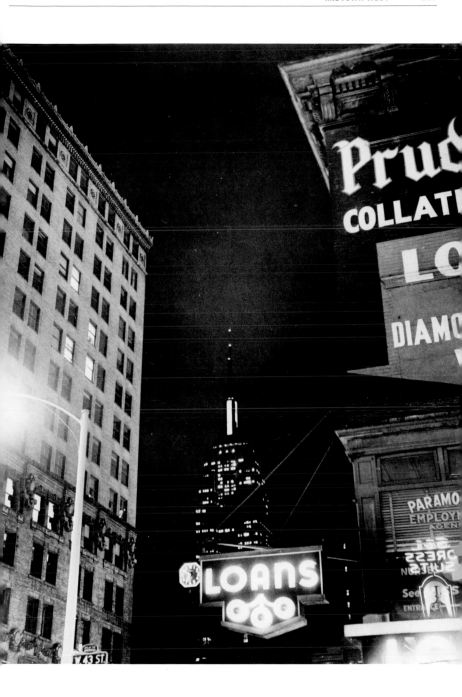

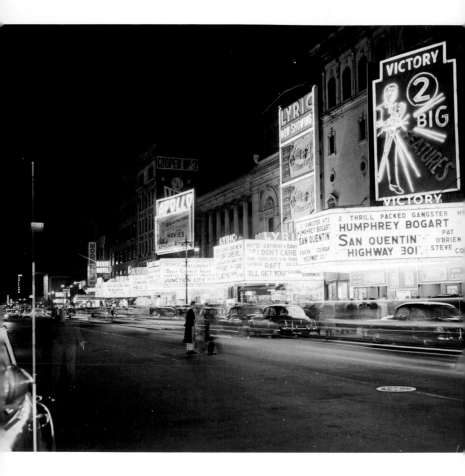

29 **WEST 42ND STREET BETWEEN SEVENTH AND EIGHTH AVENUES, NORTH SIDE OF BLOCK**

Showing Tonite, 1953

Looking west along 42nd at the movie marquees lining the street (right to left): the Victory (No. 209), Lyric (No. 213), the Apollo (No. 223), and the Selwyn (no. 227). The Apollo and Lyric buildings were razed in 1996, but elements of their facades and interiors were retained in the new structure built on the site. The Selwyn was renovated in 1997 and renamed the American Airlines Theatre. The Victory building, restored in the 1990s, began life in 1900 as the Republic, the first theater built on 42nd Street. In 1942, after a stint in burlesque, the building became a movie house and was renamed the Victory.

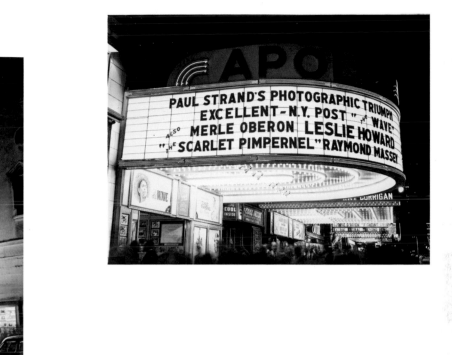

30 223 WEST 42ND STREET BETWEEN SEVENTH AND EIGHTH AVENUES, NORTH SIDE OF BLOCK

[Apollo Theatre marquee], August 1941

Paul Strand's *Redes* (1936), about a fishing village in Mexico, was released in the U.S. as *The Wave* in 1937. The Apollo Theatre, opened in 1920, featured a neoclassical facade (see 29) and a spectacular auditorium dome. The building was demolished in 1996, but many of the Apollo's original architectural features were rescued and incorporated into the new structure on the site (now the Foxwoods Theatre).

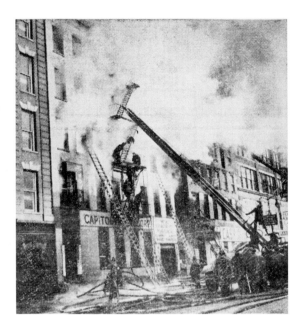

31 439 WEST 42ND STREET BETWEEN NINTH AND TENTH
AVENUES, NORTH SIDE OF BLOCK
[Deadly fire at the Standard Hotel],
PM Daily, December 26, 1943

The building housed the Capitol Bronze Corp. (see also 07.14) on
the ground floor and the Standard Hotel, a rooming house for
night workers and transients, on the upper floors. The fire, which
killed at least seventeen people, broke out on the afternoon of
Christmas Eve 1943 and consumed the interior of the building.

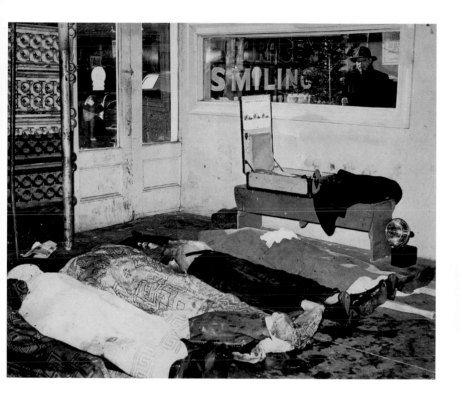

32 433 WEST 42ND STREET BETWEEN NINTH AND TENTH AVENUES, NORTH SIDE OF BLOCK

[Standard Hotel fire casualties on the floor of the Smiling Irishman], December 24, 1943

The Smiling Irishman, a used car dealership in Manhattan, served as a temporary morgue for victims of the Standard Hotel fire (31). Weegee later returned to the scene and documented renovations to the storefront (33). *Galerie Berinson, Berlin*

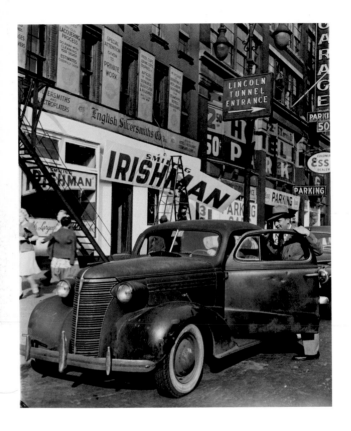

33 **433 WEST 42ND STREET BETWEEN NINTH AND TENTH
AVENUES, NORTH SIDE OF BLOCK**
[Smiling Irishman], 1944
17819.1993, 17820.1993

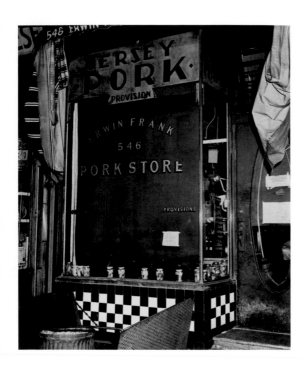

34 **546 NINTH AVENUE BETWEEN WEST 40TH AND 41ST STREETS, EAST SIDE OF BLOCK**
[Jersey Pork, Erwin Frank Pork Store], ca. 1943
15566.1993

35 **527 NINTH AVENUE NEAR WEST 39TH STREET, WEST SIDE OF BLOCK**
[Greyhound bus crashes into the Central Fish Market], November 9, 1942
14161.1993

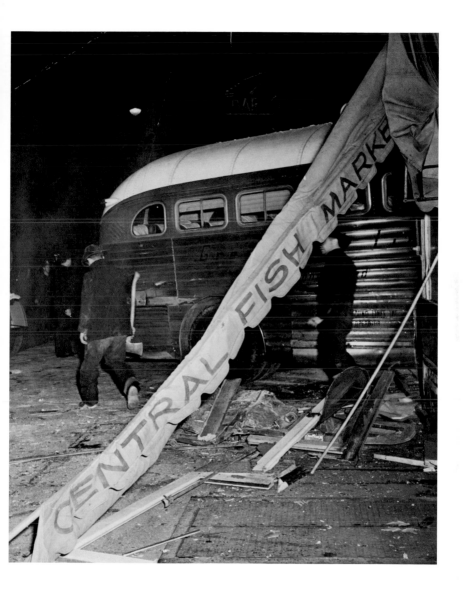

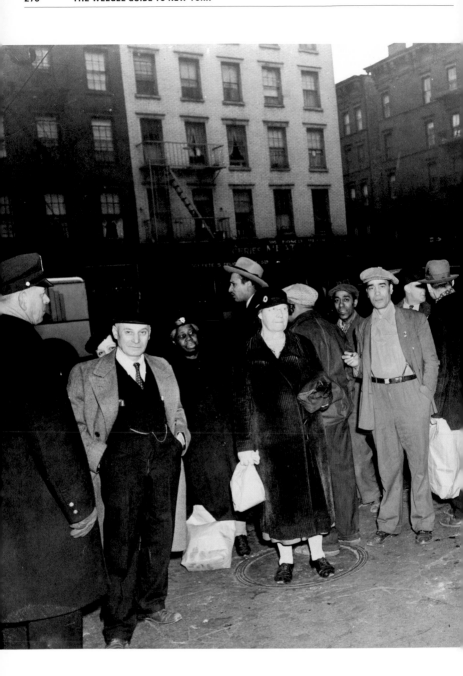

36 **NINTH AVENUE BETWEEN WEST 37TH AND 38TH STREETS,
FACING NORTHWEST**
[Wartime rationing: buyers line up outside a pork store],
ca. 1943
15552.1993

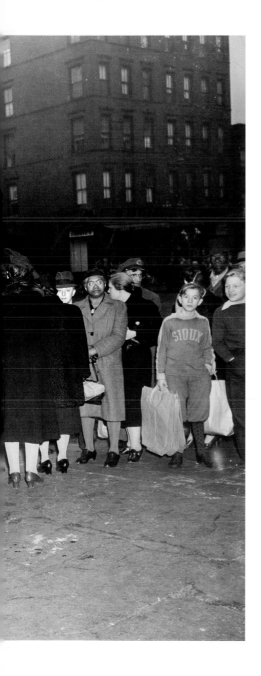

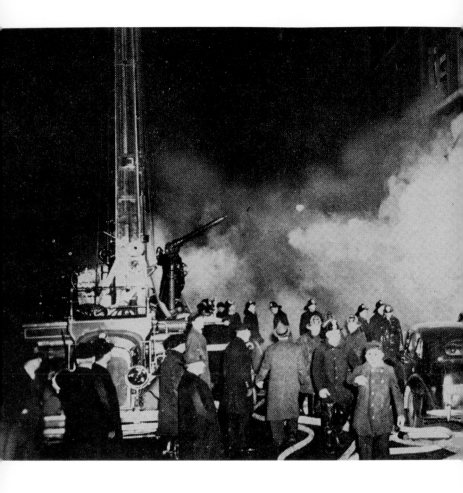

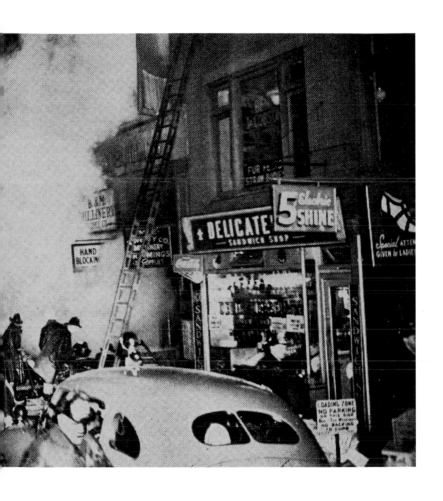

37 70 WEST 38TH STREET BETWEEN FIFTH AND SIXTH AVENUES, SOUTH SIDE OF BLOCK
[Fire in the Garment District], *PM Daily,* January 24, 1941

38 HERALD SQUARE, LOOKING NORTH FROM GREELEY SQUARE AND WEST 32ND STREET

[Flagpole painter at Greeley Square], ca. 1940
On the west side: Gimbel's (Sixth Avenue and West 33rd), Saks department store (Sixth Avenue and West 34th). On the east side: Hotel Martinique (Broadway and West 33rd), Hotel McAlpin (Broadway and West 34th), Herald Square Building (1332 Broadway). In the far background: the Times and Paramount buildings at Times Square. *14746.1993*

39
EIGHTH AVENUE BETWEEN WEST 31ST AND
33RD STREETS, WEST SIDE OF BLOCK
[Installation of Franklin Delano Roosevelt bust
at main branch of the U.S. Post Office],
January 18, 1943
14749.1993

40
EIGHTH AVENUE AND WEST 34TH STREET,
NORTHWEST CORNER
[New Yorker Hotel], ca. 1943
14740.1993

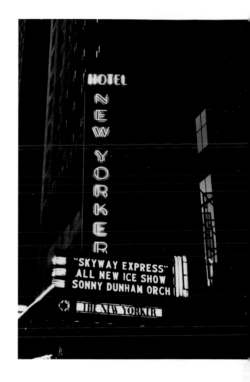

41 EIGHTH AVENUE BETWEEN WEST 35TH AND 36TH STREETS
[Celebration in the Garment District on Japanese offer to surrender], August 10, 1945

Looking north up Eighth Avenue. The building in the right foreground is Ludwig Baumann's furniture store at 500 Eighth Avenue. *15617.1993*

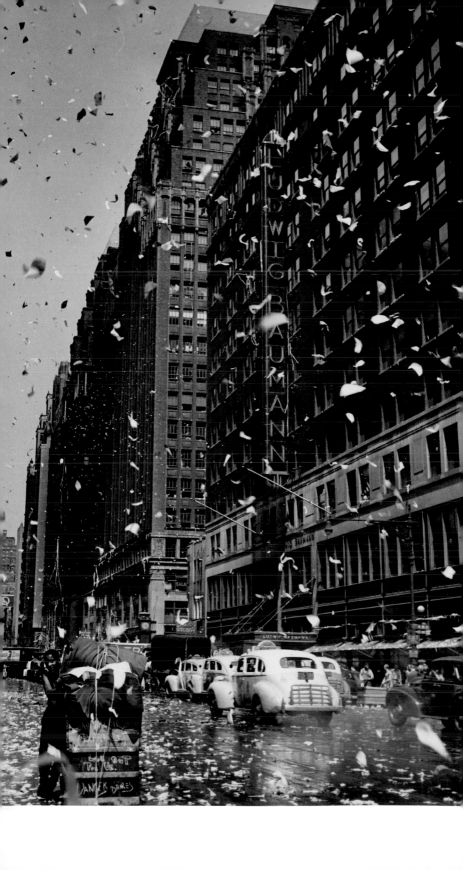

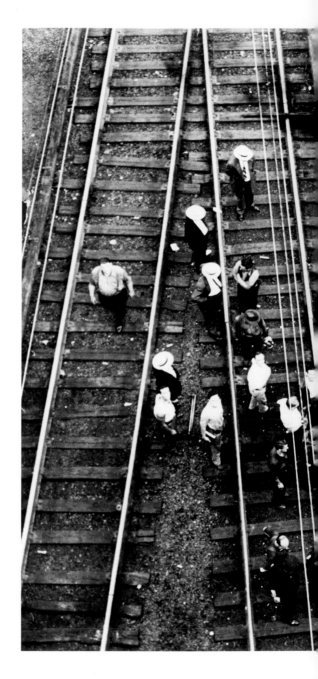

42 **WEST SIDE YARD BETWEEN NINTH AND ELEVENTH AVENUES,
WEST 31ST TO 33RD STREETS**
[Man electrocuted in the West Side Yard (aka Penn Yard)],
ca. 1938
2407.1993

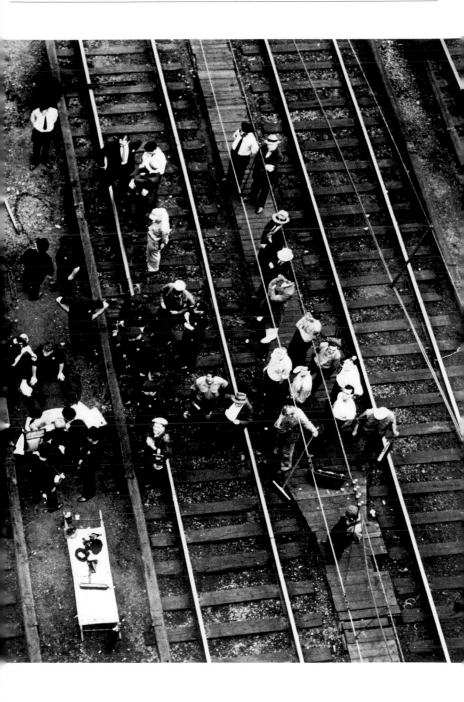

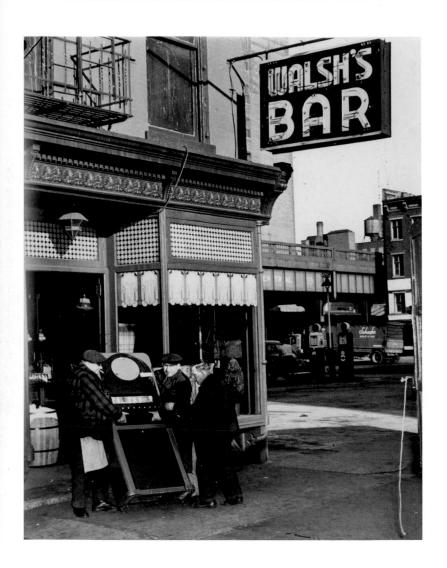

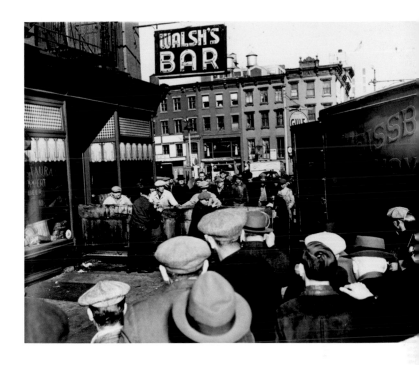

43 **213 TENTH AVENUE BETWEEN WEST 22ND AND 23RD STREETS, WEST SIDE OF BLOCK**
[Tavern dismantled after bootleg liquor raid],
November 24, 1943
Looking northwest on Tenth Avenue. The West Side Line is visible
in the left photo (center right). The freight line cut through
warehouses in the blocks between Ninth and Eleventh Avenues.
13993.1993, 13992.1993

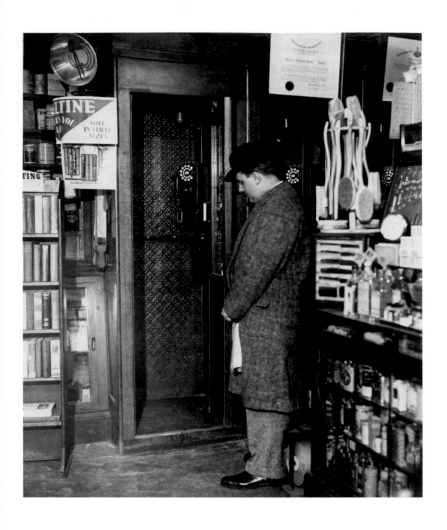

44 **314 WEST 23RD STREET BETWEEN EIGHTH AND NINTH AVENUES, SOUTH SIDE OF BLOCK**
Where Coll was bumped off in phone booth, ca. 1936
Interior of the London Chemists drugstore, where, in 1932, mob assassin Vincent "Mad Dog" Coll was gunned down in a phone booth. *14084.1993*

45 **211 WEST 22ND STREET BETWEEN SEVENTH AND EIGHTH AVENUES, NORTH SIDE OF BLOCK**
[Thwarted suicide attempt], *PM Daily,* September 3, 1940

46 **WEST 20TH STREET BETWEEN SEVENTH AND EIGHTH AVENUES, SOUTH SIDE OF BLOCK**
[Filming *The Naked City*], 1947
Looking west along West 20th Street. The building at left is the 10th Precinct of the New York Police Department (No. 230). *7558.1993*

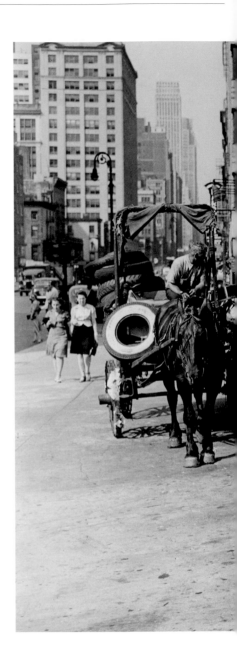

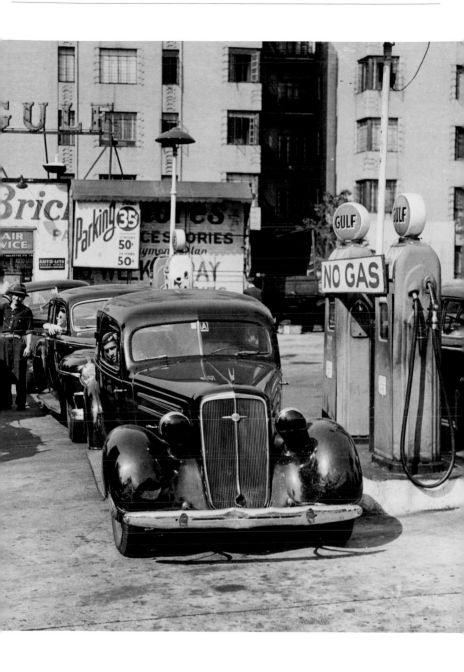

47 **161 SEVENTH AVENUE BETWEEN WEST 19TH AND 20TH STREETS, EAST SIDE OF BLOCK**

Traffic Jam, July 22, 1942

15290.1993

48 28 WEST 22ND STREET
BETWEEN FIFTH AND SIXTH AVENUES,
SOUTH SIDE OF BLOCK
[Fire in a loft building], 1948
Looking east on West 22nd Street toward Fifth
Avenue. *14986.1993*

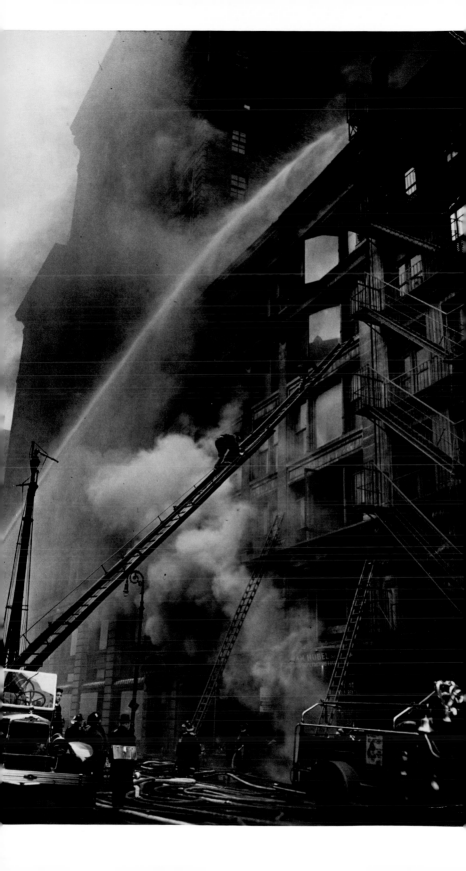

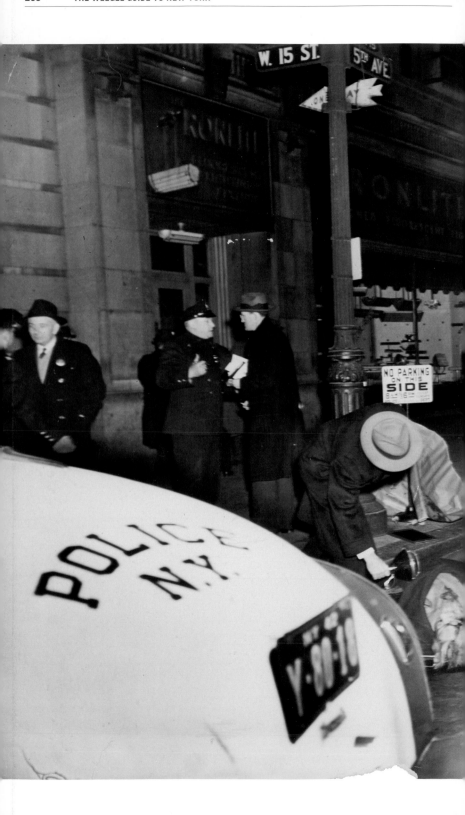

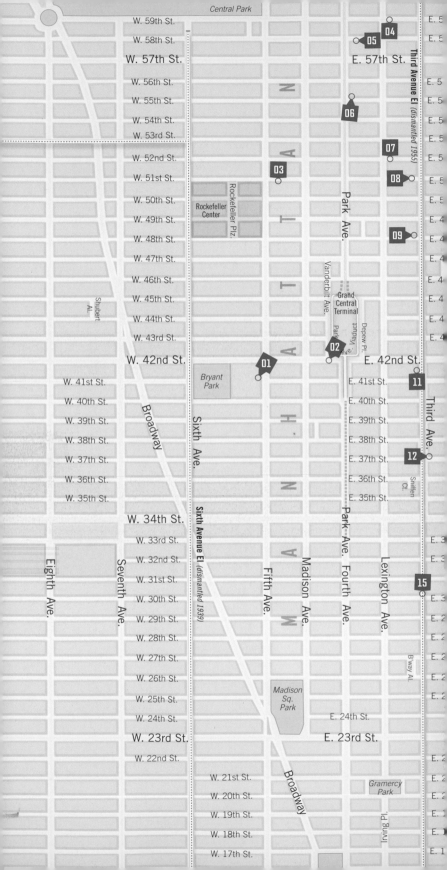

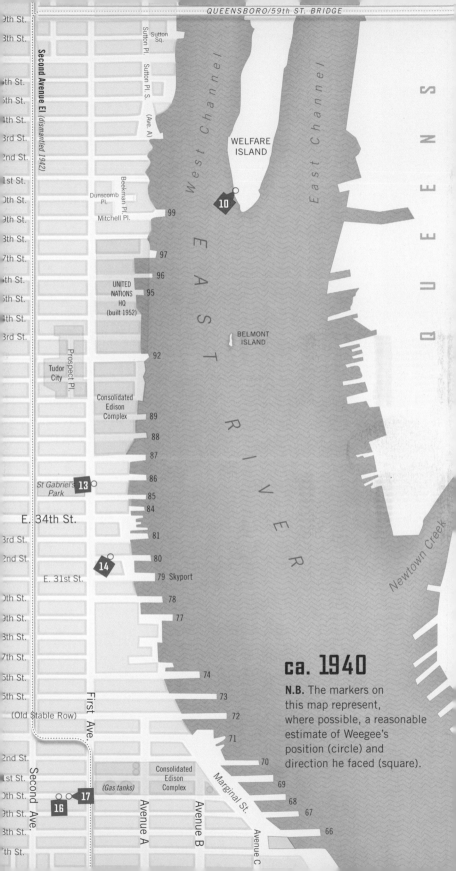

49 **FIFTH AVENUE AND WEST 15TH STREET, NORTHWEST CORNER**
[Carlo Tresca assassination],
January 11, 1943
Carlo Tresca was gunned down on Fifth Avenue
after dodging a police tail. Under surveillance
for his radical activities—as a socialist, anarchist,
and labor organizer—Tresca was likely killed by
mafiosi in retaliation for his vocal campaign,
conducted in the pages of his newspaper
Il Martello, against the Mafia and their ties to
Mussolini. *The Friedsam Collection*

07 MIDTOWN EAST

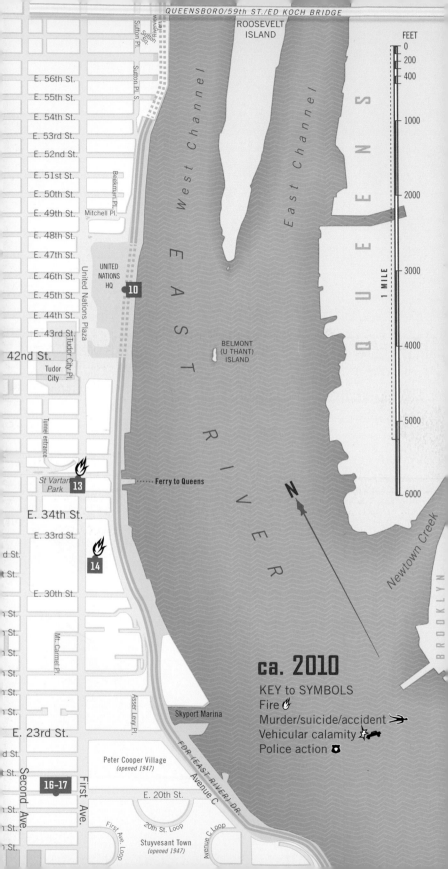

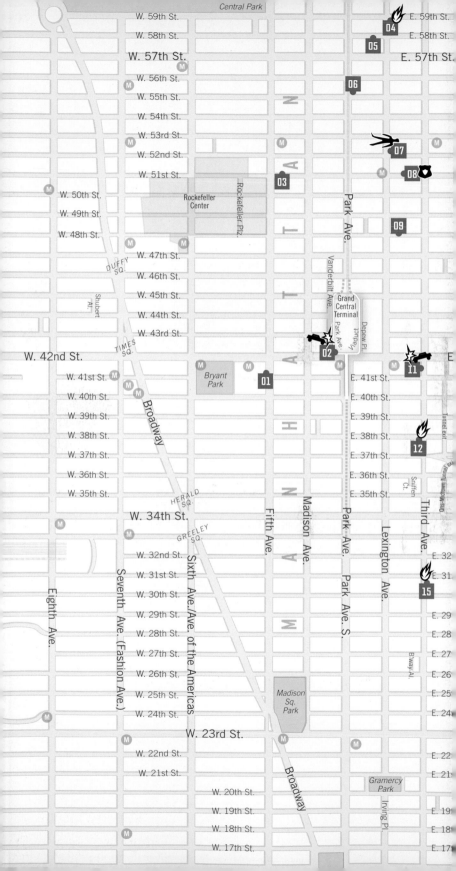

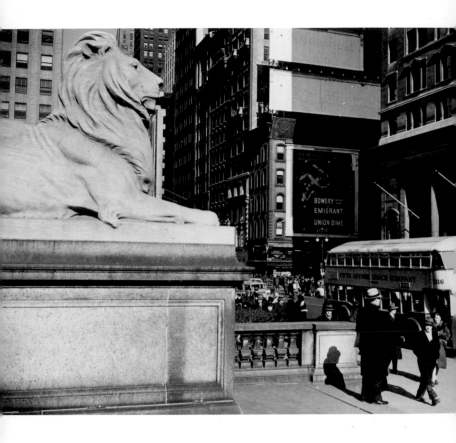

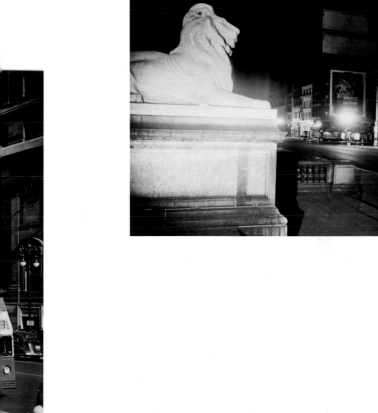

01 **FIFTH AVENUE AND 42ND STREET**
[New York Public Library lion, day and night],
ca. 1942

Photographed from the steps of the main branch of the New York
Public Library, looking north along Fifth Avenue at the intersection
with 42nd Street. At right: Bankers Trust Co., 501 Fifth Avenue. At
the northeast corner of the intersection: Seymour Building (No.
503). The Fifth Avenue Coach Company's double-decker bus fleets
were demobilized in 1953. *14743.1993, 14744.1993*

02 **VANDERBILT AVENUE AND EAST 42ND
STREET, NORTHEAST CORNER**
[Accident on upper roadway of Grand
Central Terminal], 1944
112.1982

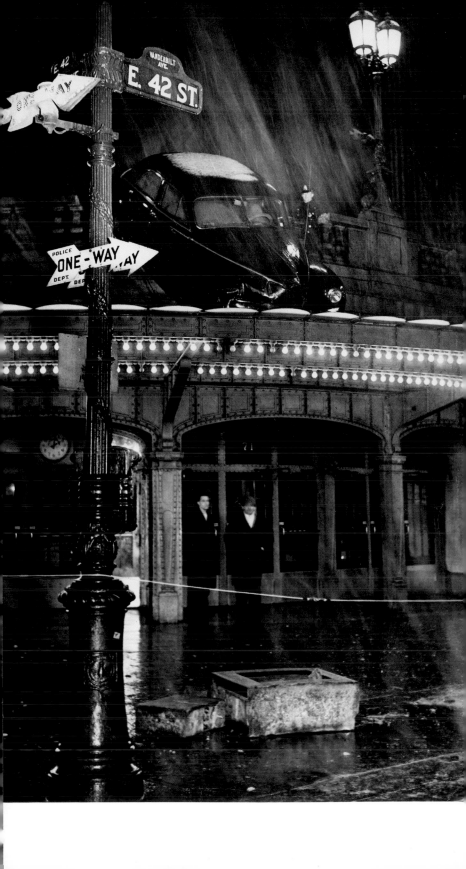

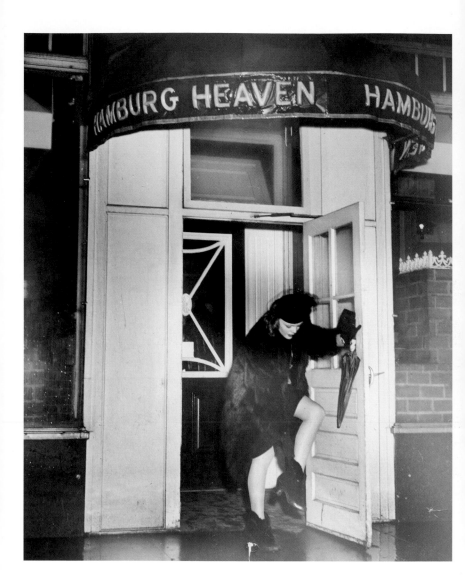

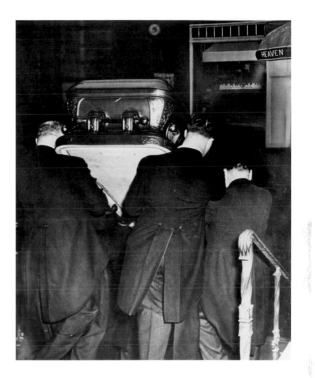

03 **5 EAST 51ST STREET NEAR FIFTH AVENUE,
NORTH SIDE OF BLOCK**

[Hamburg Heaven], ca. 1945

16233.1993

The best people go to heaven, ca. 1945

16245.1993

In the right photo, pallbearers carry a coffin down the steps of
Saint Patrick's Cathedral (side entrance) toward the Hamburg
Heaven restaurant (upper right corner).

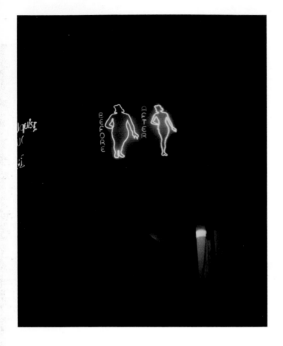

04 **741 LEXINGTON AVENUE AT EAST 59TH STREET, SOUTHEAST CORNER**
[Neon sign above the Steinbrook Pharmacy],
September 1, 1941
15046.1993
[Fire in the Steinbrook Pharmacy],
September 1, 1941
15047.1993

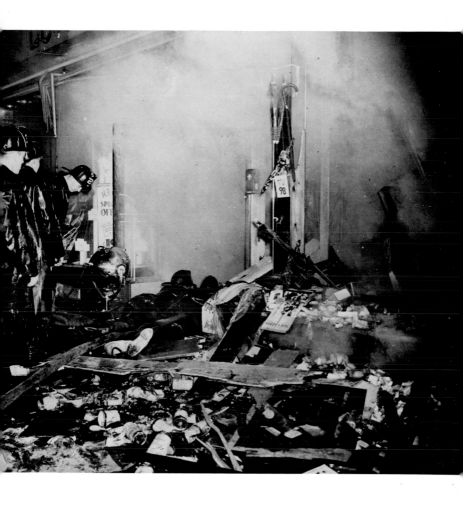

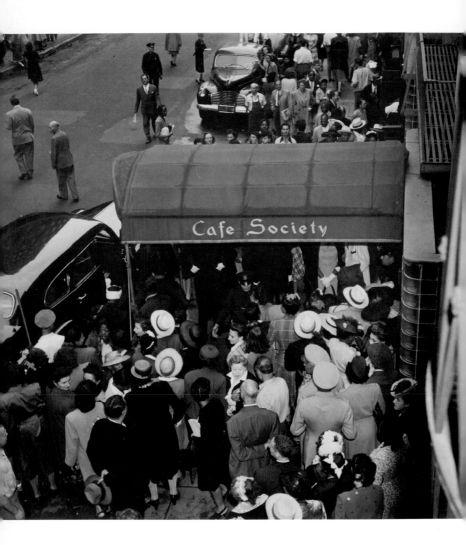

05 **128 EAST 58TH STREET BETWEEN PARK AND LEXINGTON AVENUES, SOUTH SIDE OF BLOCK**
[Café Society Uptown], ca. 1945
Barney Josephson opened Café Society, New York's first integrated nightclub, at Sheridan Square in the Village in 1938. Two years later, he opened Café Society Uptown at 128 East 58th Street (next door to the New York Genealogical and Biographical Society). Both venues featured top black and white musicians. The clubs did a booming business for several years, until Josephson's brother was cited for contempt by the House Un-American Activities Committee. When Josephson himself came under scathing attack by right-wing columnists Westbrook Pegler and Walter Winchell, business at the clubs plummeted and he was forced to sell in 1948.
16250.1993

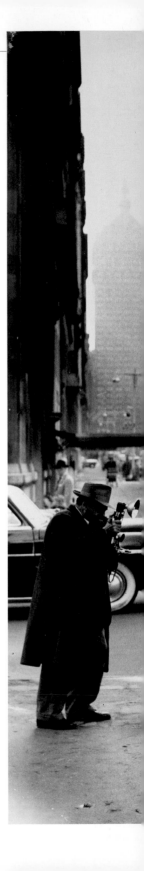

06 **PARK AVENUE AND EAST 55TH STREET,
NORTHEAST CORNER**
Unidentified Photographer,
[Weegee photographing three dogs on
Park Avenue], after 1952
Looking south to the New York Central Building
at 230 Park Avenue. Lever House (390 Park
Avenue, completed 1952) is on the right. *19810.1993*

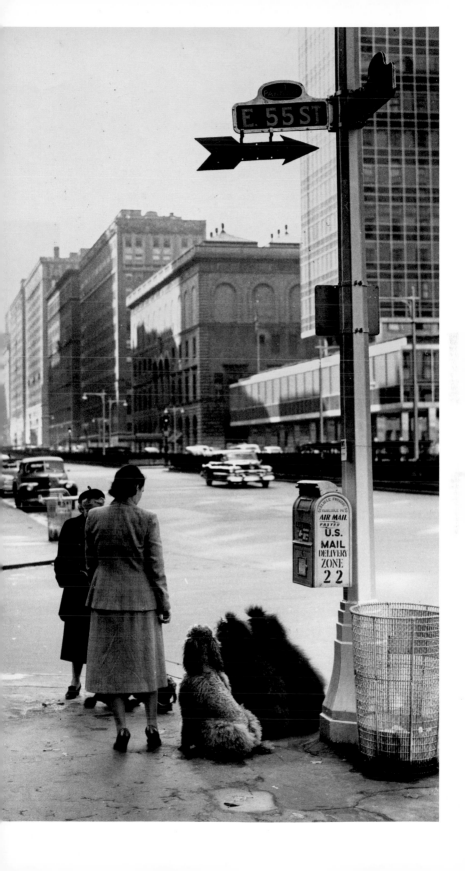

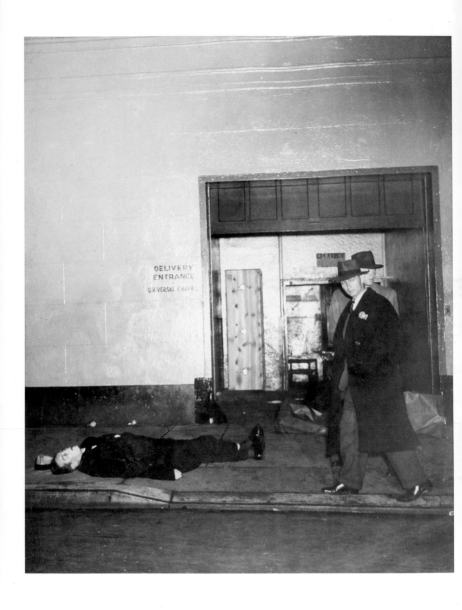

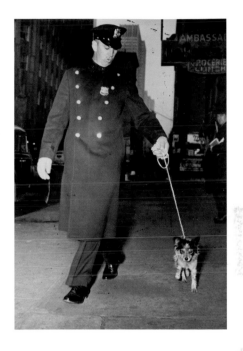

07 **597 LEXINGTON AVENUE AT EAST 52ND STREET, NORTHEAST CORNER**

Fate's Little "Jokes," December 6, 1941

An off-duty patrolman, Officer Thomas Casey, was shot by hold-up men as he was on his way home. His body was found at the delivery entrance to the Universal Chapel Funeral Parlor. *The Friedsam Collection*

08 **143 EAST 51ST STREET NEAR LEXINGTON AVENUE, NORTH SIDE OF BLOCK**

Arrested for Vagrancy, December 1943

Looking west on East 51st Street toward Lexington Avenue and the IRT subway station. The Ambassador Delicatessen (sign in upper right) is at 143 East 51st. *2049.1993*

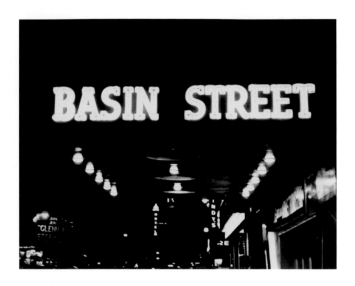

09 **137 EAST 48TH STREET BETWEEN LEXINGTON
AND THIRD AVENUES, NORTH SIDE OF BLOCK**
[Basin Street], 1954
Looking west on East 48th toward Lexington, from beneath
the neon sign of the Basin Street jazz club (No. 137). The Hotel
Lexington sign is in the center background. The movie marquee
at left advertises *The Glenn Miller Story* (1954). *14773.1993*

10 **THE UNITED NATIONS AT EAST 42ND STREET,
FROM WELFARE ISLAND**
[United Nations Building], after 1952
On the left: a stack rising above the Consolidated Edison complex
on the East River; beyond that, the towers of the Met Life Building
at Madison Park (left) and the New York Life Building (right). Far
right: Tudor City. *16634.1993*

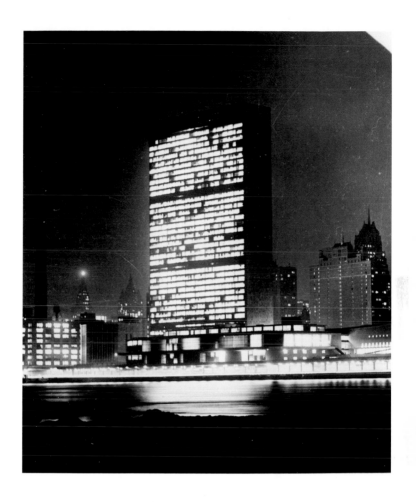

11 **650 THIRD AVENUE BETWEEN EAST 41ST AND 42ND STREETS, WEST SIDE OF BLOCK**
[Police and bystanders with body of
Stanley Sandler, a passenger in an
automobile that crashed into a Third
Avenue Elevated pillar and caught fire],
April 16, 1942
Joy of Living and *Don't Turn Them Loose* are
playing at the Tudor (formerly the Tuxedo), a
small theater located next to the Third Avenue
Elevated. By 1955, an office building had risen on
the site. *Weegee portfolio 30*

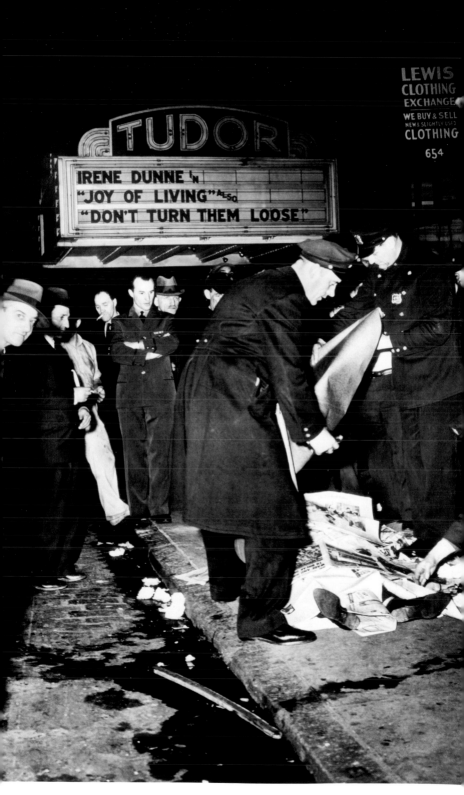

12 **560 THIRD AVENUE AT EAST 37TH STREET, NORTHWEST CORNER**
[Fire above the Third Avenue Elevated], ca. 1945
14999.1993

13 SAINT GABRIEL'S PARK, FIRST AVENUE AND EAST 36TH STREET

[Bystanders watching a fire at an aeronautics factory],
March 1, 1944

A crowd watches a fire in an aeronautics factory from Saint
Gabriel's Park (now called Saint Vartan Park). Bounded by East
36th Street on the north and First Avenue on the east, the park was
established in 1901, then reconstructed in 1936 to add a play-
ground, wading pool, and roller skating track. The five-alarm fire
occurred at 411 East 36th Street between First Avenue and the East
River. The building, completely destroyed, housed manufacturers
of military equipment. *674.1993*

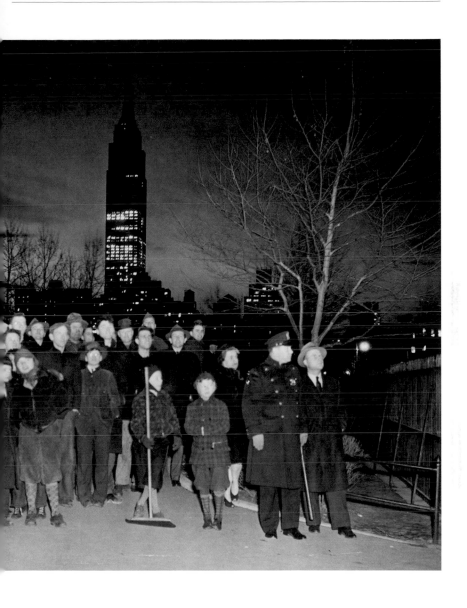

14 **410 EAST 32ND STREET BETWEEN FIRST AVENUE
AND THE EAST RIVER, SOUTH SIDE OF BLOCK**
[Fire on the East Side], ca. 1946
15002.1993

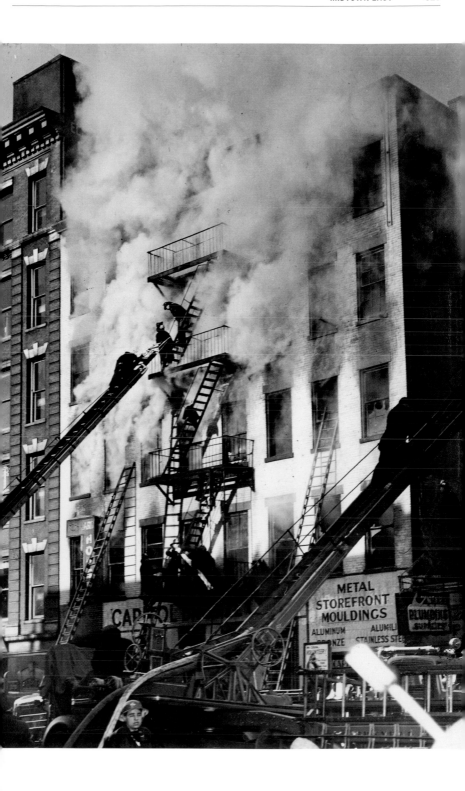

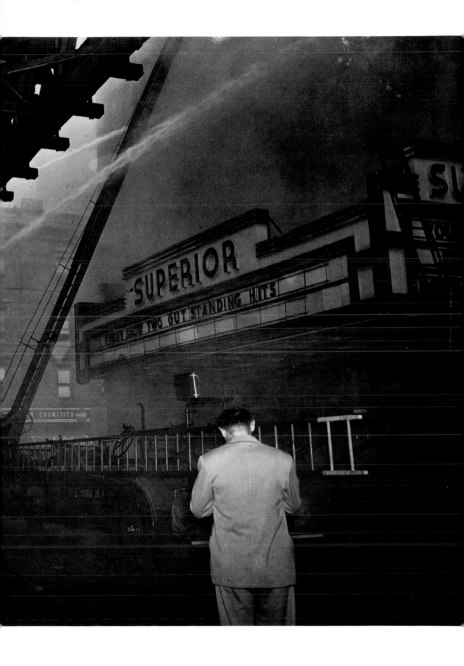

15 **443 THIRD AVENUE BETWEEN EAST 30TH AND 31ST STREETS,
EAST SIDE OF BLOCK**
[Fire in the Superior Theatre], August 26, 1943
Looking north along Third Avenue from under the Elevated. The
Superior Theatre operated from 1920 to around 1950. By 1958, it
had been demolished and replaced by a parking lot. *15000.1993*

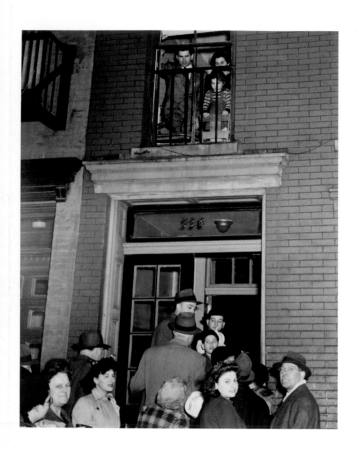

16 **338 EAST 20TH STREET BETWEEN FIRST AND SECOND AVENUES, SOUTH SIDE OF BLOCK**
[Home of the Zabinskys, parents of kidnapped infant],
May 1, 1943
2265.1993

17 **EAST 20TH STREET BETWEEN FIRST AND SECOND AVENUES**
[The Zabinskys, surrounded by neighbors, after the
return of their kidnapped baby], May 1, 1943
Looking east on East 20th Street toward First Avenue. The neigh-
borhood was dominated by Con Ed's gasholders, hence its moni-
ker—the "Gashouse District." Part of the area was razed in 1945 to
make way for Stuyvesant Town–Peter Cooper Village. *657.1993*

HUDSON (NORTH) RIVER

Cathedral Parkway W. 110th St.

W. 109th St.
W. 108th St. **12**

Broadway
Strauss Park

W. 107th St.
W. 106th St. **11** **13 09-10**
W. 105th St.

Riverside Park

W. 104th St.
W. 103rd St.
W. 102nd St.
W. 101st St.
W. 100th St.

Columbus Ave.

Manhattan Ave.

97th St. Transverse

W. 99th St.
W. 98th St.
W. 97th St.

W. 96th St.

W. 95th St.
W. 94th St. **08** **07**

Pomander Walk

W. 93rd St.
W. 92nd St.
W. 91st St.
W. 90th St.
W. 89th St.
W. 88th St.
W. 87th St.

West End Ave.

Amsterdam Ave.

86th St. Transverse

W. 86th St. **06**
W. 85th St.

Central Park

W. 84th St.
W. 83rd St.
W. 82nd St.
W. 81st St.
W. 80th St.
W. 79th St.

MANHATTAN SQ.

Central Park W.

79th St. Transverse

W. 78th St.
W. 77th St.
W. 76th St.
W. 75th St.
W. 74th St. **05**
W. 73rd St.

Riverside Dr.

VERDI SQ.

Ninth Avenue El (dismantled 1940)

W. 72nd St.

SHERMAN SQ.

W. 71st St.
W. 70th St.

9A

HENRY HUDSON PKWY.

West Dr.

Terrace Dr.

Center Dr.

W. 69th St.
W. 68th St.
W. 67th St.
W. 66th St.
W. 65th St.
W. 64th St.

WEST SIDE ELEVATED (MILLER HIGHWAY)

108
107
106
105
104
103
102

04

02 LINCOLN SQ.
01

03 W. 63rd St.
W. 62nd St.
W. 61st St.
W. 60th St.

Broadway

65th St. Transverse

99
98

W. 59th St.
W. 58th St.

COLUMBUS CIRCLE

Central Park S.

ca. 1940

N.B. The markers on this map represent, where possible, a reasonable estimate of Weegee's position (circle) and direction he faced (square).

FRAWLEY CIRCLE

MANHATTAN

E. 110th St.
E. 109th St.
E. 108th St.
E. 107th St.
E. 106th St.
E. 105th St.
E. 104th St.
E. 103rd St.
E. 102nd St.
E. 101st St.
E. 100th St.
E. 99th St.
E. 98th St.
E. 97th St.
E. 96th St.
E. 95th St.
E. 94th St.
E. 93rd St.
E. 92nd St.
E. 91st St.
E. 90th St.
E. 89th St.
E. 88th St.
E. 87th St.
E. 86th St.
E. 85th St.
E. 84th St.
E. 83rd St.
E. 82nd St.
E. 81st St.
E. 80th St.
E. 79th St.
E. 78th St.
E. 77th St.
E. 76th St.
E. 75th St.
E. 74th St.
E. 73rd St.
E. 72nd St.
E. 71st St.
E. 70th St.
E. 69th St.
E. 68th St.
E. 67th St.
E. 66th St.
E. 65th St.
E. 64th St.
E. 63rd St.
E. 62nd St.
E. 61st St.
E. 60th St.
E. 59th St.
E. 58th St.

Fifth Ave.
Madison Ave.
Park Ave.
Lexington Ave.
Third Avenue El (dismantled 1955)
Third Ave.
Second Avenue El (dismantled 1942)
Second Ave.
First Ave.
York Ave.
Marie Curie Ave.
East End Ave.
Henderson Pl.
Cherokee Pl.

EAST RIVER DR.

WARDS ISLAND

EAST RIVER

Hell Gate

MILL ROCK

Carl Schurz Park

Gracie Sq.

WELFARE ISLAND

John Jay Park

West Channel

East Channel

The Rockefeller Institute

Marginal St.

GRAND ARMY PLAZA

East Dr.

QUEENSBORO/59th-ST. BRIDGE

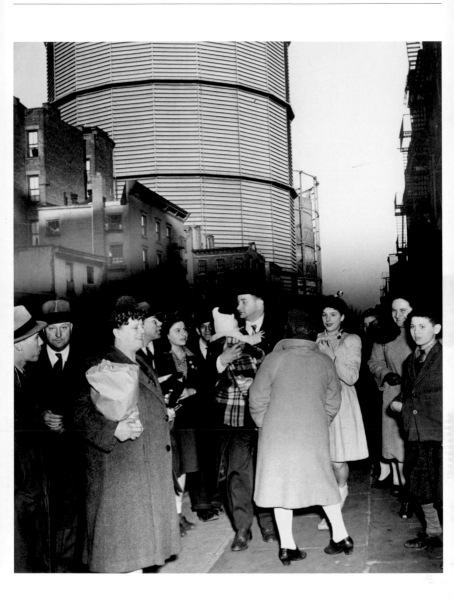

08 THE UPPER WEST SIDE

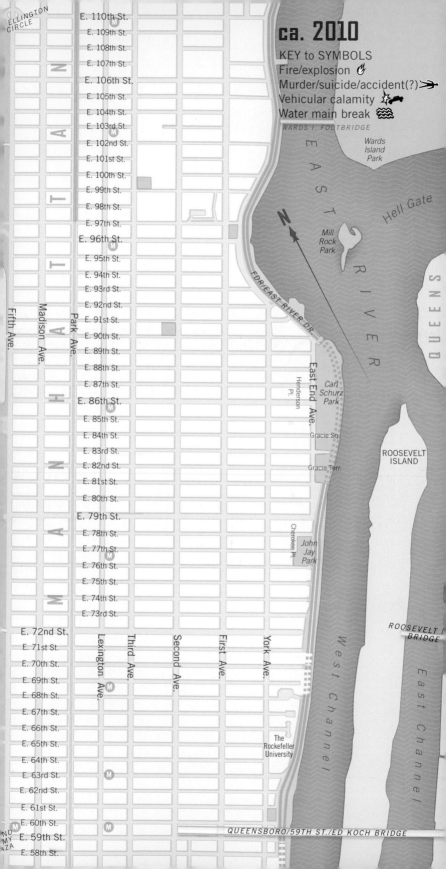

ca. 2010

KEY to SYMBOLS
Fire/explosion 🔥
Murder/suicide/accident(?) ➤
Vehicular calamity 🚗
Water main break 〰

WARDS I. FOOTBRIDGE

Wards Island Park

EAST

Hell Gate

Mill Rock Park

RIVER

QUEENS

ELLINGTON CIRCLE

E. 110th St.
E. 109th St.
E. 108th St.
E. 107th St.
E. 106th St.
E. 105th St.
E. 104th St.
E. 103rd St.
E. 102nd St.
E. 101st St.
E. 100th St.
E. 99th St.
E. 98th St.
E. 97th St.
E. 96th St.
E. 95th St.
E. 94th St.
E. 93rd St.
E. 92nd St.
E. 91st St.
E. 90th St.
E. 89th St.
E. 88th St.
E. 87th St.
E. 86th St.
E. 85th St.
E. 84th St.
E. 83rd St.
E. 82nd St.
E. 81st St.
E. 80th St.
E. 79th St.
E. 78th St.
E. 77th St.
E. 76th St.
E. 75th St.
E. 74th St.
E. 73rd St.
E. 72nd St.
E. 71st St.
E. 70th St.
E. 69th St.
E. 68th St.
E. 67th St.
E. 66th St.
E. 65th St.
E. 64th St.
E. 63rd St.
E. 62nd St.
E. 61st St.
E. 60th St.
E. 59th St.
E. 58th St.

MANHATTAN

Fifth Ave.
Madison Ave.
Park Ave.
Lexington Ave.
Third Ave.
Second Ave.
First Ave.
York Ave.

F.D.R./EAST RIVER DR.

East End Ave.
Henderson Pl.
Carl Schurz Park
Gracie Sq.
Gracie Terr.

Cherokee Pl.
John Jay Park

The Rockefeller University

ROOSEVELT ISLAND

West Channel

East Channel

ROOSEVELT I. BRIDGE

QUEENSBORO/59TH ST./ED KOCH BRIDGE

ND MY ZA

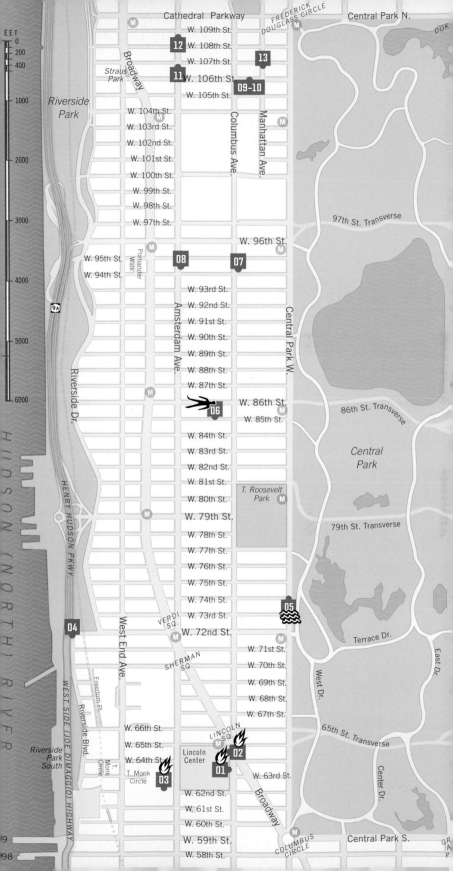

01 88 COLUMBUS AVENUE BETWEEN WEST 63RD AND 64TH STREETS, WEST SIDE OF BLOCK

[Explosion in a gymnasium],
February 17, 1943

The gymnasium of the Catholic Youth Organization, 88 Columbus Avenue, damaged by an explosion. Looking east to the thirty-foot replica of the Statue of Liberty atop the Liberty Warehouse at 43 West 64th Street (just east of Broadway). (The statue is now in the Brooklyn Museum.) At the end of West 64th is Harperly Hall, an apartment building (41 Central Park West). On the far right: the West Side branch of the YMCA (5 West 63rd Street). *15216.1993*

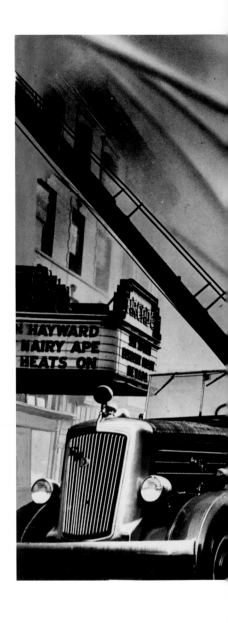

02 **1931 BROADWAY BETWEEN WEST 64TH AND 65TH STREETS,
WEST SIDE OF BLOCK**
[Fire at the Arcade Theatre], 1944
Looking north up Broadway from West 64th. The movie mar-
quee advertises *The Hairy Ape* (1944). In the distance is the Hotel
Dauphin, at 126 West 67th. *14981.1993*

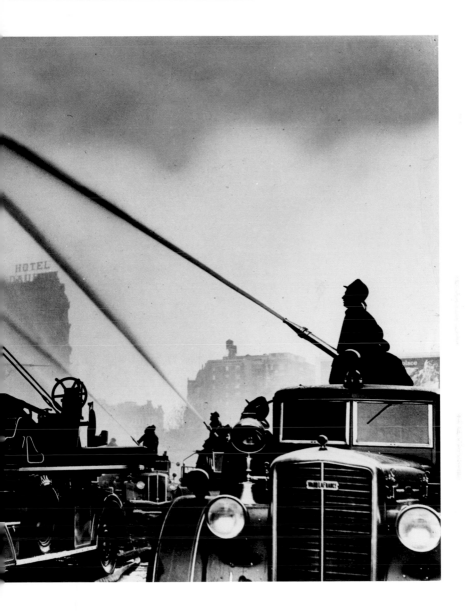

03 209 WEST 62ND STREET BETWEEN AMSTERDAM AND
WEST END AVENUES, NORTH SIDE OF BLOCK
[Elderly woman rescued from fire], July 19, 1940
1091.1993

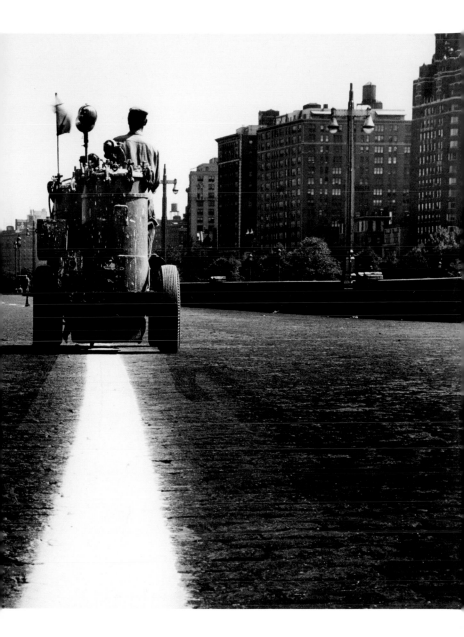

04

HENRY HUDSON PARKWAY
[Line painter on Henry Hudson Parkway],
ca. 1940
Looking north along the Parkway, Riverside Park to the
right. The vista culminates at the Soldiers' and Sailors'
Monument (West 89th Street and Riverside Drive).
Grant's Tomb and Riverside Church are faintly visible
beyond. The building at right is 22 Riverside Drive at
West 74th. *14863.1993*

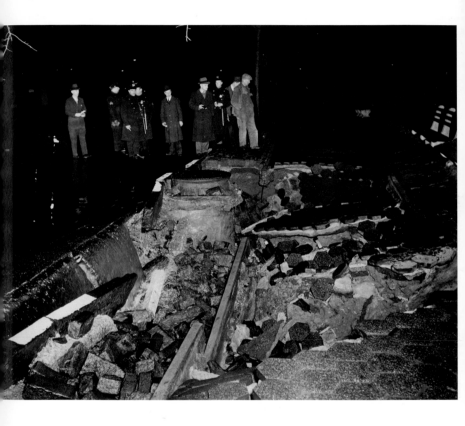

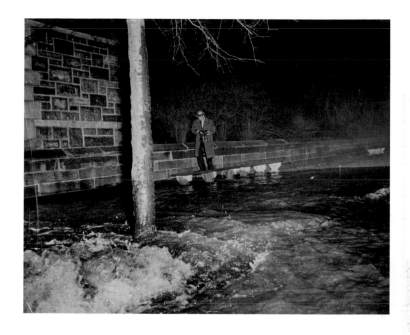

05 **CENTRAL PARK WEST AND WEST 74TH STREET**
[Water main break on Upper West Side], October 13, 1947
14198.1993, 14199.1993

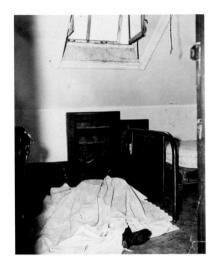

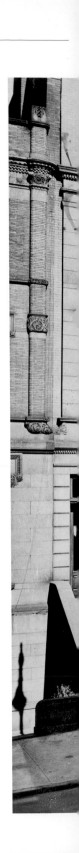

06 **127–131 WEST 85TH STREET BETWEEN COLUMBUS AND AMSTERDAM AVENUES, NORTH SIDE OF BLOCK**
[The body of Henry Pederson, found in an attic closet in Frank Drury's home], February 25, 1944 *14077.1993*
Where Killing Occur[r]ed, February 25, 1944 *14100.1993*

Home of fifteen-year-old Frank Drury (No. 129, center house in photo), who accidentally shot a friend while cleaning a rifle and hid the victim's body in an attic closet for two weeks before it was discovered.

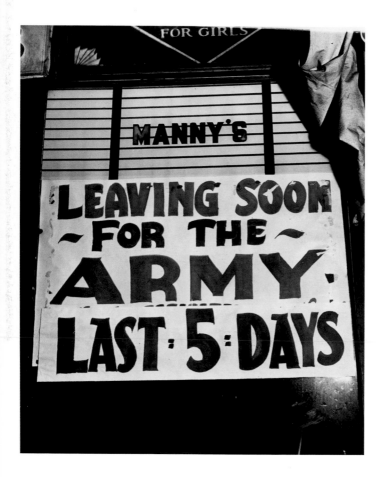

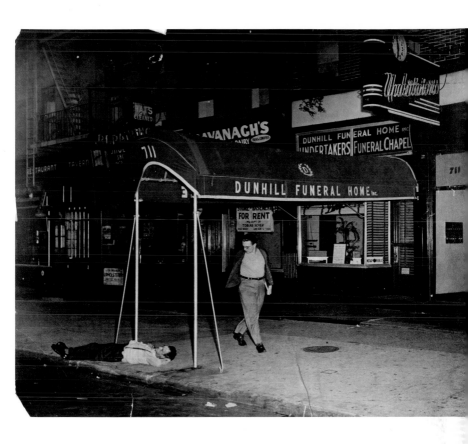

07 **701 COLUMBUS AVENUE AT WEST 94TH STREET,
NORTHEAST CORNER**
[Manny's], January 18, 1943
15370.1993

08 **711 AMSTERDAM AVENUE BETWEEN WEST 94TH AND 95TH
STREETS, EAST SIDE OF BLOCK**
[Dunhill Funeral Home], July 13, 1941
2266.1993

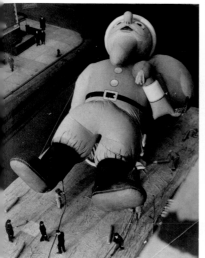

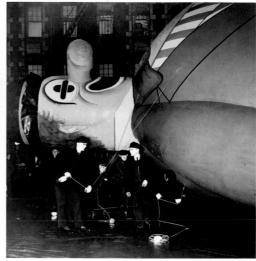

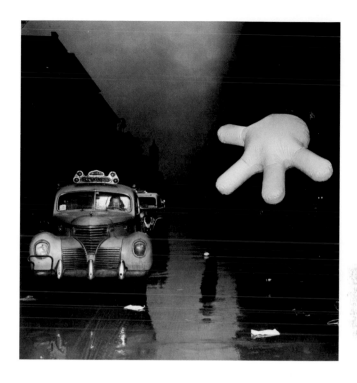

09 MANHATTAN AVENUE AND WEST 106TH STREET
[Inflating Santa Claus for the Macy's Thanksgiving Day
Parade], November 20, 1940
3076.1993

10 PROBABLY WEST 106TH STREET BETWEEN COLUMBUS
AND MANHATTAN AVENUES
[Clown filled with helium gas for the annual Macy's
Thanksgiving Day Parade], ca. 1942
3077.1993

11 AMSTERDAM AVENUE, LOOKING SOUTH FROM
WEST 107TH STREET
[Woman cab driver and Macy's clown], ca. 1942
In the left background is the tower of the West End Presbyterian
Church at West 105th Street. *3078.1993*

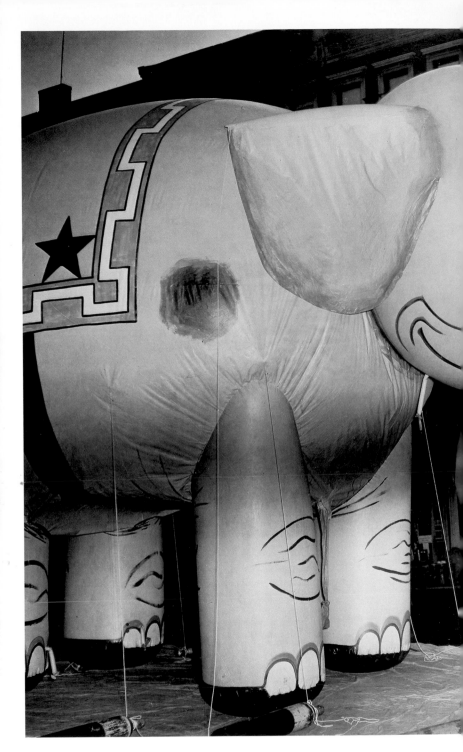

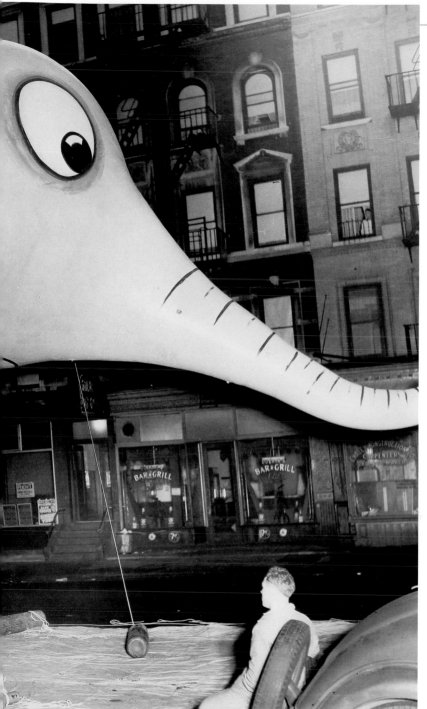

12 **AMSTERDAM AVENUE BETWEEN WEST 108TH AND 109TH STREETS**
[Inflating Dumbo for the Macy's Thanksgiving Day Parade], ca. 1942
Galerie Berinson, Berlin

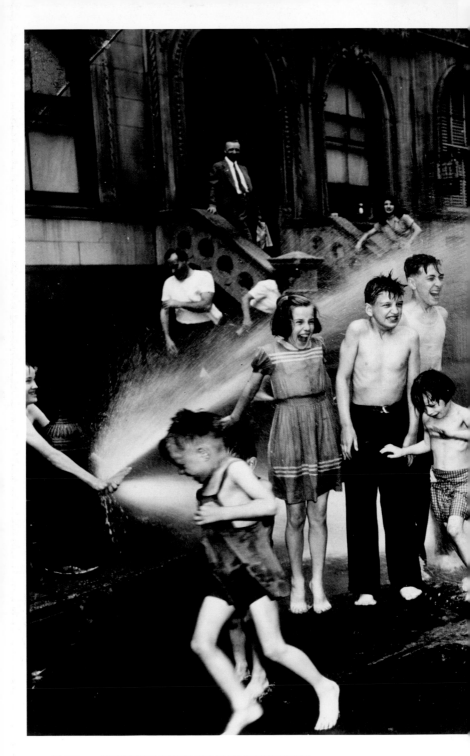

13 **MANHATTAN AVENUE AND WEST 107TH STREET**
[Children playing in water sprayed from an open fire
hydrant], ca. 1945
Looking south on Manhattan Avenue from West 107th Street.
Weegee portfolio 14

ca. 1940

N.B. The markers on this map represent, where possible, a reasonable estimate of Weegee's position (circle) and direction he faced (square).

Cathedral Parkway W. 110th St.

HUDSON (NORTH) RIVER

Columbus Ave.

Manhattan Ave.

W. 102nd St.
W. 101st St.
W. 100th St.
W. 99th St.
W. 98th St.
W. 97th St.

97th St. Transverse

W. 96th St.

Pomander Walk

W. 95th St.
W. 94th St.
W. 93rd St.
W. 92nd St.

Riverside Park

W. 91st St.
W. 90th St.

West End Ave.

Amsterdam Ave.

W. 89th St.
W. 88th St.
W. 87th St.

Riverside Dr.

W. 86th St.

86th St. Transverse

W. 85th St.

W. 84th St.
W. 83rd St.
W. 82nd St.
W. 81st St.

Central Park

9A

W. 80th St.

MANHATTAN SQ.

Central Park W.

W. 79th St.

79th St. Transverse

W. 78th St.
W. 77th St.
W. 76th St.

HENRY HUDSON PKWY.

W. 75th St.

W. 74th St.

W. 73rd St.

Ninth Avenue El (dismantled 1940)

VERDI SQ.

W. 72nd St.

W. 71st St.

Terrace Dr.

SHERMAN SQ.

W. 70th St.

W. 69th St.
W. 68th St.
W. 67th St.

West Dr.

Center Dr.

W. 66th St.

108
107

W. 65th St.

LINCOLN SQ.

65th St. Transverse

106

105

W. 64th St.
W. 63rd St.

104

103

W. 62nd St.

102

W. 61st St.

WEST SIDE ELEVATED (MILLER) HIGHWAY

W. 60th St.

Broadway

W. 59th St.

99

COLUMBUS CIRCLE

Central Park S.

98

W. 58th St.

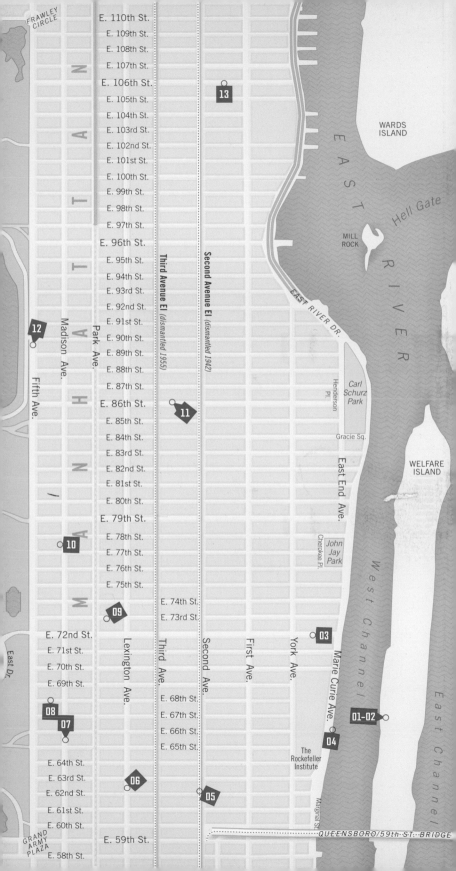

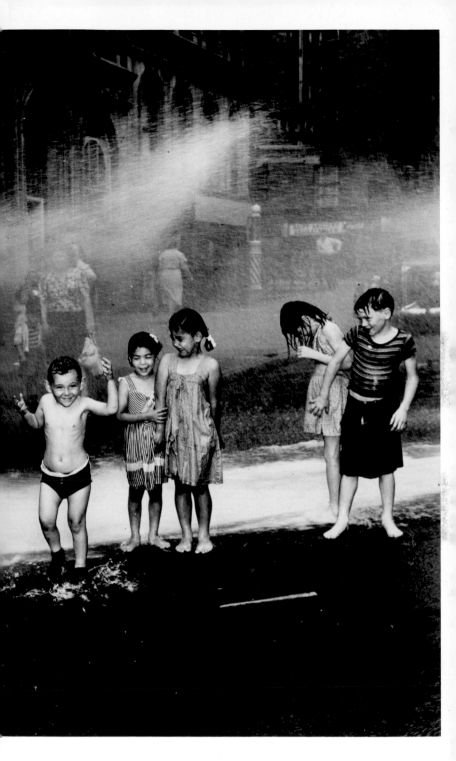

09 THE UPPER EAST SIDE

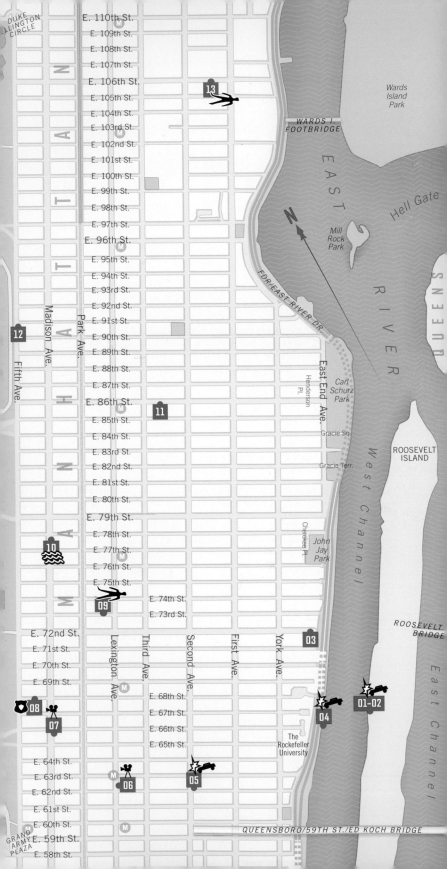

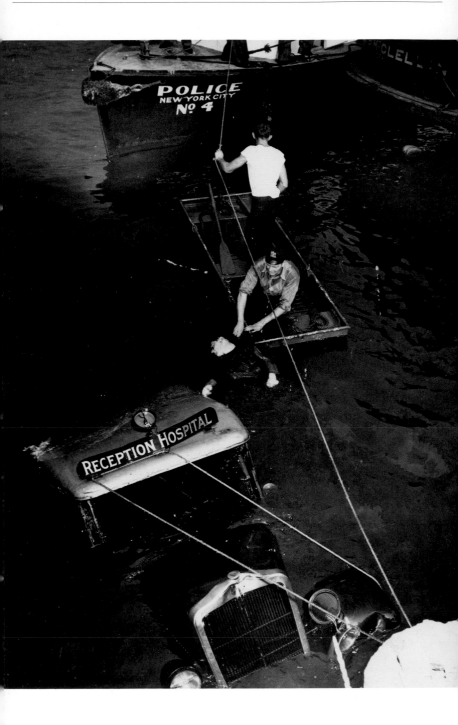

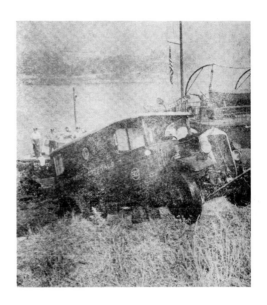

01 **WELFARE ISLAND, LOOKING WEST ACROSS THE EAST RIVER TO MANHATTAN**
[Reception Hospital ambulance hauled from river],
PM Daily, August 24, 1943

02 **WELFARE ISLAND, WEST SHORE, NEAR THE QUEENSBORO BRIDGE**
[Police officer and assistant removing body of Reception Hospital ambulance driver Morris Linker from East River, off Welfare Island], August 23, 1943

The Reception Hospital ambulance was leaving the New York City Home for the Aged and Infirm (the old Alms House), located in the center of Welfare Island on the west side (parallel to East 67th Street in Manhattan), when it plunged into the river. The island was formerly called Blackwell's, site of a variety of nineteenth-century institutions to house criminals, the poor, and the infirm. It became Welfare Island in 1921 and was renamed Roosevelt Island in 1971.

133.1982

03 **528 EAST 72ND STREET BETWEEN YORK AVENUE AND THE EAST RIVER, SOUTH SIDE OF BLOCK**
[Night scene], ca. 1945
The sign in the background reads "Philharmonic Radio Corporation." *Galerie Berinson, Berlin*

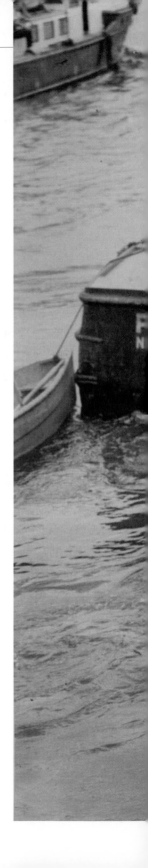

04 EAST 66TH STREET AND MARIE CURIE AVENUE

[Police rescue car from the East River], August 21, 1938

Exterior Street, running along the East River from 53rd to 80th Streets, was renamed Marie Curie Avenue in 1935. The arterial was considered an appropriate locale to honor the world-renowned scientist as it is lined on its west side by hospitals and medical research centers. Marie Curie Avenue had a short life. Within five years, it had been widened and absorbed into the East River (now FDR) Drive. *The Friedsam Collection*

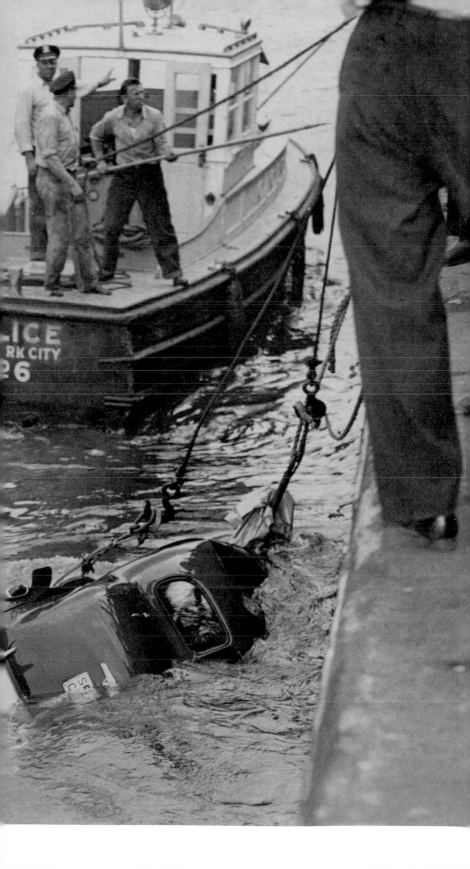

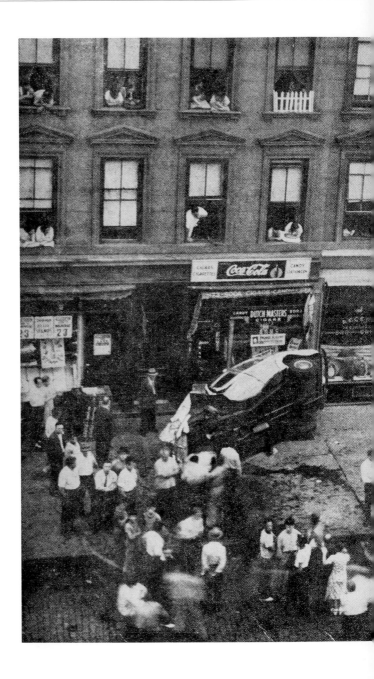

05 **SECOND AVENUE AND EAST 62ND STREET, NORTHEAST CORNER**
[Early morning traffic accident], *PM Daily,* July 2, 1941
The Regent Restaurant (corner building) is at 1180 Second Avenue.

06 **807 LEXINGTON AVENUE BETWEEN EAST 62ND AND 63RD STREETS, EAST SIDE OF BLOCK**
[Filming *The Naked City*], 1947
Cast members of *The Naked City*: House Jameson (smoking a pipe),
Howard Duff (in the background, wearing a white hat), and David
Opatoshu (smoking a cigarette). *14836.1993*

07 **MADISON AVENUE AND EAST 66TH STREET**
[Filming *The Naked City*],
1947
Looking north up Madison Avenue. *7567.1993*

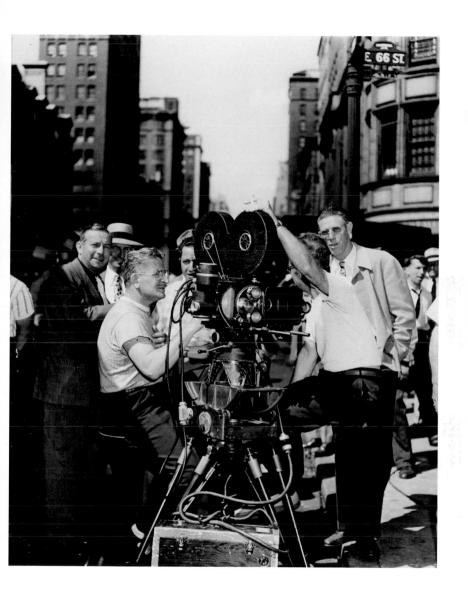

18 EAST 68TH STREET BETWEEN FIFTH AND MADISON AVENUES, SOUTH SIDE OF BLOCK
[Ermine-wrapped patron caught in gambling den],
December 22, 1940
2055.1993

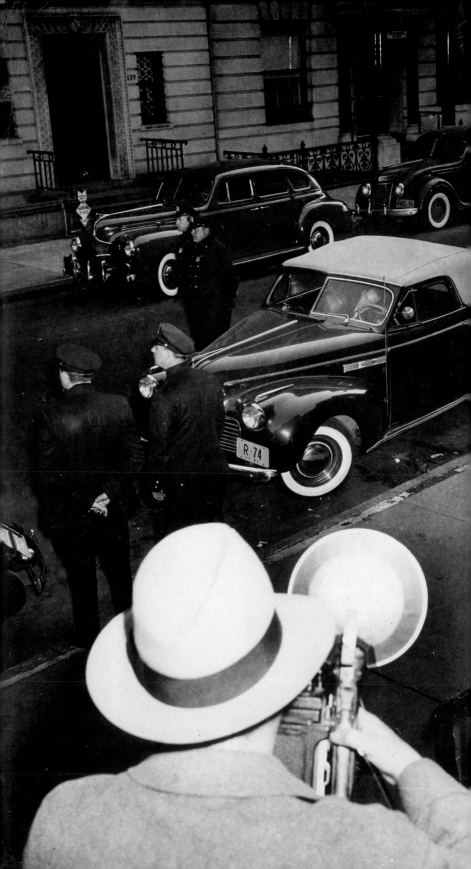

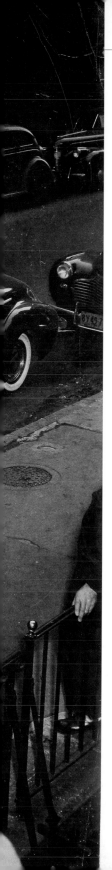

09 EAST 73RD STREET BETWEEN PARK AND LEXINGTON AVENUES

[Robbery victim Harry V. Maxwell shot dead in his car], May 4, 1941

Harry Vance Maxwell, an advertising executive, was shot in a hold-up as he sat in his car with girlfriend Mary Cassidy in front of her house at 151 East 81st Street. After the robbers fled and, thinking that Maxwell had merely fainted from fright, Cassidy drove him to his brownstone at 136 East 73rd Street, where she then discovered that he was in fact dead. *Galerie Berinson, Berlin*

10 MADISON AVENUE BETWEEN EAST 77TH AND 78TH STREETS,
EAST SIDE OF BLOCK
Water Main Burst Uproots Madison Ave. New York,
May 25, 1945
15225.1993

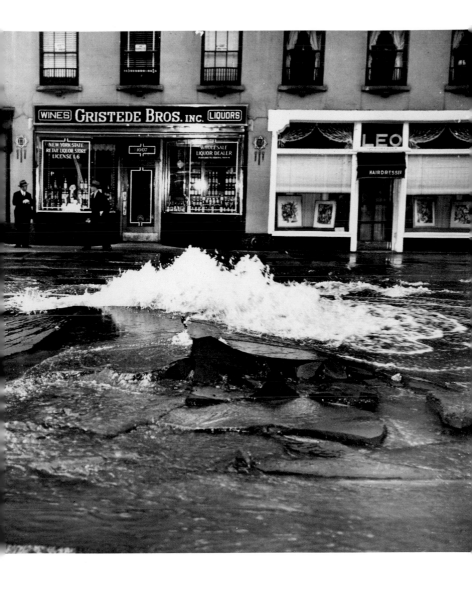

11

**EAST 86TH STREET BETWEEN
SECOND AND THIRD AVENUES,
SOUTH SIDE OF BLOCK**
[Street scene, Yorkville neighbor-
hood], ca. 1942

The culturally diverse neighborhood of Yorkville
was home to a large contingent of Eastern
Europeans, Germans, and Irish. During the
1930s, it was the home base of the Nazi German
American Bund, which is probably why Weegee
photographed this scene, as part of his report-
age for *PM*. The Silver Shirts, a fascist organiza-
tion founded by Hitler admirer William Dudley
Pelley, held their first meeting in 1933 at Kreutzer
Hall (228 East 86th, Rheinland restaurant on the
first floor). Pelley was convicted of sedition in
1942. *16653.1993*

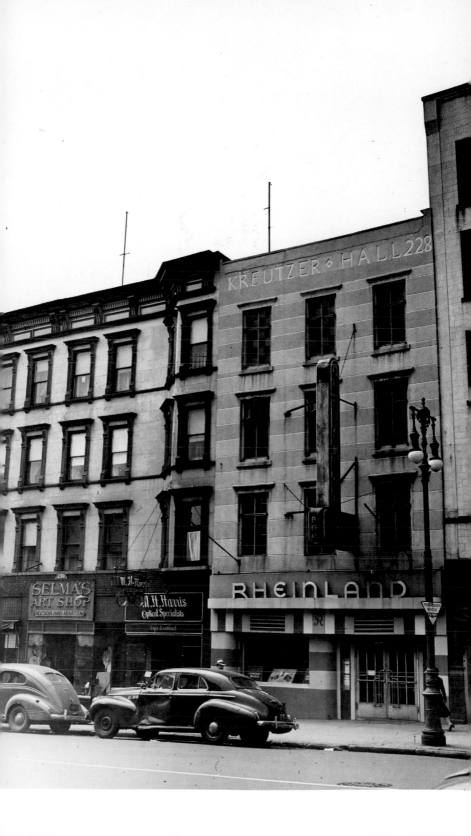

01

GEORGE WASHINGTON BRIDGE

Fort Washington Park

HIGHBRIDGE

J.H. Wright Park

W. 177th St.
W. 176th St.
W. 175th St.
W. 174th St.
W. 173rd St.
W. 172nd St.
W. 171st St.
W. 170th St.
W. 169th St.
W. 168th St.
W. 167th St.
W. 166th St.
W. 165th St.
W. 164th St.
W. 163rd St.
W. 162nd St.
W. 161st St.
W. 160th St.
W. 159th St.
W. 158th St.
W. 157th St.
W. 156th St.
W. 155th St.

Wadsworth Ave.
St Nicholas Ave.
Broadway
Audubon Ave.
Jumel Pl.
Edgecombe Ave.
Jumel Terr.
Sylvan Terr.
Amsterdam Ave.
St Nicholas Pl.
St Nicholas Ave.
Edgecombe Ave.
Bradhurst Ave.
Macombs Pl.
Seventh Ave.
Eighth Ave.
Ninth Avenue El (dismantled 1940)
St Nicholas Ave.

Highbridge Park

MITCHEL SQ.
MCKENNA SQ.
MEYER SQ.

Fort Washington Ave.
Haven Ave.
Riverside Dr.
E.M. Morgan Pl.

IRT Car Storage Yard
PUTNAM
Polo Grounds
Old Manhattan Field
MAHER CIRCLE

02
03

W. 156th St.
W. 155th St.
W. 155th St. Viaduct
W. 154th St.

Trinity Cemetery

W. 153rd St.
W. 152nd St.
W. 151st St.
W. 150th St.
W. 149th St.
W. 148th St.
W. 147th St.
W. 146th St.

Colonial Park

Hamilton Pl.
Hamilton Terr.

MANHATTAN

HUDSON (NORTH) RIVER

04

JASPER OVAL

St Nicholas Park

St Nicholas Terr.

W. 1
W. 1
W. 1
W. 1
W. 1
W. 1
W. 1
W. 1

05

Riverside Dr. Viaduct
Twelfth Ave.
HENRY HUDSON PKWY.

Edgewater Ferry

06
07

St Clair Pl.
Old Broadway
Lawrence St.
Convent Ave.
Tiemann Pl.
W. 125th St.
Moylan Pl.
ROOSEVELT SQ.
La Salle St.
Hancock Pl.

08
09

Sakura Park

Riverside Park

Claremont Ave.
Broadway
Amsterdam Ave.
Morningside Dr.
Morningside Ave.
Manhattan Ave.
St Nicholas Ave.

W. 1
W. 1
W. 1
W. 1
W. 1
W. 1
W. 1

Morningside Park

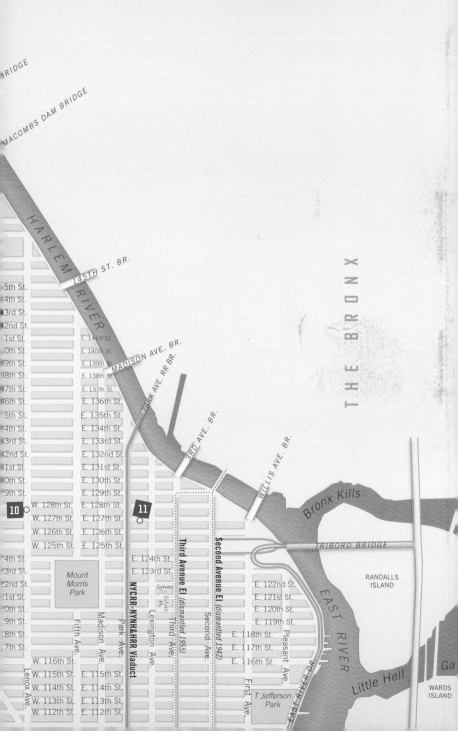

ca. 1940

N.B. The markers on this map represent, where possible, a reasonable estimate of Weegee's position (circle) and direction he faced (square).

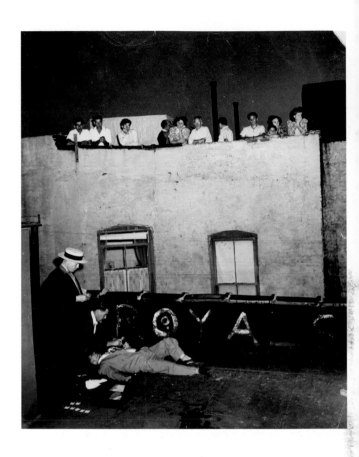

12 **FIFTH AVENUE AND EAST 91ST STREET**
[Hansom cab hitched to tow truck on Fifth Avenue],
May 18, 1942
Looking north up Fifth Avenue. The building directly behind the bus
is the Andrew Carnegie mansion (2 East 91st Street, southeast cor-
ner), now the Smithsonian Cooper Hewitt National Design Museum.
Above it is the Otto Kahn mansion (1 East 91st Street, northeast
corner), now the Convent of the Sacred Heart. *15282.1993*

13 **312 EAST 106TH STREET BETWEEN FIRST AND SECOND**
AVENUES, SOUTH SIDE OF BLOCK
[Bystanders watching police take fingerprints from
murder victim Joseph Gallichio, found next to his pigeon
cote], August 13, 1941
123.1982

10

UPPER
MANHATTAN

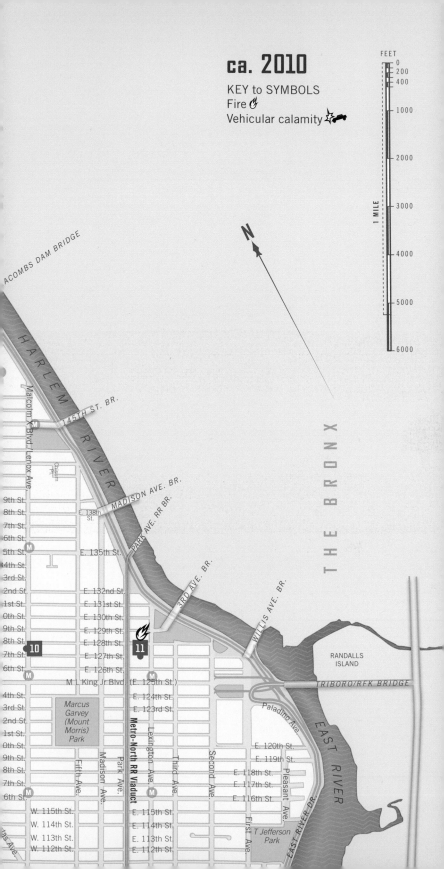

ca. **2010**

KEY to SYMBOLS
Fire 🔥
Vehicular calamity 🚗

FEET

0
200
400

1000

2000

1 MILE

3000

4000

5000

6000

ACOMBS DAM BRIDGE

HARLEM RIVER

N

THE BRONX

Malcolm X Blvd./Lenox Ave.

145TH ST. BR.

Chisüm Plr.

MADISON AVE. BR.

PARK AVE. RR BR.

3RD AVE. BR.

WILLIS AVE. BR.

9th St.
8th St.
7th St.
6th St.
5th St.
4th St.
3rd St.
2nd St.
1st St.
0th St.
9th St.
8th St.
7th St.
6th St.

E. 138th St.

E. 135th St.

E. 132nd St.
E. 131st St.
E. 130th St.
E. 129th St.
E. 128th St.
E. 127th St.
E. 126th St.

🔥

10

11

RANDALLS ISLAND

4th St.
3rd St.
2nd St.
1st St.
0th St.
9th St.
8th St.
7th St.
6th St.

M L King Jr Blvd (E. 125th St.)

TRIBORO/RFK BRIDGE

Marcus Garvey (Mount Morris) Park

E. 124th St.
E. 123rd St.

Paladino Ave.

Metro-North RR Viaduct

Fifth Ave.
Madison Ave.
Park Ave.
Lexington Ave.
Third Ave.
Second Ave.
First Ave.
Pleasant Ave.

E. 120th St.
E. 119th St.
E. 118th St.
E. 117th St.
E. 116th St.

EAST RIVER

EAST RIVER DR.

W. 115th St.
W. 114th St.
W. 113th St.
W. 112th St.

E. 115th St.
E. 114th St.
E. 113th St.
E. 112th St.

T Jefferson Park

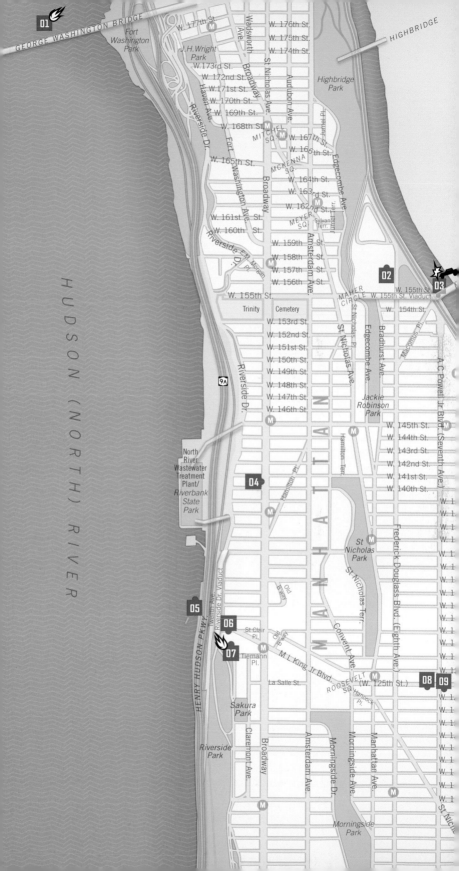

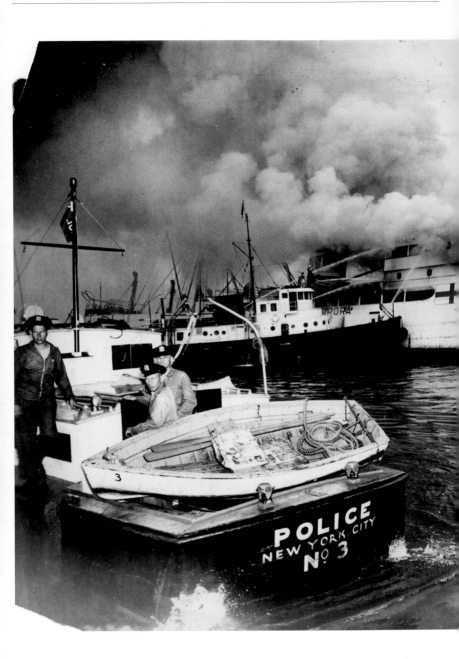

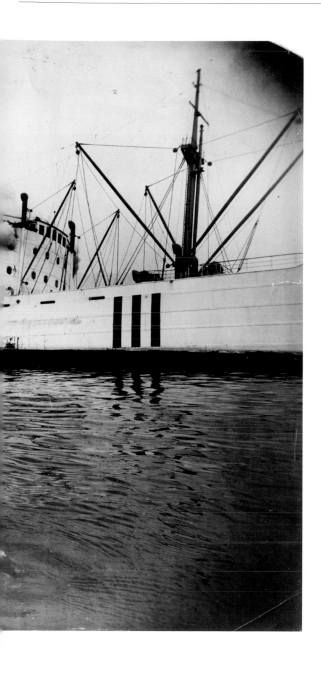

01 **HUDSON RIVER, NORTH OF THE GEORGE WASHINGTON BRIDGE**
[The Finnish freighter *Aurora* burns on the Hudson River
off Manhattan], August 22, 1941
15038.1993

02 THE POLO GROUNDS, EIGHTH AVENUE AND WEST 155TH STREET

[Air raid simulation at the Polo Grounds], September 20, 1942

Over several nights in September 1942, the public was treated to mock air raids and bombings in the Polo Grounds. The show, called "Action Overhead," was orchestrated by the War Department's Civilian Protection School. Miniature structures were bombed, exploded, and burned to demonstrate the effects of various incendiaries. Mayor LaGuardia considered the first night's events so educational that he announced the public would be admitted free to the repeat performances. *15302.1993*

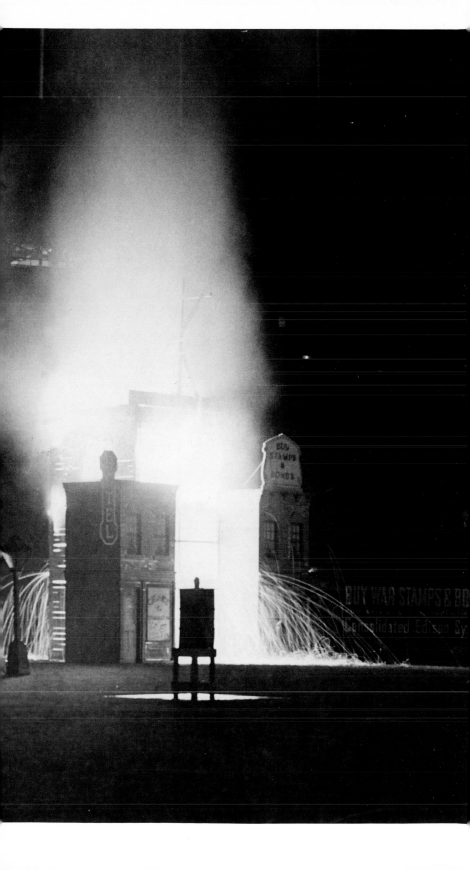

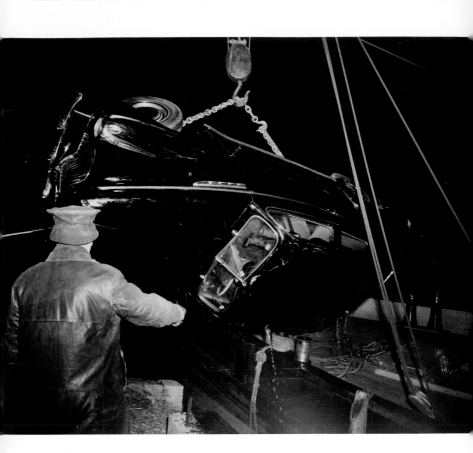

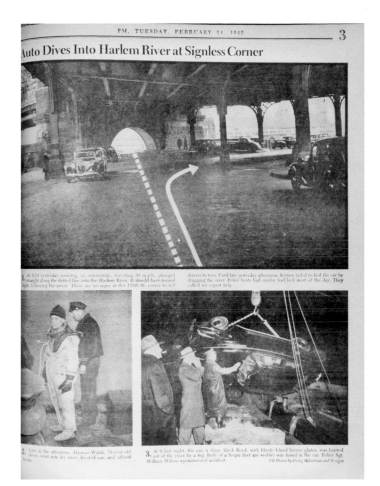

PM, TUESDAY, FEBRUARY 24, 1942

3

Auto Dives Into Harlem River at Signless Corner

1. At 3:40 yesterday morning, an automobile, traveling 50 m.p.h., plunged straight along the dotted line into the Harlem River. It should have turned right following the arrow. There are no signs at this 155th St. corner to tell drivers to turn. Until late yesterday afternoon, firemen failed to find the car by dragging the river. Police boats had similar bad luck most of the day. They called for expert help.

2. Late in the afternoon, Thomas Walsh, 78-year-old diver, went into icy river, located car, and affixed hooks.

3. At 9 last night, the car, a shiny, black Buick, with Rhode Island license plates, was hoisted out of the river by a tug. Body of a Negro (feet are visible) was found in the car. Police Sgt. William Wilson eyewitnessed accident.

PM Photos by Irving Haberman and Weegee

03 WEST 155TH STREET AT THE HARLEM RIVER
[Black Buick with dead passenger pulled out of the Harlem River], February 23, 1942
113.1982
"Auto Dives into Harlem River at Signless Corner,"
PM Daily, February 24, 1942
The top photo on the *PM* page is by Irving Haberman: looking northeast to Macombs Dam Bridge and the Bronx.

04 BROADWAY BETWEEN WEST 140TH AND 141ST STREETS,
WEST SIDE OF BLOCK
Morning Papers, ca. 1940

05 132ND STREET PIER, HARLEM
[1,250 revelers continuing the trip after three women
were trampled to death in excursion-ship stampede],
August 18, 1941
1020.1993

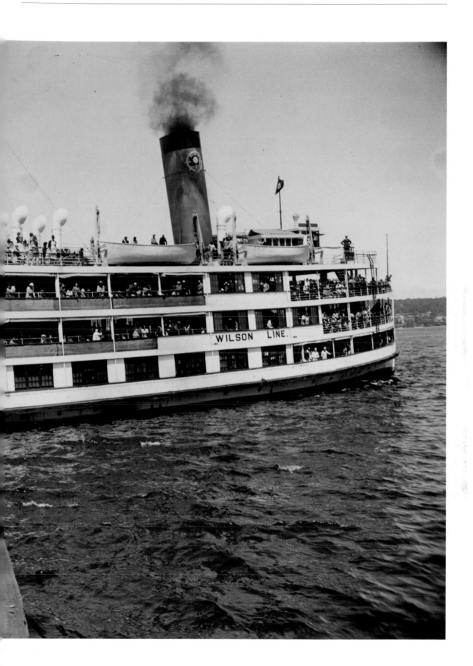

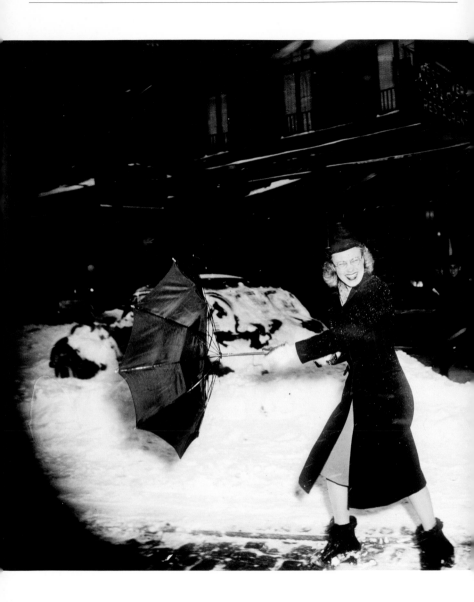

06 **650 WEST 125TH STREET BETWEEN BROADWAY AND RIVERSIDE DRIVE, SOUTH SIDE OF BLOCK**

[New Jersey commuter en route from the 125th Street ferry], March 8, 1941

The West River Coffee Shop, 650 West 125th, is in the background.

Weegee portfolio 44

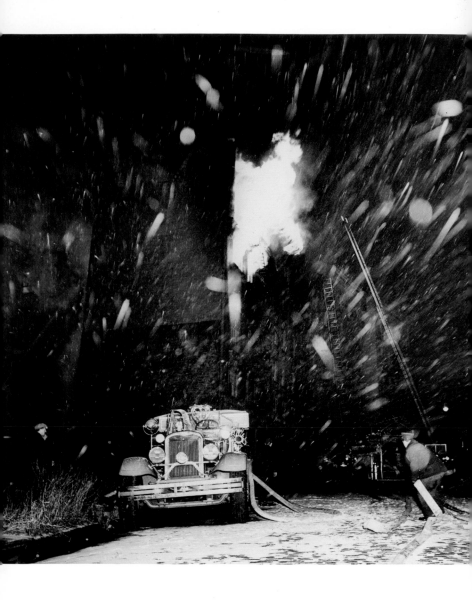

07 **552 RIVERSIDE DRIVE NEAR TIEMANN PLACE**
[Apartment house fire],
January 27, 1943

The Madrid apartment building at 552 Riverside Drive is "not on
Drive proper, but on a narrow extension that runs down a hill from
Tiemann Place and the Drive to West 125th Street and Twelfth
Avenue" (*New York Times*, January 28, 1943). *15150.1993*

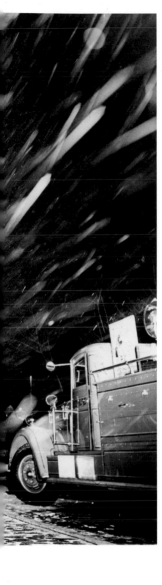

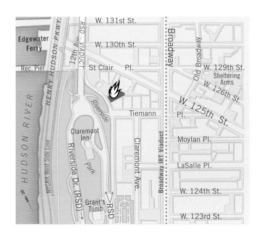

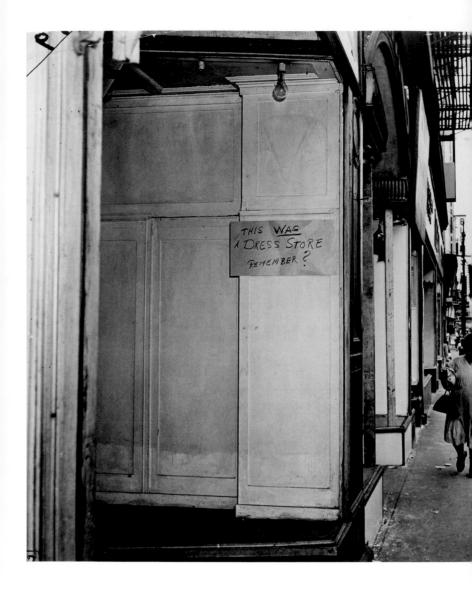

08 WEST 125TH STREET, LOOKING WEST FROM SEVENTH AVENUE
Harlem—125th St. After Last Riot,
August 1943

On August 1, 1943, in Harlem's Hotel Braddock, a black soldier came to the aid of a black woman who was being assaulted by a white police officer. The officer shot the soldier, sparking a riot. Six people died and scores of businesses—mostly white-owned— were destroyed and looted. In the photo, a sign in a storefront window reads "This was a dress store, remember?" Lining the street on the north side: Harlem Theatre (No. 207); Keystone Building (No. 213); Empire City Savings Bank (No. 231), Victoria Theatre (No. 233), Apollo Theatre (No. 253). *14684.1993*

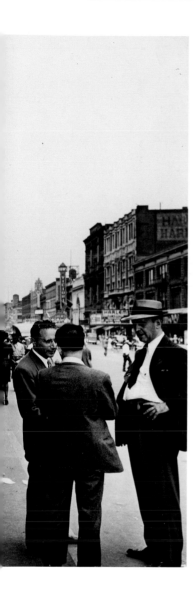

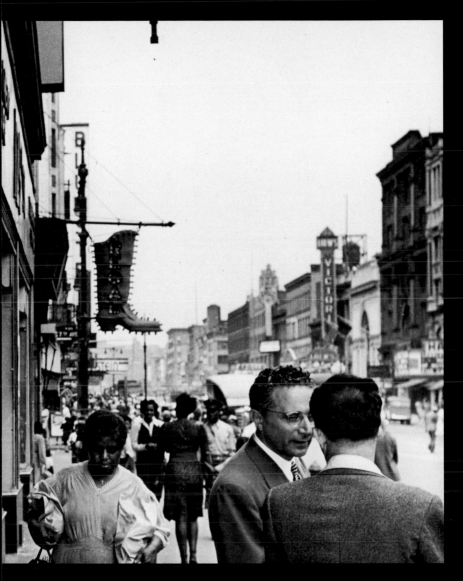

Detail of 08 showing theaters lining
West 125th Street.

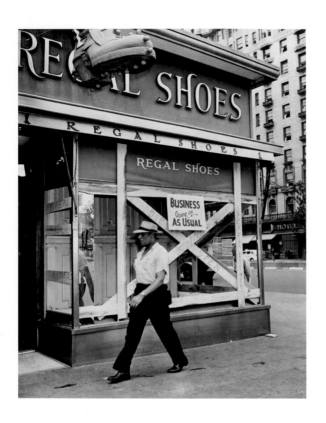

09 **166 WEST 125TH STREET AT SEVENTH AVENUE, SOUTHEAST CORNER**
Harlem—125th St. After Last Riot, August 1943
Hotel Theresa is across the street (southwest corner). *14688.1993*

10 **351 LENOX AVENUE BETWEEN WEST 127TH AND 128TH STREETS, WEST SIDE OF BLOCK**
[Cosmetics and herbal store, Harlem], ca. 1943
14629.1993

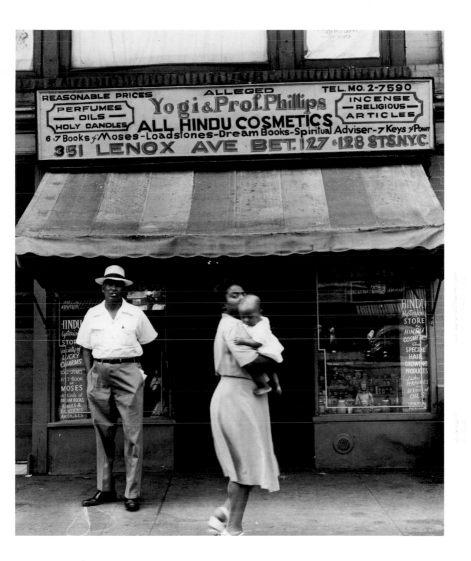

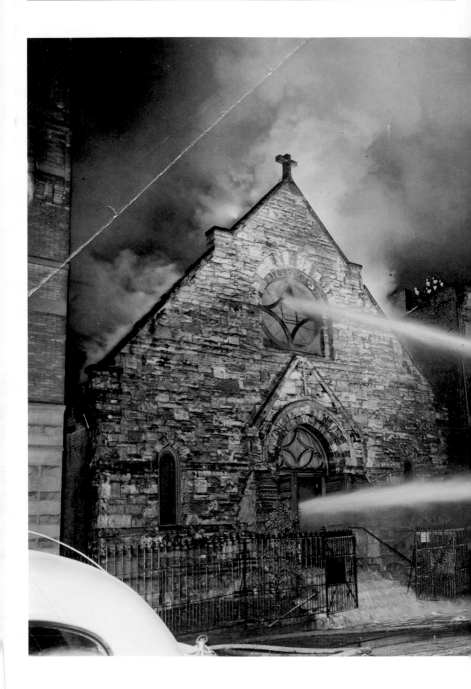

11 **121 EAST 127TH STREET BETWEEN PARK AND LEXINGTON AVENUES, NORTH SIDE OF BLOCK**
[Fire at Saint Mary's Greek Orthodox Church],
March 7, 1943
14998.1993

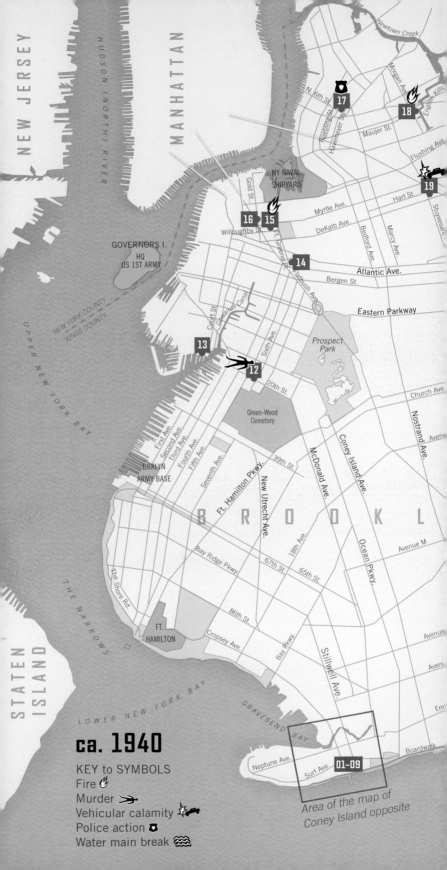

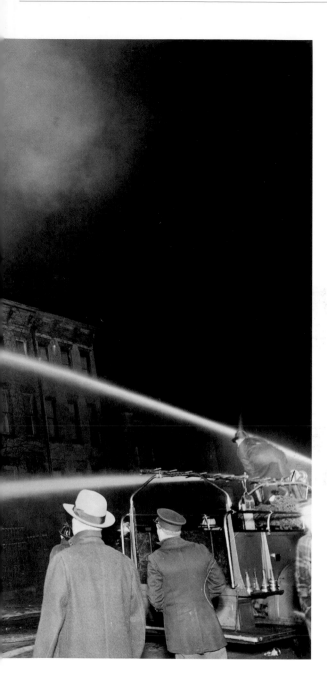

11 BROOKLYN & ROCKAWAY

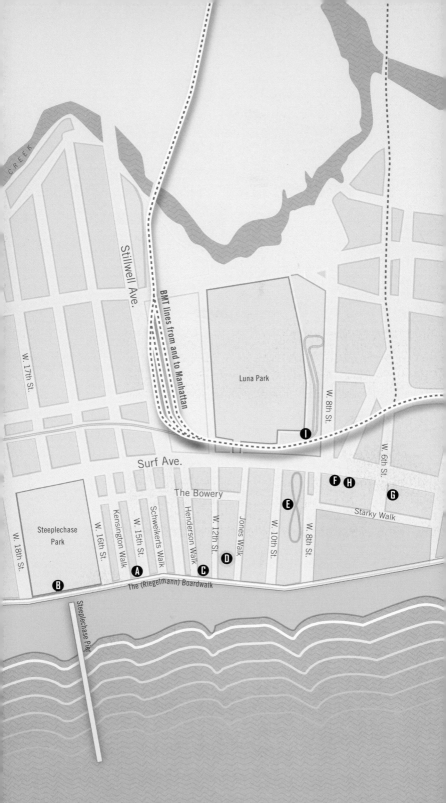

CREEK

Stillwell Ave.

BMT lines from and to Manhattan

W. 17th St.

Luna Park

W. 8th St.

W. 6th St.

Surf Ave.

The Bowery

Steeplechase
Park

W. 18th St.

W. 16th St.

Kensington Walk

W. 15th St.

Schweikerts Walk

Henderson Walk

W. 12th St.

Jones Walk

W. 10th St.

W. 8th St.

Starky Walk

The (Riegelmann) Boardwalk

Steeplechase Pier

OCEAN

A **B** **C** **D** **E** **F** **H** **G** **I**

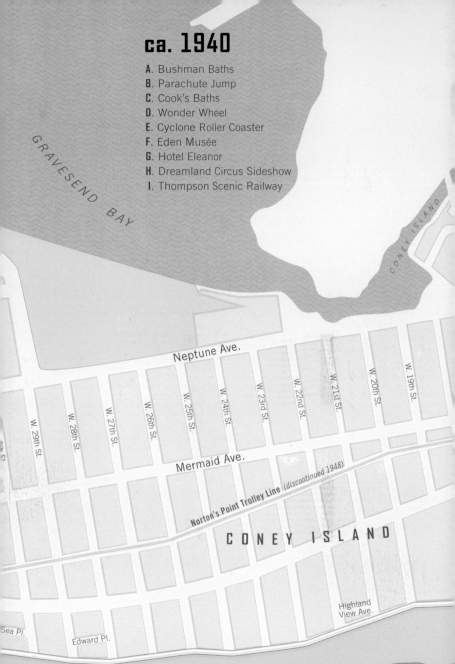

ca. 1940

A. Bushman Baths
B. Parachute Jump
C. Cook's Baths
D. Wonder Wheel
E. Cyclone Roller Coaster
F. Eden Musée
G. Hotel Eleanor
H. Dreamland Circus Sideshow
I. Thompson Scenic Railway

GRAVESEND BAY

CONEY ISLAND

Neptune Ave.

W. 29th St.
W. 28th St.
W. 27th St.
W. 26th St.
W. 25th St.
W. 24th St.
W. 23rd St.
W. 22nd St.
W. 21st St.
W. 20th St.
W. 19th St.

Mermaid Ave.

Norton's Point Trolley Line (discontinued 1948)

CONEY ISLAND

Highland View Ave.

Sea Pl.
Edward Pl.

Coney Island Beach

ATLANTIC

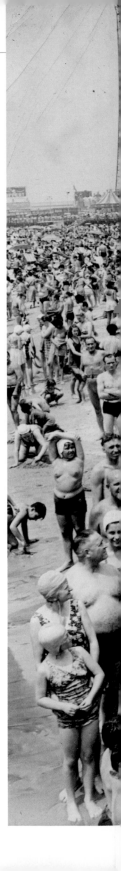

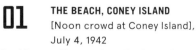

01 **THE BEACH, CONEY ISLAND**
 [Noon crowd at Coney Island],
 July 4, 1942
Looking northwest, from Bushman Baths (on the
far right) to the Ferris wheel at Steeplechase
Park and the Parachute Jump, which was moved
from the 1939 World's Fair to Coney Island in
1940. *2044.1993*

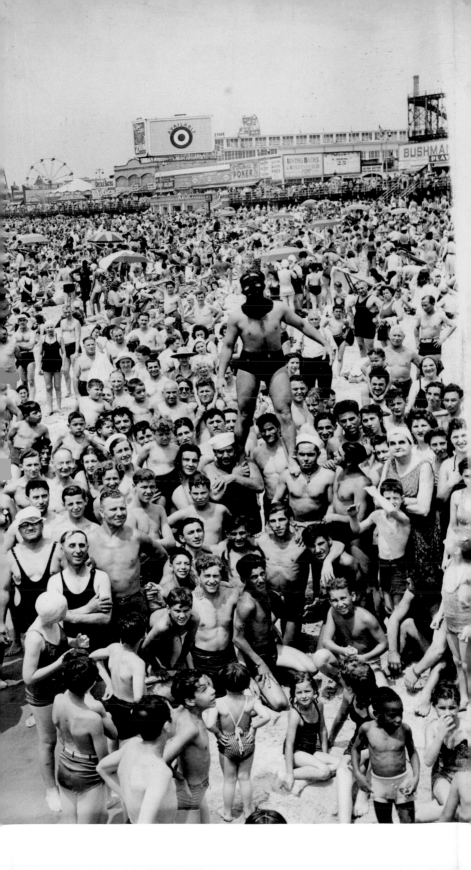

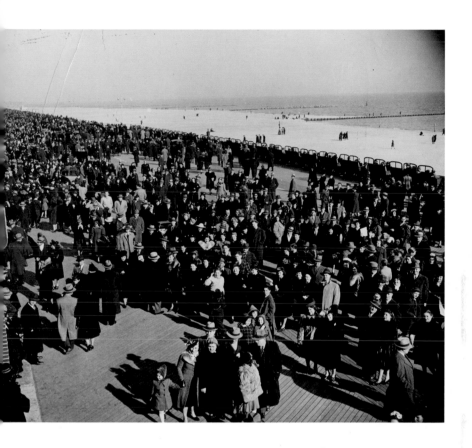

02 **THE BOWERY ON CONEY ISLAND**
[Sunbather in front of a padlocked shooting gallery],
January 19, 1941
Coney Island's Bowery, a plank street named after its seedier
counterpart in Manhattan, ran from West 16th Street to Jones Walk
between (and parallel to) Surf Avenue and the Boardwalk.
Weegee portfolio 8

03 **THE BOARDWALK, CONEY ISLAND**
Spring Comes to Coney Island,
March 22, 1941
Far left: Cook's Baths, at the corner of the Boardwalk and
Henderson Walk. The Boardwalk was built in 1923. *2038.1993*

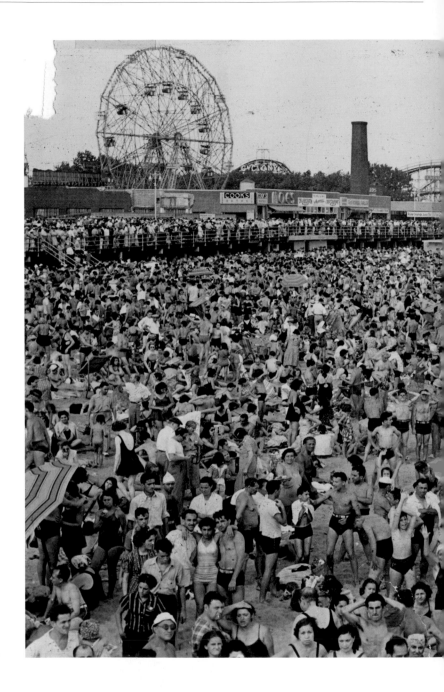

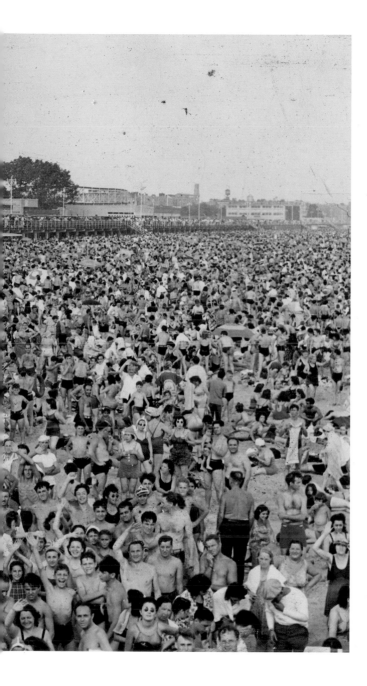

04 **THE BEACH, CONEY ISLAND**
[Afternoon crowd at Coney Island],
July 21, 1940
Looking northeast toward Cook's Baths and the Wonder Wheel.
The Cyclone, which began operation in 1927, is in the background.
2043.1993

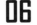 **BEHIND THE EDEN MUSÉE, CONEY ISLAND**
[Eden Musée waxworks],
March 23, 1941

Looking east to West 6th Street. In the background: Hotel Eleanor
on West 6th Street and Surf Avenue. The Eden Musée, brought to
Coney Island by sideshow impresario Samuel Gumpertz (1868–
1962), featured bizarre and sensationalist wax tableaux such as a
reenactment of Ruth Snyder and lover's murder of her husband.
7213.1993

06 **CONEY ISLAND SIDESHOW**
[Civil defense blackout in a sideshow],
ca. 1944

When Dreamland Park was gutted by fire in 1911, manager Samuel
Gumpertz built a new showcase for his Congress of Curious People
and Living Wonders of the World, on Surf Avenue (next to another
of his Coney establishments, the Eden Musée [05]). The new venue,
Dreamland Circus Sideshow, attracted up to 30,000 visitors a day
in the 1920s and its success spawned other freak shows at Coney
Island, featuring performers like Zip the "What-Is-It" and partner
Pip. *15500.1993*

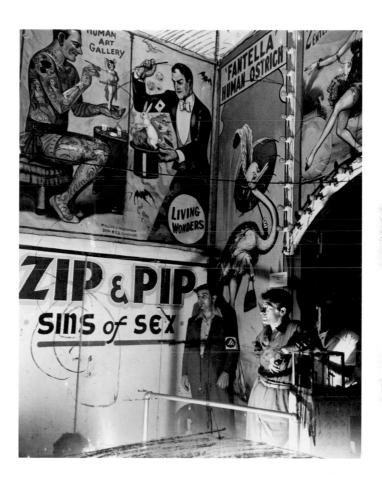

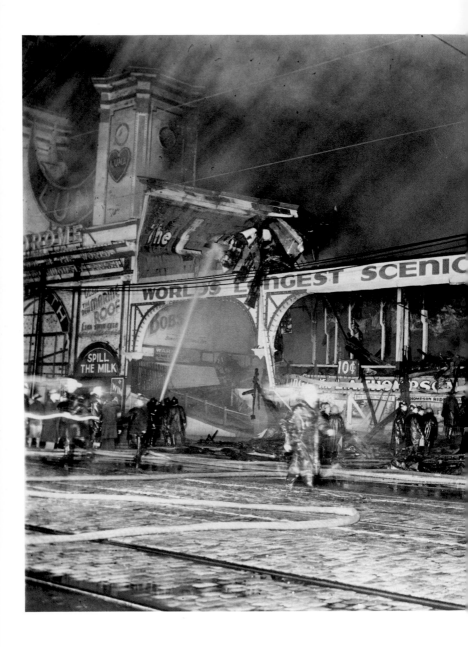

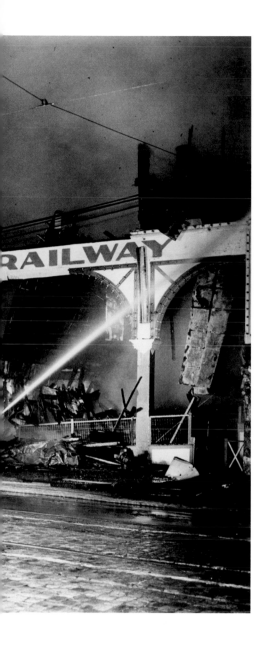

07 **SURF AVENUE AND WEST 8TH STREET, CONEY ISLAND**
[Thompson Scenic Railway destroyed by fire],
February 26, 1944
The Scenic Railway, which ran adjacent to Luna Park (on the left),
was built by amusement entrepreneur La Marcus Thompson
(1848–1919), who designed and constructed the world's first roller
coaster at Coney Island in 1884. *15037.1993*

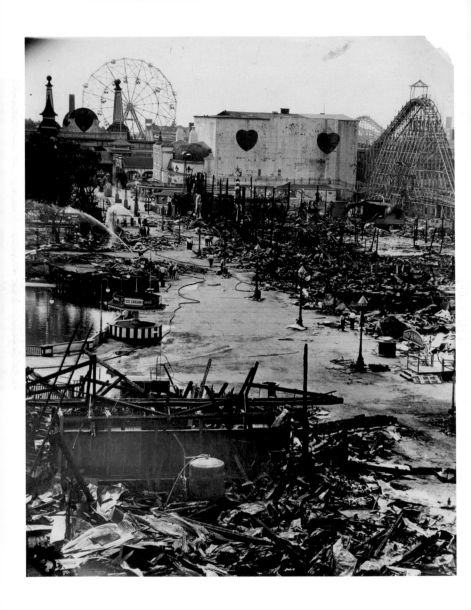

08 **LUNA PARK, CONEY ISLAND**
[Luna Park after fire],
August 13, 1944

The entrance towers to Luna Park are on the upper left, the
Wonder Wheel beyond. The 150-foot Wheel began operation in
1920. The August 12, 1944, fire destroyed more than half of Luna
Park. Although some of the rides were repaired, wartime rationing
of building supplies prevented a complete reconstruction. Instead,
visitors could view the ruins for ten cents. Luna Park closed com-
pletely in 1946. *2372.1993*

09 **LUNA PARK, CONEY ISLAND**
[Fox Photo Studio destroyed in fire], August 13, 1944
15209.1993

10 **116–06 ROCKAWAY BEACH BOULEVARD
BETWEEN BEACH 116TH AND 117TH
STREETS, NORTH SIDE OF BLOCK**
[Maher's Hotel], *PM Daily,*
January 4, 1944
This small structure in Far Rockaway still exists
in virtually the same condition.

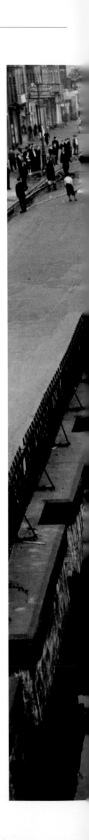

11 ATLANTIC AVENUE AND EASTERN PARKWAY

[Water main break floods the Long Island Railroad tunnel on Atlantic Avenue], October 16, 1938

Looking east on Atlantic Avenue from Eastern Parkway toward Sherlock Place and Sackman Street. The flood routed 350 people from a dozen apartment buildings.

Collection Christopher George

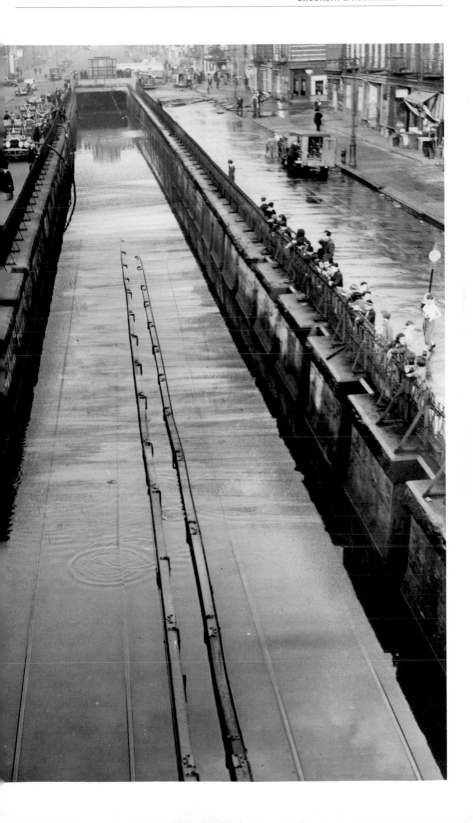

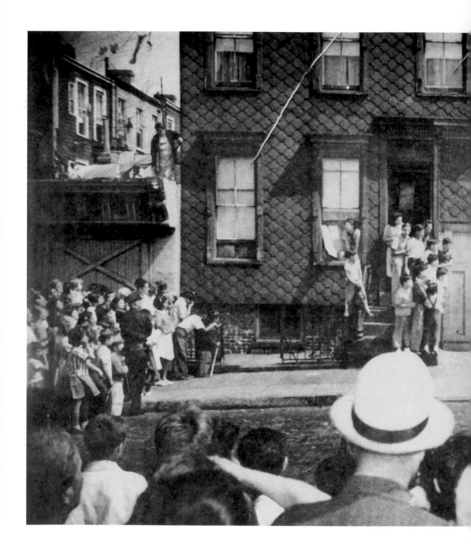

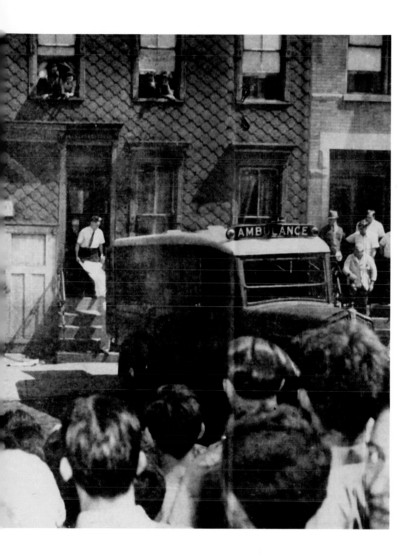

12 311 20TH STREET NEAR SIXTH AVENUE
[Tragedy in Brooklyn], *PM Daily,* August 28, 1941

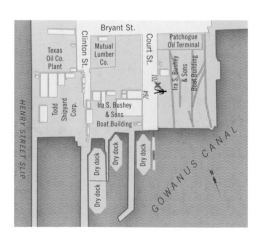

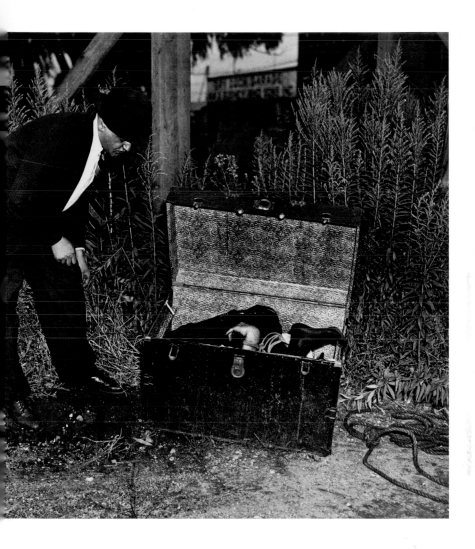

13 701 COURT STREET NEAR BRYANT

[Weegee inspecting trunk containing body of William Hessler, who had been stabbed to death], August 5, 1936
The site is a vacant lot a block from the Gowanus Canal in the Red Hook neighborhood of Brooklyn. In the background: Ira S. Bushey & Sons Dry Dock Garage, 764 Court Street. *2212.1993*

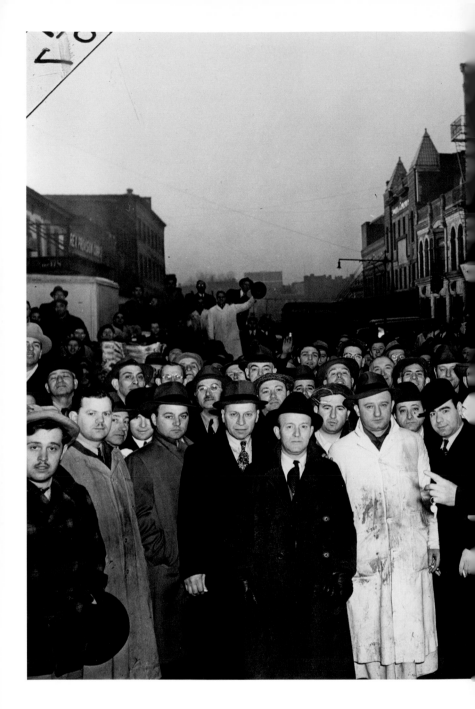

14 **FORT GREENE PLACE BETWEEN ATLANTIC AVENUE AND HANSON PLACE, WEST SIDE OF BLOCK**
[Wartime rationing: retail butchers await arrival of meat], March 18, 1943
Looking south on Fort Greene Place to Atlantic Avenue. *15350.1993*

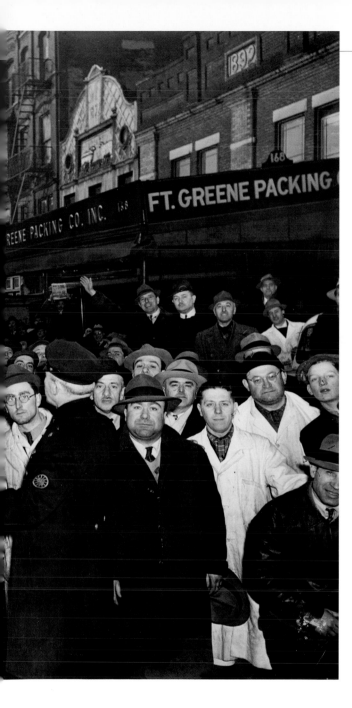

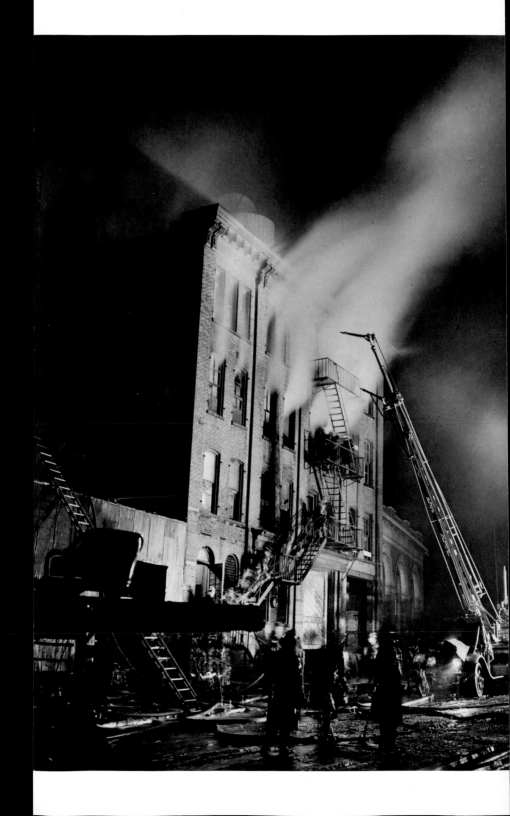

15 **249 WILLOUGHBY STREET,
NORTH SIDE OF BLOCK**
[Fire in a mattress factory],
January 31, 1942
The squat building on the right is the Brooklyn
Pumping Station, at the corner of St. Edwards
and Willoughby Streets. *1057.1993*

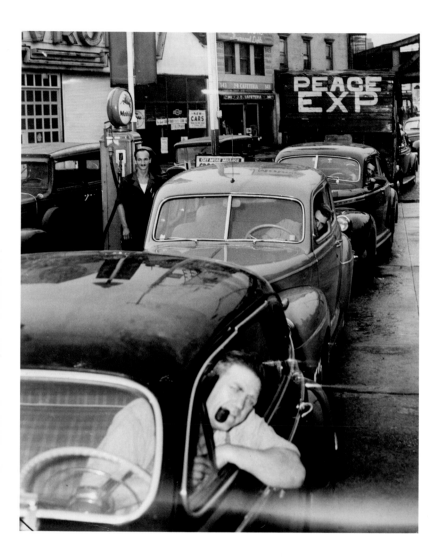

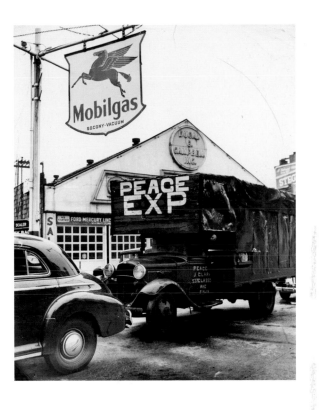

16 **335 GOLD STREET BETWEEN MYRTLE AND JOHNSON,
EAST SIDE OF BLOCK**
[Wartime rationing: Peace Express], July 4, 1942
15288.1993, 15289.1993

17 **NORTH 6TH STREET BETWEEN HAVEMEYER AND ROEBLING**
[Press photographers cover the shooting of shakedown
artist Peter Mancuso, Brooklyn], October 8, 1941
The building at the far left is No. 250–252 North 6th. The pho-
tographer on the truck is facing Public School 143. The shooting
occurred in front of the school, as 2,500 students streamed out
of the building.

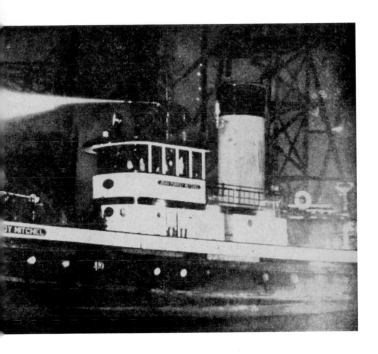

18 **MAUJER STREET AND MORGAN AVENUE**
[Fire at the English Kills], *PM Daily,*
August 12, 1941

A fire at the Brooklyn Union Coal Company on the bank of the English Kills in the East Williamsburg neighborhood of Brooklyn.

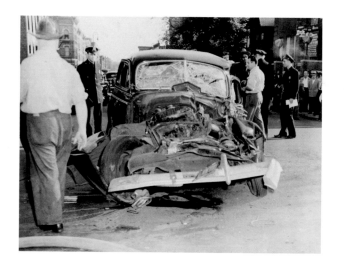

19 **STUYVESANT AVENUE AND HART STREET**
[Car and truck collision], ca. 1947
14157.1993, 14158.1993

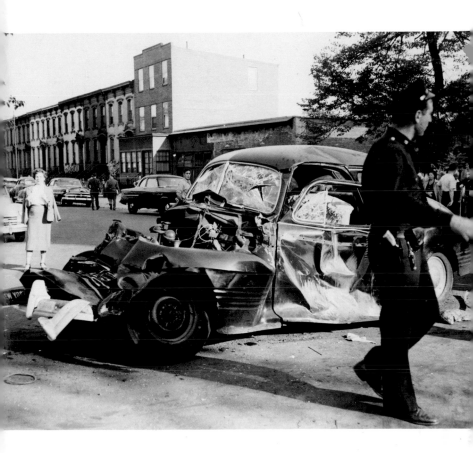

The Weegee Guide to New York

Published by the International Center of Photography
and DelMonico Books, an imprint of Prestel.

International Center of Photography
1114 Avenue of the Americas
New York, NY 10036
www.icp.org

DelMonico Books, an imprint of Prestel, a member of
Verlagsgruppe Random House GmbH

Prestel Verlag	Prestel Publishing Ltd.	Prestel Publishing
Neumarkter Strasse 28	14–17 Wells Street	900 Broadway, Suite 603
81673 Munich	London W1T 3PD	New York, NY 10003
Germany	United Kingdom	tel 212 995 2720
tel 49 89 4136 0	tel 44 20 7323 5004	fax 212 995 2733
fax 49 89 4136 2335	fax 44 20 7323 0271	sales@prestel-usa.com
www.prestel.de		www.prestel.com

Library of Congress Control Number: 2014957065

Director of Publications, ICP: Philomena Mariani
Production Manager, DelMonico Books: Karen Farquhar
Design: Elisa H. Maezono
Cartography: Adrian Kitzinger
Printed in China

ISBN 978-3-7913-5355-5